TRACEY CUNNINGHAM'S

True Color

THE ESSENTIAL HAIR COLOR HANDBOOK

Tracey Cunningham with Erin Weinger

Abrams Image, New York

Editor: Shannon Kelly
Designer: Claudia Wu
Production Manager: Denise LaCongo

Library of Congress Control Number: 2018958804

ISBN: 978-1-4197-3811-1
eISBN: 978-1-68335-676-9

Printed and bound in the United States
10 9 8 7 6 5 4 3 2 1

Abrams Image books are available at special discounts when purchased in quantity for premiums and promotions as well as fundraising or educational use. Special editions can also be created to specification. For details, contact specialsales@abramsbooks.com or the address below.

Abrams Image® is a registered trademark of Harry N. Abrams, Inc.

ABRAMS The Art of Books
195 Broadway, New York, NY 10007
abramsbooks.com

CONTENTS

FOREWORD

This is the story of Tracey Cunningham, a legend in our family and one of our greatest sources of pride and joy. Tracey came into our family when she was about nineteen as our daughter's nanny. We all adored her immediately. She was beautiful, sweet, creative, and kind.

Her only flaw was that she could not cook—not even a little. Because my husband and I were often out of town and we didn't want Sophie, our daughter, living on takeout, we decided to send Tracey to cooking school. Off she went, and a few months later, she graduated with new, staggering skills. She could now do anything: baking, roasting, soups, sauces . . . you name it. She made gefilte fish from scratch! Her matzoh balls were unbelievable! We realized we had a diamond in the rough.

Time marched on. In 1991 I starred in *For the Boys,* where Tracey met a man on the crew and subsequently had a baby. Some of us were worried about her raising a child all on her own, but in true Tracey fashion, she decided she could, and she did. We were there for the birth, and Max became part of our family too.

Time kept marching on. Eventually, we promoted Tracey to our family assistant. By then she knew our household very well, and she was a terrific assistant, but I could tell something was gnawing at her.

One day, I asked her what was wrong. She said that she felt stuck. She wanted to get ahead for Max's sake, and she felt there was more in store for her than a position as an assistant. I asked her what she wanted to do most and was absolutely floored when she said, "Well, I always wanted to do hair."

So off we sent her to beauty school, and the rest is history. To say we are proud of her and all she has accomplished is to minimize the depth of our feelings about what she has managed to do. She has justified our faith in her beyond our wildest dreams. She has become a star.

Her talent and work ethic have taken her and Max around the world, sent Max to college, given her a salon of her own, and showered her with endorsements and her own product lines. She has met and worked with celebrities, stars, the greats, the near-greats, and the soon-to-be-greats, and all of them return again and again, because she herself is great at what she does. She is celebrated online and in print as the hair colorist to the stars, and justifiably so.

It's a great ending to a story at which we often marvel ourselves, and one that has encouraged our family to do as much as we can to identify and educate those who have big dreams but no resources or access. If, in reading this, you feel the compulsion to do what we did, do it. You never know who the next star will be, and to have a hand in helping someone become somebody? The greatest feeling in the world.

Thank you, Tracey.

—Bette Midler

Part I:

Hair Co

olor 101

INTRODUCTION

I know what you're probably thinking: *How can there possibly be this thick of a book about hair?*
It's just hair. Yes, technically our hair is dead. But for something that isn't living, hair has a magical power to turn bad days into good ones; make us feel like we can conquer the meeting, kick ass during the speech, or feel radiant on the first date; and even turn a regular shopping trip into our very own fashion show when our awesome hair day makes us want to work the mirror. Hair is able to transform us. Some people change their hair color and style as a means to express themselves, while others identify so deeply with a particular color that they truly don't feel like themselves without it.

As you'll learn shortly, the art of changing the color of one's hair has been around for thousands of years as a way to denote social class and signify professions (yes, ancient sex workers were sometimes required to sport blonde hair) or socioeconomic standing. Today, certain hair coloring techniques and the frequency with which you get your hair professionally colored can certainly connote those same things. But, as we'll hear from some of my clients later, hair color at its core really allows women to feel like their true selves—whether it's the color they were born with or not. There's nothing more empowering than the confidence that comes from a strong sense of self and a comfort in your own skin—and hair!

I've wanted to write this book forever not only as a way to inspire and teach those who already color their hair or might be thinking about doing so, but also as a way to speak to all of the aspiring hair colorists out there (I read your DMs; I know there are a lot of you!)—this book is also for you because, once upon a time, I was just a teenager washing the towels and serving tea as an unpaid intern at Seattle's hottest salon and thinking about what a future career could look like. While I always felt in my gut that I'd embark on a hairstyling career, I never in a million years could have imagined that I'd end up with

a career that looked quite like the one I've built: taking a red-eye to New York to do Jessica Biel's hair for her TV show premiere, jumping on a flight to Miami to give J.Lo color for the Super Bowl, and coming straight back to LA for thirty back-to-back appointments at MèCHE, the salon that I co-own, where I get to mentor and nurture the next generation of truly great hairstylists. A combination of very, very hard work, a genuine curiosity to learn the business and the craft, and the magical good fortune of having a network of incredible and generous mentors has allowed me to create a career of my dreams (and face the exhaustion that comes with it, but never mind that). More than anything, I hope that this book shows you that even though it's going to be hard as hell, you really can do it, too—if you want it badly enough.

I've split this book into three sections: **Part I** goes over the basics—the history, the terminology, and my own journey and philosophy as a hair colorist (and just someone who really gleans purpose and fulfillment from helping my clients feel their best). **Part II** is the really fun part, the photos. This is where I show you guys my pop-culture color heroes and some of my clients—and their gorgeous personal photos that showcase their hair colors, from natural to now (as you'll learn soon enough, I urge every single client to look at their own baby photos to see what their true color really is so we can match it in the chair). I hope you'll dog-ear your favorites and bring this book to your own colorist for inspiration during your next appointment (someone else's baby picture works, too!). A shade that looks like your true color— aka the color that makes you feel like you—is, in my opinion, the best color. Always. And **Part III** gets down to brass tacks: how to achieve the hair—and, if you want it, the colorist career—of your dreams.

So let's dive in, shall we?

TRACEY'S TRUE COLOR

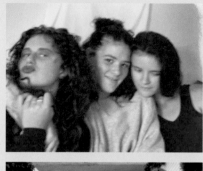

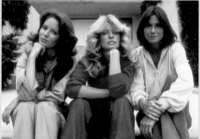

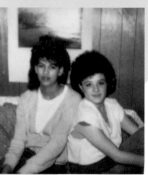

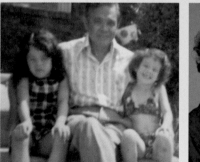

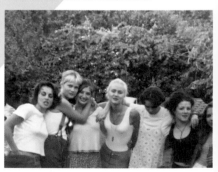

Clockwise, from top left: With my friends Catherine Saenen and Brenda Davis, right after I had a baby and my hair was falling out; the cast of *Charlie's Angels*, my ultimate hair inspo; three-year-old me; my friend April's blonde bob is still one of the coolest haircuts I've ever seen; my best friend Alison Moody and me during high school; me with my fellow single-mom friends; my sister Sandi and my weird, brushed-down hair; My other best friend Julie Ford, who became my friend because I forced her to straighten my hair and the rest was history; me, Sandi, and our grandpa; I cut my hair to look like Molly Ringwald, who was (and still is!) the coolest thing ever.

I was just a kid the first time I realized I loved hair. I was growing up in Seattle, Washington, and was slightly obsessed with the gorgeous actresses on *Charlie's Angels* and *The Love Boat*. Farah Fawcett and Jaclyn Smith were my icons, despite the fact that they had perfect blowouts lacking even a single flyaway or split end and I was a kid who was just learning how to deal with my reddish-brown mop of unruly curls. I couldn't get enough of Farrah's bleach-blonde feathered flip or Loni Anderson's tow-headed tucked-under bob (more on the magic of blondes later). To pay proper homage to my small-screen beauty superheroes, I convinced my mom to let me use her as my very own test head, where I would blow-dry and style her hair to mimic the looks that I saw on TV (yep, still just a kid). At this ripe old pretween age, I didn't know that I wanted to be a hairstylist exactly, but I did know that hair held a big place in my heart. I also knew that I was *good*. My mom's hair did what I told it to. It moved in harmony with my brush and flipped with a wave of my hand. It straightened out as I varied my force. And, as if by magic, it stayed perfectly in place as I twisted and twirled different pieces into position. I was completely mesmerized and undeniably hooked.

Once I got to high school, my interest in hair only grew stronger. By now I was into Stevie Nicks (I was definitely inspired by blondes in those days) and spent hours scouring thrift stores for gauzy vintage dresses that felt like the ones she would wear. I would notice my friends walking the halls at school in their chic acid-washed skirts and leather jackets, but what always stood out to me was their hair—especially my friend April's platinum-blonde bob. It was a Friday night during high school, and I was at a football game with another friend. And in the distance we noticed a girl who looked like the coolest, prettiest girl we'd ever seen. We had no idea who it was, so we walked over to investigate, and we were seriously shocked that it was our friend April with an entirely new cut and color, courtesy of her dad's best friend, who happened to be a hairdresser. All of a sudden everyone else at school thought April looked like the coolest thing they'd ever seen, too, and this moment still stands out as a major creative turning point for me because it's when I first distinctly remember noticing how powerful hair could be as both an accessory *and* as a storytelling device.

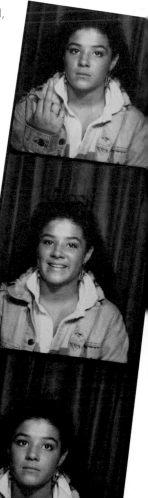

As I'll mention soon, color itself never felt like my "thing" until my career got off the ground. But I do remember the first time I really noticed someone's hair and thought, *She needs color*. A new student transferred to my high school from her native Norway and had that beautiful, eighties-era Calvin Klein–model blonde—that somewhat dirty, dishwater blonde that truly happens only if it grows out of your head. It was really pretty. But I remember looking at my new classmate and thinking that her hair needed to be either really light or really dark to better complement her complexion—not the in-between blonde it was. So I convinced her to let me take her to Fred Meyer, our local Seattle drugstore chain, to get some box color and go to town. We chose a super-blonde shade and went back to her house. I had never colored hair before and had abso-lutely no clue how to do it beyond what was written on the box (YouTube tutorials most definitely didn't exist). I put the color all over my friend's head, followed the

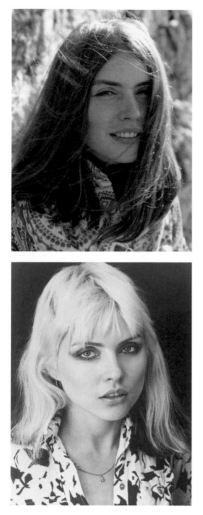

instructions, and soon she was a bona fide bright blonde. By the following Friday, the newfound confidence resulting from her new look scored my friend a date with one of the cutest boys in school (because back then that was all that mattered, obviously). And I couldn't believe how someone could make a major change in their life just by changing their hair color. I feel that way whenever I look at old pictures of Debbie Harry, who was a very pretty girl with light brown hair until her platinum locks transformed her into Blondie. Just like my high school friend, one day she blended in. And the next day she very, very much didn't.

Hair has the power not only to transform you but also to communicate who you are to the world. It helps create your vibe. And your hair also transmits messages, whether you're straightening your naturally curly locks because you think you'll feel more polished for a job interview or coloring your chestnut-brown tresses dirty blonde because you just went through a breakup and feel like having a different view in the mirror for a few months. I knew I loved hair. But this was the first time I really started to understand its power. Hair makes you *feel*. And I knew I needed to be part of it in a bigger way.

When I was fifteen, my high school offered a work-for-credit program that allowed us to get after-school jobs typically reserved for older kids. And I knew right away that I wanted to work in a salon. As you'll discover throughout this book, I've always had a knack for sniffing out salons that resonate with me because of their vibe and reputation (there are plenty of "cool" salons that don't have particularly pleasant vibes *or* good reputations for treating their clients or workers well). And the first of the many amazing salons in which I would end up working was Gene Juarez, which was founded in 1971 and was the absolute coolest and best place to get your hair done in the city (it's still open in Seattle today). While my new "office" was glamorous, my duties were anything but. I was responsible for doing laundry, washing towels. I swept up hair in between clients, and I brought them cups of MarketSpice tea from the famous tea shop in Seattle's Piko Place Market. No, my job wasn't fancy. But I became part of the salon family and absorbed every little detail of every little thing that I was seeing. I was welcomed into the salon's world, complete with the bustling energy of clients and music and adrenaline, and to me every day seemed to feel like a party. I couldn't understand how people actually got paid to do this. Who wouldn't want to be at a party all day long?

After I graduated high school, a friend of mine happened to be living in La Jolla, California, and I was ready for an adventure. She asked if I wanted to join her and I thought, *Why not?* So I packed up

my stuff and got in the car. I was still thinking about hair, but I wasn't quite ready for a career yet, so I accepted an entry-level job at Coldwell Banker, a real estate firm. (Funnily enough, I worked for a real estate agent there named Mike Bruno who would go on to start the super-successful online antiques marketplace 1stdibs—I've always been fortunate to find myself among remarkable people!). After a few years in La Jolla, which I spent going to the beach constantly and answering phones, two of my friends decided they wanted to move to LA. So in typical Tracey fashion, I packed up my stuff and got in the car yet again. I got to LA with very little money and no job, but I was having so much fun going out and being with my friends that I still wasn't ready to really think about a career. I ended up working with a temp agency, and after a quick stint at the scouting division of LA Model Management, the agency secured me an interview at PMK, one of the biggest celebrity PR firms in town, where I started as the company receptionist.

I was barely making ends meet on my receptionist's salary and couldn't even afford to get home to Seattle for Christmas. I knew I needed a different job, but, feeling very much the kid in her early twenties enjoying her new LA life, I still wasn't ready to take the plunge into hairstyling. While doing research, I discovered Rose's Agency, a business that staffed nannies, assistants, and housekeepers. It was during a phone call with them that I learned that Bette Midler was in need of a new nanny. I was put in touch with Bette's husband, Martin, and promptly hired, meaning I had to give my notice to the owner of the firm—where Bette happened to be a client herself. It was an early lesson in using my voice to move my life forward, something that takes courage, pluck, and a bit of blind naivete. I soon found myself on my very first assignment as Bette Midler's daughter's nanny: a playdate pickup at none other than actress Candice Bergen's house. I knew immediately I was going to love my new job.

I quickly became part of the family, and Bette even sent me to cooking school so I could hone my culinary skills (which were absolutely nil) and make dinner for the family. I'd drive Sophie, Bette's daughter, to and from school and to playdates (including ones with Lily Aldridge at her mom, Laura's, house just up the street), take care of household errands, and—my favorite perk—watch famed hairstylist Robert Ramos do his handiwork when he'd come to the house to get Bette ready for an event (he still gets her ready for events today!). I studied his every move. And I was completely in awe.

Robert was one of the busiest celebrity hairstylists in town, complete with Emmy nominations, Estilo, his wildly popular salon, and a client list that would make the most ardent consumer of pop culture blush (Stevie Nicks, anyone?). And as such, he wasn't always available to do house calls, especially when Bette just needed a quick everyday blowout. So I raised my hand and asked if I could act as his understudy. Bette, who already trusted me with her child and her dinner, was more than happy to trust me with her hair, too. And she didn't just trust me; she loved when I did her hair. Soon we developed a morning routine: Bette would hop in the shower while I made her hard-boiled eggs and coffee for breakfast, and as she ate, she would flip through a cookbook to decide on dinner while I blew out her hair. Even to this day, my mornings with Bette remain some of my happiest hair memories of all time.

In 1991, I accompanied Bette to set as she filmed *For the Boys*, which earned her a Golden Globe win and a Best Actress Oscar nomination. During the shoot, I met an assistant, and . . . well, sparing you the details, I soon found out I was pregnant. None other than Bette herself volunteered to be my Lamaze coach.

Soon, I was a new, single mom in her early twenties, so when Bette and her family decided they wanted to spend more time in New York and invited me to join, I decided it was more important to create stability for my son, Max, and finally figure out a real career. I wanted to be able to give him the life he deserved. One day shortly before their move, while I was talking with Bette about the future, she remarked that she couldn't believe I'd never gone to beauty school. And that was the first time that it truly hit me—I actually couldn't believe I'd never gone to beauty school, either. I set out to change that.

I didn't have a lot of money and now had a new baby to contend with, so I stopped by the local community college to ask about financial aid—which, it turned out, I didn't qualify for. (I could write a whole chapter about my rage toward the US educational system, but that's a subject for another book.) I didn't know what options I had, short of quitting my job so I could qualify for aid and actually afford to go to school. But again, in true Bette form, she had my back.

"I'll pay for your beauty school. Pick whichever one you want."

Bette, Martin, and their entire family had always been so generous toward me and really made me feel like one of their own. The last thing I ever would have wanted to do was take advantage of their kindness, so instead of choosing the "best" beauty school—which, at that time, would have set them back at least twenty-five thousand dollars—I found the cheapest: the Marinello School of Beauty. It was on a really busy street in the middle of LA in a building that now houses a Ross Dress for Less and that, if I'm being honest, was kind of gross. It was crowded and noisy and didn't feel glamorous in any way. I hated every second. Chris Palmer, my new boyfriend at the time (whom I've now been with for twenty-seven years), would listen to me complain every single day about how much I detested my know-it-all instructors and my classes, which seemed to be filled with people who weren't paying attention and didn't want to be there, either. I didn't have time to socialize or make friends with anyone anyway, because I had a baby at home and was still working for Bette whenever she was in town. But I felt isolated and alone, and there were countless times that I seriously wanted to keep driving past the school instead of going to my classes in the morning. I didn't want to be in a classroom, I just wanted to be doing hair.

At the same time that I was reluctantly pursuing my official beauty education, I was also spending weekends hanging out in Robert Ramos's salon, where I'd not only watch Robert do his thing but also observe super-famous stylists, including Chris McMillan and Teddy Antolin, who both worked there at the same time (you may already know Chris as the man who gave Jennifer Aniston the iconic "Rachel," while Teddy was David Bowie's longtime mane man and was the matchmaker who introduced him to Iman). I remember being in slight awe of the models and movie stars that would come through there every day. Rachel Hunter and I even compared pregnancy stories once. And when the people-watching died down,

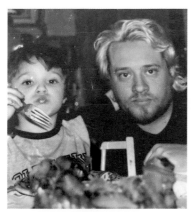

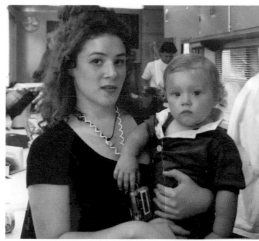

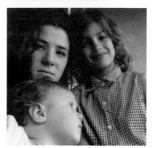

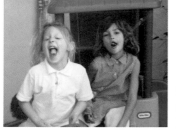

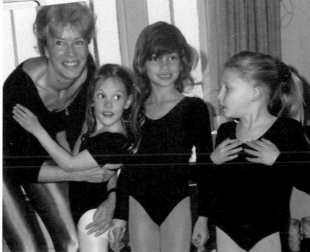

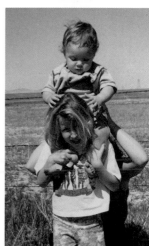

Left to right, top to bottom: Max with Chris, who's sporting my very first bleach and tone; me and Max on the set of *Hocus Pocus*—check out my beeper; Max all grown up; me, Max, and Lily; Sophie and Lily acting like perfect little ladies; Sophie's squad (I used to take Sophie and Lily to ballet class); Sophie and Max—her honorary little brother; two more of me with Max as a baby; with Bette and Sophie in New York while I was pregnant with Max; me with the ballet girls; me and Sophie, all grown up

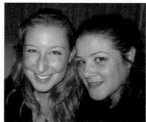

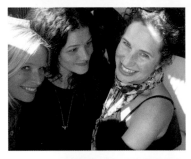

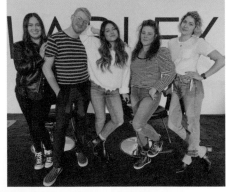

Left to right, top to bottom: Andy Lecompte and Byron Williams; Robert Ramos; fellow colorist-who-never-stops Lorri Goddard; my friends Tonya and Allison; the late Nanci Ryder, a dear friend and client who passed away from ALS in 2020 who introduced me to Renée, Reese, J-Lo, and so many people who are still clients and friends today; Team Nanci at the L.A. County Walk to Defeat ALS; Art Luna; superstylist Adir Abergel; Nicola Clarke, the blonde English version of me; my amazing friend Sharon McConochie; Sally Hershberger, whom I worked with for years; a shoot for Olaplex; my sister; in the photo booth with Byron Williams; my amazing MèCHE team—Sean Metcalfe, Tyle Mahoney, Loz Jung, Minya Alisa, and Jacon Schwartz; "The Rachel" inventor himself, Chris McMillan

I'd do my own hair in the mirror and watch Robert and his team work magic on their clients. I felt like the coolest girl in the world and couldn't wait to work in a salon—especially one that was a complete 180 from the deplorable conditions I faced at Marinello—even though I was seriously contemplating becoming a beauty school dropout.

"You have to stick it out," Robert would tell me, usually right after I was done complaining about how awful beauty school was. "It doesn't matter where you go to school."

"But I'm not learning anything!" I'd cry.

"It doesn't matter. You'll learn when you start assisting."

My other best cheerleader was my boyfriend, Chris, who always encouraged me to keep going. Of course I always thought about my son, Max, too, and I knew that giving up wouldn't be the best thing for his future. Without the three of them, I don't think I would have been able to make it through.

You'll hear me talk later in the book about the true ins and outs of choosing a beauty school and why being an assistant (and a kick-ass one, at that) is so much more important than the institution name on your certification. Once Robert and his colleagues drilled that wisdom into me, I decided to keep going with school so I could have the kind of future that deep down I always knew I wanted (even while bitching and moaning the entire way). I knew that Robert would offer me an assisting job at Estilo, but I didn't want to turn a place where I had so many friends and so much fun into a work situation. I wanted to make it on my own and challenge myself, so I knew I had to find my own next move.

One day while I was visiting my friend Laura, who I'd become close with during Sophie's playdates with her daughter Lily Aldridge, I happened to pick up a *W* magazine that featured photographs shot by her stepson, Miles, a well-known fashion photographer. One story caught my eye: "Meet Art Luna, Hollywood's Hottest Hair Stylist." I was used to seeing magazine articles about actresses who *maybe* gave a one-line shout out to their hairstylist, if even that. This was the first time I saw a stylist featured as the star of the show, and I was completely blown away. I grabbed the phone book (remember those?) and quickly looked up the number of Art's salon, calling cold and asking the receptionist who answered if they happened to be looking for assistants. As it turned out, they were.

When I started working at Art Luna in 1995, the salon had just opened in Hollywood and everyone from Reese Witherspoon to Diane Lane to Renée Zellweger frequently appeared in Art's chair, getting primed for whatever film or event they had coming up. I knew what a privilege it was to have an opportunity to learn from Art and his associate Sheri Román, who I also assisted, and I didn't take it for granted for a single second. I worked my ass off.

While I was killing it for Art and Sheri, I was simultaneously failing my beauty school tests (I ended up having to take them four times before I finally earned my certification). But I was absolutely in love with working under Art. He was a master at creating a vibe in the salon, using flowers and music and fashion

to craft an atmosphere of relaxed "cool." I loved every detail. Just like when I was a teenager, I was still obsessed with vintage clothes and thrift-store treasure and had an ever-growing penchant for the same peasant dresses, Doc Martens, and chokers that Art's famous clients would come in wearing—only mine came from Goodwill.

The importance that Art placed on creating his salon vibe taught me to do the same, and I still strive to do so today. Rotating various 1970s playlists and using a certain type of china to serve tea may seem like tiny details, but they really add up and allow clients to have a certain feeling when they step inside the salon. And if they have a memorable experience and end result combined with a great feeling about being there, they'll keep coming back.

I was working my ass off and going above and beyond my assisting duties. Even though my primary interest was coloring hair, I spent many of those early days helping Sheri give her clients blowouts, which they all seemed to be obsessed with. And I soon found that the saying is true: Hard work really does pay off.

"We have to put you on the floor," Art said to me one day. "You're so good."

I had officially graduated from being an assistant, and soon I had my very own station and client list—including Portia de Rossi, who was just starting to make it big on *Ally McBeal* and, as such, was generating a ton of press. I started fielding calls from magazines about her hair and got my very first taste of what being an LA celebrity stylist entailed. Word of mouth built, and I started to book up weeks in advance. I was doing color, but I was also doing everything else—lots of blowouts very much included. And the more I acted as a jack-of-all-trades stylist, the more I confirmed that I enjoyed coloring hair more than the other stuff. When I was a beauty student, all of the young hair models would let us experiment and try different techniques on them, including, of course, the big, chunky highlights that everyone seemed to want at that time. But when I officially began working on the floor at Art Luna, I realized that those same cool, wild looks that made beauty school feel creative were not anything close to what my clients wanted. The majority of them came to see me because they wanted to cover their grays and, whether they were eighteen or eighty, they were attempting to recapture a feeling they experienced through their younger self's hair. (To see this effect in action, check out "Hair Color: Better Than Botox" on page 119.) I loved that I got to help my clients change their

outlooks and even their lives by giving them a hair color that made them feel like the true version of what they wanted to put forward to the world. Even though the majority of my work was more muted than what I was used to trying in beauty school, painting highlights and lowlights on hair and mixing color formulations felt creative and skilled all at once. I was never bored. And even though I was in my early twenties and still figuring so much of life out for myself, I began to feel like it was my job to be a "fountain of youth" for my clients and make them feel confident and special as soon as they left my chair. From a career perspective, I also loved that hair color was something women won't go without no matter how dire the times. As a young, new mother who literally needed to make money to feed my son, that potential stability was a huge motivating factor in my desire to keep honing my craft.

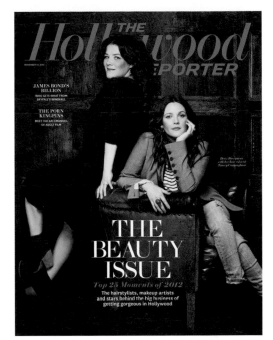

Although I grew up worshipping the mostly blonde bombshells I saw on TV, I realized how incredible it was to help women achieve a higher-impact version of their natural hair color, whatever color that was, and developed my own strategy to do so: reawakening the color they had in childhood. Oftentimes their color had changed throughout the years, both inspiring wistful memories and sometimes causing a sense of dismay as it deepened or dulled with the years. I loved returning a natural-born towhead to the golden glory she experienced as a kid. I felt fulfilled when I added dimension-building highlights back into the long locks of a woman who remembered the warm chestnut hue that lost some of its luster as she grew up. I asked clients to bring in their own baby photos so we could match the shade. Sometimes clients would bring their kids to their appointments and I would freak out at how gorgeous their natural, sun-kissed color was and insist on mixing something resembling that shade for my very adult client. Realizing that so many of the people I was working on looked beyond incredible when they dyed their hair the color that they were born with—or a version close to it—made me realize how much I loved beauty that looked natural and real. And even though today I take my clients five shades lighter at the snap of a finger and frequently change them right back a few days later, my beauty philosophy is that everyone looks their very best when they embrace their true color.

I wanted to transition into focusing on color full-time, but *Allure* magazine foiled my plans by listing me in their 1997 beauty directory as "Best Blow Out." That was my first piece of major press. And while it was incredible to have the acknowledgment of such a prestigious magazine (and the slew of new clients that came with it), as my calendar booked up with styling appointments, I wondered if I would ever be able to make the leap to doing color full-time.

After a few years on the floor at Art Luna, I decided it was time for me to move on and look for my next opportunity to grow. I ended up at another of LA's hottest salons, Sally Hershberger at John Frieda, and took my ever-expanding celebrity client list with me. This was around the same time I landed my very first magazine cover job—doing Renée Zellweger, who had been my client at Art Luna, for the cover of German *Vogue*. Before I knew it, I was in London with Renee, getting her ready for the world premiere of *Bridget Jones's Diary*. I was traveling more and more, doing press with Reese Witherspoon, Sarah Paulson, and the Australian actress Jacinda Barrett. I styled Amanda Peet for the covers of *Lucky* and *Self*. And I was working like crazy at the salon.

I was exhausted from all of the travel, and Max, who was in grade school, really wanted me home. So I cut back on travel and finally made the decision to focus solely on color. Giving all of my attention to this one aspect of my craft quickly allowed me to realize that I had found my superpower. I guess you could say that this was when I was able to find my true color—in the context of my work—too.

In 2005, I was ready for another growth spurt and decamped Sally Hershberger at John Frieda for Neil George, a new Beverly Hills salon owned by British super-stylists Amanda George and Neil Weisberg. By 2008, I had an opportunity to put my own name on a salon and opened Byron & Tracey in Beverly Hills with fellow stylist Byron Williams. And in 2012, I moved down the street to a space that is still, today, my own: MèCHE, the salon I opened with my former-boss-turned-business-partner Neil (I'll get into much more detail about what it actually takes to own a salon later in the book). That same year, I landed another magazine cover when the *Hollywood Reporter* put my client Drew Barrymore and me on their first-ever Beauty Issue. It was the first time in my entire career that I was the one on the cover instead of working behind the scenes.

Now that my son is older, I'm back to traveling like crazy (Africa to visit a movie set, Nashville to touch up Lily Aldridge's color, and yachts in St. Tropez and Ibiza included). MèCHE is busier than we've ever been. In my spare time (yeah, right) I also teach master classes and mentor fellow hair colorists all over the world as an ambassador for both Redken and Olaplex. And I have more than three hundred thousand Instagram followers, whom I update on the joys of my job every day.

As I said at the beginning, I could never in my wildest dreams have imagined that I would have this kind of career. And while hard work, perseverance, the generosity of others, timing, and immense luck have all played their part in getting me to a place I am grateful to be every single day, there's one thing that I still look back on and point to today: I always followed my passion and love for hair, even when I didn't realize it. I listened to my heart and discovered my dreams.

I let my true color lead the way.

I can't believe how lucky I am to have such an amazing group of inter-
esting, talented clients and friends. Here, from the top left to right:
Jessica Biel; Jennifer Lopez; Jennifer Garner and Adir Abergel; Bette
Midler; Fergie at her baby shower; Renée Zellweger; Katharine McPhee;
Lana Del Rey; Tyle Mahoney and Lisa Marie Presley; Maggie Q; Nikki
Pennie; Julie Ford and Khloe Kardashian; Lily Aldridge; Ali Larter;
Tatum O'Neal; Dr. Barbara Sturm

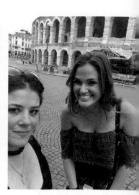

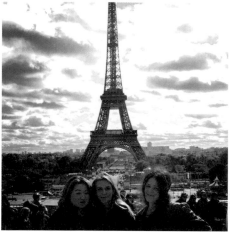

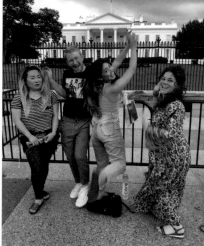

Before the COVID crisis, I basically lived on airplanes so I could teach classes, see clients, launch product lines, and do salon residencies all over the world. While I was constantly exhausted, I have enough wonderful memories to last me a lifetime. Here are just a few of my travel pics: Rome, Paris, Washington DC, London, Italy, all over Asia and the Middle East—some of my absolute favorite places to work.

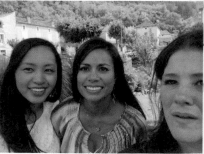

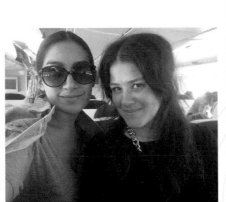

HAIR COLOR 101: A GLOSSARY

ACTIVATOR: Also referred to as "developer," this chemical—which is oftentimes peroxide—is an oxidizing agent added to hair color that "activates" the chemical process that deposits hair color into the hair shaft.

AMMONIA: This alkaline chemical, which is found in most permanent hair colors, is used to raise the pH level of hair, which then "lifts" the cuticle of each strand of hair and allows for color to penetrate the hair's natural melanin so the "activator's" chemical reaction can occur on each hair shaft's cortex—or the inner part of the hair—and color can be deposited.

BABYLIGHTS: Superfine highlights that mimic the sun-kissed look most of us had naturally as babies.

BALAYAGE: A highlighting technique inspired by the French word for "to sweep," in which a colorist hand-paints small sections of hair for a natural effect.

BASE: Your canvas. This is the color that gets applied all over your head and either provides the—yep—"base" for the highlights and lowlights that will ultimately add natural-looking dimension or changes your root color. If you already have your base color done, you apply base to the line of demarcation to "touch up" your roots.

BLEACH: Bleach oxidizes the pigment-producing melanin inside your hair shaft, leaving it colorless and ready to take on a new hue. Bleach is mixed with activator to do its thing.

CONTRAST: The shades of your highlights and how they differ from the shade of your base.

High-contrast stands out more amidst your base and is more noticeable, while low-contrast blends in for a more natural look.

COVERAGE: The amount of gray that a specific hair color covers.

DEMI-PERMANENT: Color that contains little to no ammonia or peroxide and that, when mixed with a low-volume developer, deposits a color with minimal lightening power and lasts roughly twenty-four shampoos. *See also: Semi-Permanent and Temporary Color*

DIMENSION: The opposite of flat, one-color hair. Dimension is what you get when highlights and lowlights create full, multidimensional color that has movement.

DOUBLE PROCESS: You can make a salon appointment for just a base or just highlights. But when you combine the two—ta da!—double process.

FOILING: A technique in which your colorist paints highlights and lowlights on strips of hair that are folded in foil.

FULL HIGHLIGHTS: When highlights are painted all over your head, not just on the topmost layer. *See also: Partial Highlights*

GLOSS: Either transparent or containing a slight color, a gloss treatment is either semi- or demi-permanent and coats and seals the hair cuticle to give a shiny, "glossy" surface look.

HENNA: Derived from the *Lawsonia inermis* tree, henna has been used as a cosmetic dye for more than six thousand years, with its first recorded use

as hair color dating back to the ancient Egyptians (Nefertiti, Cleopatra, and mummies alike). Since then flappers, opera singers, Lucille Ball, and hippies have used it to lend their locks a reddish tint (while it's still used as celebratory body art in many parts of India and the Middle East). Since henna doesn't chemically alter the hair, it typically begins to fade within a few weeks. There are various types of henna (compound henna is usually mixed with indigo), including black henna, which contains PPD and can cause allergic reactions in some. *See also: Temporary color and Para-Phenylenediamine.*

HOT ROOTS: When your roots are a noticeably different, warmer color than the rest of your hair. This can be caused by using the wrong color and/or keeping color on the roots for the wrong amount of time. It's a mistake that a skilled colorist won't typically make.

HUE: The pure spectrum colors commonly referred to by the "color names"—red, orange, yellow, green, blue, violet. *See also: Pigment*

LEVEL: The universal color chart standard used across salons and hair color manufacturers. A "level" is used to describe how light or dark a hair color is—the higher the number, the lighter the hair.

LINE OF DEMARCATION: A term that refers to the border between North and South Korea and—just as important—the place where hair grows out, separating colored hair from new growth.

LOWLIGHTS: Just as lighter streaks are used to brighten up hair during highlighting, lowlights use darker streaks to add dimension to your color.

MEA: Monoethanolamine is an ingredient that takes the place of ammonia in "ammonia-free" hair colors. While a close relative of ammonia, MEA doesn't have the same effect of allowing dye to penetrate the hair shaft as deeply as its stronger-smelling cousin and is therefore considered slightly less effective than traditional dye.

METALLIC DYE: A type of hair dye derived from metallic "salts" including aluminum, iron, chromium, tin and copper. Metallic dyes take a few applications to get to a dark, desired result making them popular with men who want a gradual color change instead of an instantaneous dramatic new look.

OMBRÉ: The French word for "shade," ombré is a hand-painted coloring technique that paints hair only from midshaft to end, so your head goes from darker to lighter starting at the roots for a gradual color effect. Also the thing that *everybody* asks for at MèCHE

PARA-PHENYLENEDIAMINE: Otherwise known as PPD, this petroleum-derived chemical, which was discovered in 1883, is the most well-known—and the most controversial due to its high rate of allergic reactions—component of hair dye. It darkens with oxidation, so darker dyes tend to contain higher levels while lighter shades contain less.

PARA-TOLUENEDIAMINE SULFATE: In studies, this chemical—better known as PTDS—has been found to cause fewer allergic reactions than PPD, its chemically similar cousin. While less effective at dyeing hair than PPD, it's frequently touted as an alternative and often

appears in ingredient lists of "natural" and "PPD-free" products.

PARTIAL HIGHLIGHTS: A great option if you're short on time and/or budget—this is where we paint only the top layer of hair to frame and brighten your face. *See also: Full Highlights*

PIGMENT: Naturally occurring melanin protein bonds in the middle or "cortex" layer of hair. Otherwise known as "color." To be clear, it's not pigments that are being applied to your hair when you use permanent hair dye, but rather a cocktail of chemicals that react when conjoined and emit color. *See also: Hue*

PINTURA: Think of this as the balayage technique for curly hair in which each curl is hand-painted with color, sans foil, depending on the pattern and bend of each curl.

SEMI-PERMANENT: No activator required. This type of color only partially penetrates the hair shaft and gradually fades over the course of roughly twelve shampoos. *See also: Permanent and Temporary Color*

SINGLE PROCESS: When an appointment yields your desired color results with just one technique.

TEMPORARY COLOR: Color that doesn't penetrate the hair cuticle and instead sits on top of the hair strand, washing out with one or two shampoos. Can you say Manic Panic? *See also: Demi-Permanent and Semi-Permanent*

TEXTURE: The way your hair feels and the thickness of each strand, dependent on the shape and size of your hair follicles. Flat, oval-shaped follicles tend to produce curly hair, while round follicles create straight hair. While texture types are typically described as fine, medium, or thick, there are dozens of different types of curl patterns within those adjectives—think kinky, wavy, and coiled. Your specific hair texture and pattern has everything to do with the formula and technique a professional will (or at least, should) use to get the best results when coloring your hair.

TINT: Technically defined as a "slight" modification to an existing color, in the hair dye world a tint is a nonpermanent product that deposits color on top of strands without lifting (aka altering) their original pigment.

TONE: In hair speak, the degree of your hair color's warmth or coolness is its tone. Tone is typically categorized as warm (think copper, gold, and orange), cool (ash, beige), and neutral—same as your skin.

TONER: A demi-permanent product that alters the pH level of a hair color, neutralizing unwanted warm or cool tones and helping you leave the salon with the exact shade you came in for.

VOLUME: The "strength" of a developer: how much peroxide a developer contains and how many shades your hair will change from using it. Five volume is the gentlest developer, while thirty volume will transform your hair three to four shades.

EVEN CLEOPATRA HAD A DYE JOB: A TIMELINE OF HAIR COLOR

If you think Jean Harlow (or Gwen Stefani) was the first bleach blonde in existence, think again. The art of using dyes to change hair color has been around for thousands of years (perhaps being a hair colorist is the world's actual oldest profession). Here, we examine the highlights:

ANCIENT EGYPT, 3000 BC:

Ancient Egyptians shaved their heads and used human hair to make styled wigs that protected them from the sun and signified their social status. The most common wig color was black, until around 2000 BC, when alfalfa, henna, indigo, and saffron came into use as dye. To cover their grays, the ancient Egyptians mixed oil with the blood of black cats. Really.

PALEOLITHIC PERIOD AND THE IRON AGE:

Early humans used the red iron oxide from dirt to decorate and dye their dwellings, textiles, and, eventually, their heads. Meanwhile, the Celts and Gauls used limewater—a derivative of lye—to create shocking platinum-white locks.

THE MIDDLE AGES:

Blonde was all the rage in Europe, and dyes were made from saffron, eggs, and calf kidneys—among other appetizing ingredients that would make even a lifestyle wellness guru blush in modern times.

ANCIENT GREECE AND ROME, 400 BC:

Two thousand years ago, the very first permanent hair dyes were used by the Greeks and Romans, who created a recipe for a lead-based compound that chemically altered the keratin protein of the hair shaft, changing it from gray to black. The foundation of modern permanent hair dye was born. In Greece, the trend was blonde hair to mimic the Gods (sprinkled gold dust was just one way to achieve the look), while in Rome, dark hair began to give way to lighter versions, due to the towheaded slaves being brought in from the area of what is now France. Fun fact: In addition to being a coloring favored by the wealthy, blonde hair was also the mark of high-class sex workers.

ELIZABETH. 1558-1603.

THE 1800s:

While the French studied and made advances in hair dye preparations in the 1700s, it was American "fancy goods dealer" Jules Hauel who began selling a vegetable-based hair dye in his Philadelphia parfumerie in 1839 that promised to change "red or grey hair, whiskers, eyebrows, etc. to a black, brown or chestnut color" with its "easy mode of application and its instantaneous effect, without the least favorable result." In 1856, while searching for a cure for malaria, British chemistry student William Henry Perkin accidentally discovered the first synthetic dye—mauveine purple—which was used for textiles but set the stage for the hair possibilities to come. And in 1883, French cosmetics company Monnet et Cie patented the very first dye that contained the chemical PPD, a substance still commonly used in many permanent hair colors today—especially darker ones—because, well, it works. PPD is a petroleum-based, coal-tar-derived dye additive

ELIZABETHAN ENGLAND AND THE RENAISSANCE, 1500s–1700s:

In an effort to mimic the flame-hued hair of their queen, English men and women used saffron and sulfur powder (enduring the nasty nosebleeds and sickness that came with them) to dye their hair Elizabeth I–style auburn. In 1600, British author Sir Hugh Plat published *Delights for Ladies*, a tome featuring recipes and household tips—including one suggestion to use oil of vitriol (aka sulfuric acid) to take black hair to chestnut. Lead as a hair darkener became popular during this time, as did the Italian art of using heat to set hair color, with well-to-do Venetians sitting out on their terraces so that the lye, horse urine, wine, and rhubarb on their scalps could mix with the sun and properly set.

that's come with controversy over the years because it sometimes causes allergic reactions in people on both sides of the salon chair who use it. These allergies can range from mild scalp tingling to dermatitis and facial swelling in more severe cases, which is why I always recommend a patch test for anyone who hasn't used permanent hair dye before or is getting their hair colored in another country, as some places have ingredient regulations that differ from those in the United States.

1909:

In the earliest days of the twentieth century, Parisian chemist Eugène Schueller had just finished his undergraduate degree and was working as a lab assistant at the Sorbonne when a barbershop owner sought help in developing a safe synthetic hair dye. French women were saying a resounding *non* to the existing options because of blistering, burning side effects. Even after Schueller parted ways with his barber boss, he kept trying to formulate a chemical hair dye perceived as safe for the masses. And in 1909, *Société française de teintures inoffensives pour cheveux*—or the French Company of Inoffensive Hair Dyes—was officially born. A year later, he renamed his business L'Oréal. Without a doubt, he was an instrumental figure in paving the way for today's widespread use of hair color, but his legacy is

more complicated: After the Nazi invasion of France during WWII, he aligned himself closely with fascist-leaning individuals and political groups—including, allegedly, the Third Reich itself—in his business dealings, writings, and public statements.

1925:

American author, playwright, and trailblazing female screenwriter Anita Loos brought the phrase "Gentlemen Prefer Blondes" into the lexicon with her bestselling Jazz Age novel of the same name, which became a Marilyn Monroe–starring hit film in 1953.

1928:

Loos followed up her satirical literary sensation with *But Gentlemen Marry Brunettes*.

1931:

Hollywood superstar Jean Harlow became the first public-facing "Blonde Bombshell" when eccentric billionaire producer Howard Hughes, in an effort to booster Harlow's "brand," offered ten thousand dollars to any hairstylist who could re-create her shockingly white-blonde locks. Harlow's stylist Alfred Pagano once confirmed that he—despite the actress's insistence that her hue was au naturel—used a mixture of Clorox bleach, ammonia, and peroxide to create her signature look. It was a dangerous combination; mixing bleach and ammonia produces toxic chlorine gas. Sadly, the starlet

passed away in 1937 at age twenty-six, and while her poisonous hair color likely wasn't solely to blame for her demise (she suffered from a myriad of other health issues), she was found to have experienced the same kind of kidney damage found in lab rats who, too, inhaled chlorine gas.

Also in 1931, New York chemist Lawrence Gelb and his wife, Joan, came across a hair dye called Clairol while on a family trip to Europe, a product that stood out because it penetrated the hair shaft and changed its molecular color structure instead of simply coating it externally like other existing products on the market. The couple bought two hundred dollars' worth of the newfangled hair dye, brought it back to the States, and convinced Brooklyn department store Abraham & Straus to use it in their salon. The virtues of the product spread throughout the New York hairdressing community, and soon an empire was born.

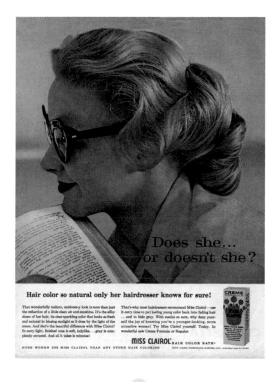

Does she...or doesn't she?

Hair color so natural only her hairdresser knows for sure!

MISS CLAIROL HAIR COLOR BATH

MORE WOMEN USE MISS CLAIROL THAN ANY OTHER HAIR COLORING

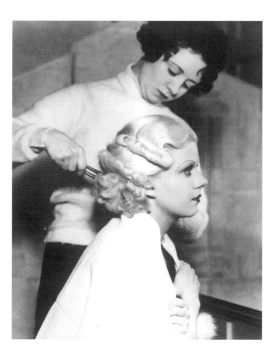

1956:
Shirley Polykoff, the lone female copywriter at New York advertising giant Foote, Cone & Belding, conceptualized the famed "Does she . . . or doesn't she?" catchphrase for her firm's new client, Clairol. At the time, only one in fifteen US women colored their hair. But helped in part by Polykoff's genius advertising campaigns (a 1962 gem asked, "Is it true . . . blondes have more fun?"), that number jumped to one in two within nine years. Within that same period of time, Polykoff also became an executive vice president at Foote, Cone & Belding—again, the sole woman to hold the prestigious position.

1969:
Changing the color of one's hair had become so commonplace that the "hair color" designation was removed from US passports.

1973:
During the height of a new women's rights movement that included the passing of Roe v. Wade and increased support for the Equal Rights Amendment, twenty-three-year-old McCann Erickson copywriter Ilon Specht came up with the beauty world's next game-changing slogan: "Because I'm Worth It." This one, written for L'Oréal, felt revolutionary in that it had nothing to do with pleasing others but for the first time in advertising put a woman in control of her own happiness and decision-making—think "self-care" as an empowerment measure long before #FaceMaskFriday became a thing. During a time when Clairol commercials featured a man's voice-over, L'Oréal's rollout of its "Because I'm Worth It" campaign featured

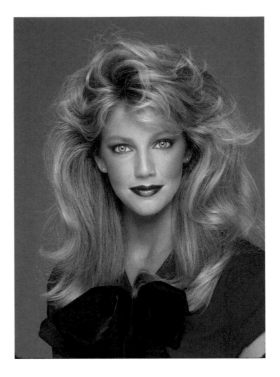

a woman speaking directly to the camera, with nary a drop of male approval in sight. The slogan lives on today in an updated, more inclusive form: "Because We're Worth It."

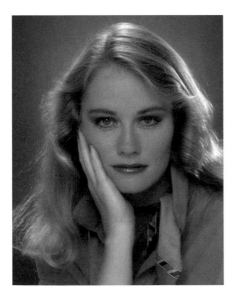

LATE 1970s AND 1980s:
The age of the celebrity endorsement descended upon the hair color industry, with icons of the era, including Farrah Fawcett, Cybill Shepherd, Jaclyn Smith, Linda Evans, and Heather Locklear, appearing in print and TV ads for the likes of Wella, Clairol, and L'Oréal.

Also during that era, Redken launched a product that ended up changing my life. When I started working, I was used to using a permanent hair color that I didn't fully love. But when I got to Sally Hershberger, I met an assistant named Tyle—now one of the busiest colorists at MéCHE —who told me that I had to try Shades EQ, an acidic hair color Redken brought to market in 1983, designed to neutralize the hair's pH and smooth out the cuticle. I was obsessed as soon as I tried it, and it's still one of my favorite products to use today. In fact, I love Shades EQ so much that it's the reason I agreed to sign on as a Redken ambassador in the first place.

THE 1990s:

The chunky, piecey highlights of nineties screen queens, including Drew Barrymore, Kirsten Dunst, Courteney Cox, and Reese Witherspoon—not to mention the Spice Girls—created the technique trend of the moment. At the same time, Manic Panic, the bold, temporary color line founded by two of Blondie's backup singers in downtown Manhattan in 1977, enjoyed a major punky, grunge-fueled resurgence with celebrities such as Dennis Rodman, Cyndi Lauper, Ione Skye, and model Jenny Shimizu going bright red, green, and everything in between.

1998:

Long before "clean" and "green" were the beauty buzzwords du jour, Clairol launched Natural Instincts, the first mass-market at-home hair color to feature natural and plant-derived ingredients. (Regardless of what the packaging purports, no hair color can be completely "clean" and "chemical-free" and be as effective as its chemical reaction-promoting cousins. More on that soon.)

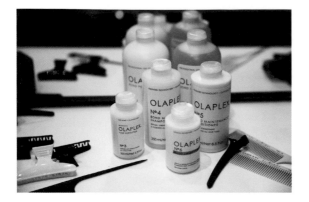

2014:
Olaplex, a hair bonding treatment that completely revolutionized the way people care for color-treated hair, launched after being discovered accidentally by renowned University of California, Santa Barbara, chemist Craig Hawker and his former PhD student Eric Pressley.

The formulation—which could restore the integrity of hair that had been chemically damaged—made its way to Joe Santy, a perm specialist, who agreed to test the product in his Philadelphia salon. It worked, but one of Santy's colleagues wondered what it would do if mixed with dye instead. And that's when the game changed.

Just as he wanted to find the best chemist to help him finish his product, Christal wanted to find the best hair colorist to help him test his potentially revolutionary hair bonder. And soon I was mixing Olaplex with bleach and watching hair that would previously break under the stress of the chemicals stay strong and silky after coloring.

I couldn't get enough of the stuff and kept calling Santa Barbara, begging for more. Luckily, the chemists kept cooking up bottles of Olaplex that ended up on the tresses of my clients. Today, the molecule-restoring product

Hawker was neighbors in Southern California with beauty industry veteran Dean Christal, who happened to be on the hunt for a new way that one could perm over highlighted hair without the hair breaking—something typically not possible up to that point. At first Hawker, who is a National Academy of Inventors fellow specializing in synthetic polymer chemistry and nanotechnology, had no interest in entertaining Christal's cold call. But the beauty guru (his family is behind masstige brands including Alterna and California Tan) was persistent in his quest to get the very best chemist for the job on board, going as far as tracking down Dr. Hawker's home phone number and ringing his front gate. The tenacity paid off, and soon, Hawker, knowing that his former student Pressley was looking for his next gig, recruited him to assist him on his journey of inventing Olaplex. (As every great entrepreneurial story goes, their first meeting was in Hawker's garage.)

is a mainstay at MèCHE, where it gets used as a stand-alone treatment before and after coloring and also added into bleach and dye to strengthen, bond, and rebuild the proteins in hair using Hawker and Pressley's patented formulations. Olaplex is now found in hundreds of thousands of salons across the globe, where countless stylists use it every single day, and I still absolutely have to have it. It did indeed revolutionize the industry.

Left: me with Angie Featherstone, my Olaplex Patient Zero; **right:** me with Dean Christal

2020:

The global COVID-19 crisis that shuttered most of the world in the spring of 2020 has proven to be a game changer for hair color, in that salons across the world were ordered to close during social distancing and safer-at-home initiatives, leaving millions of roots growing in with nary a professional colorist in sight (or legal physical proximity). While a lot of celebrities took to social media to proudly show off their newly liberated grays and some decided to ride out their quarantine with shocks of bright, vibrant hues, many public and not-so-public personas alike just wanted to feel a sense of "normalcy" by opting to re-create their standard salon color.

Mariah Carey via FaceTime, and FedExed base color kits to tons of my clients—even J.Lo did her own color (I really was taking science seriously and wasn't sneaking off to do anyone's hair during the COVID crisis, I promise!).

Meanwhile, with salons closed and house calls off-limits, the livelihoods of colorists were virtually put on pause overnight. So in an effort to help clients while keeping our own lights on, at-home color 2.0 was born. I'm not talking about a colorist helping you choose the same drugstore box that your grandmother used (though we can certainly advise on the brands we like and what we think will work best for you). But rather colorists quickly spun up new innovations: Zoom consultations, custom-mixed salon formulations delivered to client doorsteps with tools and step-by-step instructions, and even training sessions so lucky quarantine buddies could double as makeshift colorists.

During safer-at-home initiatives, I walked Ellen DeGeneres and Portia de Rossi through a virtual balayage tutorial so they could color each other's hair (only the ends, not the roots!), did a root touch-up master class with

Even some of the big professional color brands hopped on the at-home train. Dye manufacturer Madison Reed played up its direct-to-consumer roots and began offering a color quiz and at-home balayage kits (complete with video tutorials) to help would-be clients get as close as they could to a salon experience. And the data doesn't lie. As of April 2020, research firm Nielsen said that sales of at-home hair dye were up 23 percent year-over-year.

While at-home custom color kits gained prominence and recognition during the height of the COVID crisis, it's actually something I've been doing for my clients for years so they're able to manage their color on tours and long stints out of town. Of course, most people don't have access to a trusted colorist who can custom-mix a batch of base and send it across the world in a Tupperware, so you'll find some of my best DIY color advice in the next section.

THE FUTURE:

Just as there's been a recent meteoric rise in popularity of clean makeup and skin care, frequent hair dyers are craving formulas that lack PPD, resorcinol (another coal-derived chemical that can potentially irritate skin), ammonia, and various other substances that effective hair dyes almost always contain. Researchers have spent years trying to find natural, plant-derived ingredients that mimic the efficacy of petroleum-based products in demi-permanent and permanent hair dyes. Unfortunately, it's so far proven elusive to find "clean" ingredients that also actually work. Brands that boast the replacement of strong-smelling ammonia with MEA, a similarly

As of right now, despite what you're reading about in magazines and seeing in the beauty aisle at the natural food store, the truth is that there simply isn't such a thing as a "natural," "organic," or "chemical-free" hair dye that works (technically, "organic" materials are chemicals, too, after all). And at the moment, marketing is everything when it comes to "vegan" dyes that haven't been tested on animals but still contain PPD and "natural," "botanical" henna dyes—especially black henna, which contains PPD, too.

alkaline yet odorless chemical that helps open the hair shaft so color can be deposited, are definitely selling formulas that are gentler on the nose. But studies have shown that MEA can actually be more damaging to hair than ammonia and potentially cause more skin irritation than its odor-causing counterpart. Companies have also started replacing PPD with less-effective para-toluenediamine sulfate—PTDS for short—which has a higher chance of being better tolerated by people who are allergic to PPD, but can still cause an allergic reaction in some users.

My point is this: I think the future will see a continuation of research that aims to find ways to create long-lasting, permanent hair dye that looks beautiful and natural with newer ingredients not found in dye formulas today. Even Silicon Valley is getting in on the hunt for new hair color technology, with one company offering a protein treatment that helps restore hair's natural eumelanin— the dark pigment found in brunette shades that's replaced by gray over time. In the meantime, listen to your body if something you're using is irritating you and make sure you're thoroughly reading the box and understanding the ingredients in any products purporting to work the same as salon hair dye without any of the ingredients that make it work.

True C
Insp

olor
iration

INTRODUCTION

If you've ever colored your hair (and I'm guessing you have, since you picked up this book), you've probably gone through a phase (or are still in one) that has you changing your look every third appointment. Sometimes you feel like going lighter for summer. Before the holidays you're feeling a bit richer. After a breakup, you want to be a blonde. Before your next big birthday, you think adding some red could be fun. Until, that is, you want to bleach it all. You'd think that as a busy professional hair colorist I'd appreciate customers wanting to change things up all the time, but in fact that couldn't be more wrong. I call this kind of hair dye mania Color Chameleon Syndrome. And personally, I can't endorse it (though as you'll see in this section, I do have some clients who are lighthearted, spirited Color Chameleons who don't take their color too seriously and deserve to be celebrated).

I enjoy painting hair in the same way that an artist works with oils on canvas to create realism in her portraits. I think hair color looks best when it looks like a natural "I woke up like this" hue for you. I know that my philosophy might not always be the flashiest or the most fun, but when you take your color cues from the hue you were born with, it allows you to enhance your adult beauty instead of masking or changing who you really are (I say this as someone who struggled to appreciate her own mop of wild curls as a kid, and now wouldn't have them any other way).

A little bit later, we'll get to the proper way to prepare for your in-salon color appointment and talk about what it means to source an inspirational photo that is actually useful (sneak preview: Make sure the photo you show me isn't black-and-white). And while I will gladly look at Jessica Biel's Instagram to give you the balayage brown of your fantasies, I think it's much more effective to see photos of you as a child—or to see photos of your own children—to really understand the natural color and highlight placement that accompanied you when you arrived on this earth.

It's easy for a colorist to say yes to whatever their client wants—even if they happen to be a mocha-skinned, dark-eyed beauty who wants cool-toned bleach-blonde hair that isn't at all right for her

complexion. Same thing goes for porcelain-skinned girls who want to go super-dark black-brown without looking like they're starring in *The Craft*. It probably can't be done. A good colorist should be able to be honest and candid with you about whether or not the color you want works with your skin tone, features, and hair texture, never mind if your hair can even handle the chemical processing. All of my clients know that I treat major color changes like any other major life transition—they have to demonstrate how badly they want it and that they've thought it through. I'm talking pleading their case, a promise to take care of it properly, and an even bigger promise not to call me on a Sunday night at home when they realize they hate it and beg me to come fix it (a sad but all-too-common occurrence).

This is all to say that I would really love for you to at least try my way of getting back to your roots, so to speak—your true color—and consider bringing some baby and childhood photos in as inspiration for your colorist next time you're in the chair. It's a guaranteed way to get a color that you know looks amazing on you because nature made it that way to begin with.

As inspiration, I asked some of my beautiful, impressive clients—some of whom you've definitely heard of—to show me their own childhood photos so we could document their hair journeys and equip you with photos that you can show to your own colorist. And I pulled inspiration photos of my own "hair icons"— strong, powerful, unique women from all walks of life, with all kinds of hair textures and types, whom I admire and who stir the creativity that fuels my work on a daily basis. Some of these figures are working today and get their looks courtesy of the likes of Harry Josh and other talented top colorist colleagues whom I consider to be my family in the business.

I dedicate this section to all of the Color Chameleons who are scared of their true color. Don't be. I promise that the beauty of your own gorgeous color potential is just waiting to be uncovered.

FIVE COLOR CHAMELEONS

Who Make it Work

Emma Stone

Haley Bennett

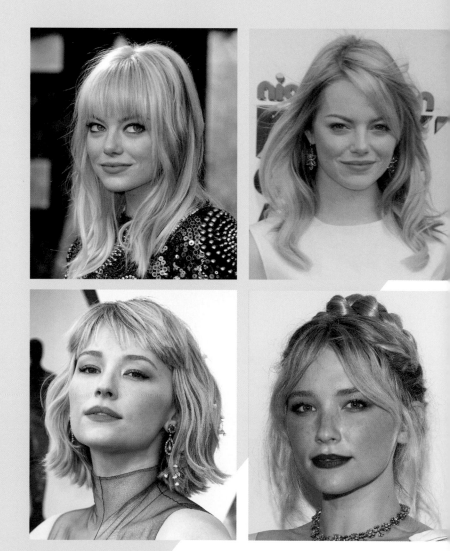

I'm going to keep saying this: My favorite hair color is the hair color that looks most like your natural childhood hue. It makes me so happy to help my clients re-create and enhance their own color, because it really does make them look like the best versions of themselves. But of course I see plenty of brunettes who want to see if blondes actually have more fun, redheads who want to test the same theory, and blondes who feel the need to dim their wattage soon as the thermometer in L.A. hits a frigid 60 degrees. If you're going to make major, frequent changes, just remember this: You have to be willing to style yourself. That means swapping out your makeup bag for a palette that matches your new hair, Olaplex treatments to keep it healthy, and remembering that unlike the photos of the celebrities you're looking at for inspiration, you probably don't have your own hair and makeup team (and the perfectly applied bronzer and blowout that come with it). If you're willing to put in a little extra getting-ready time, you can make pretty much any color work with your natural skin tone and eye color. Just don't forget the lipstick.

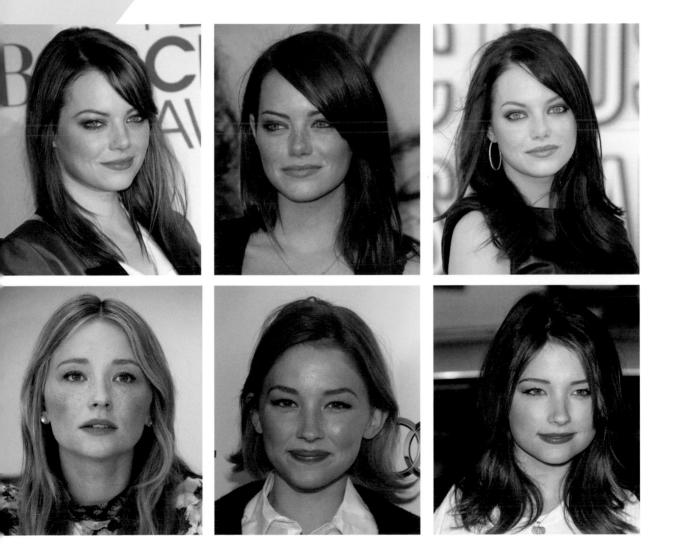

Katharine McPhee

Riley Keough

Sarah Paulson

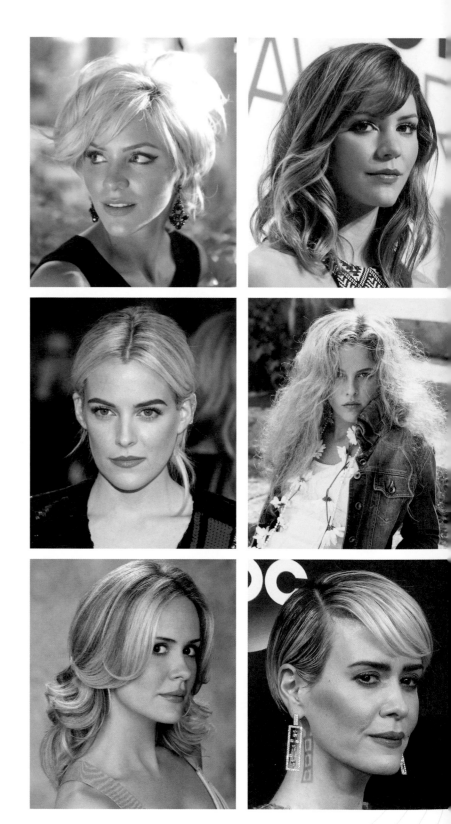

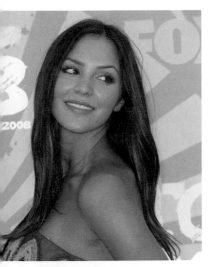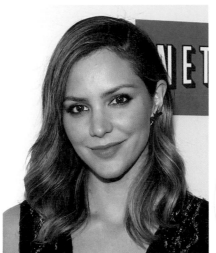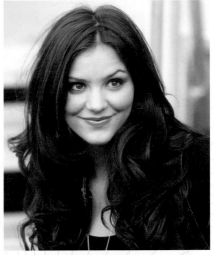

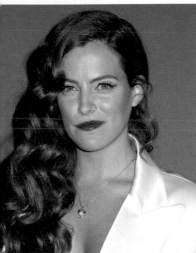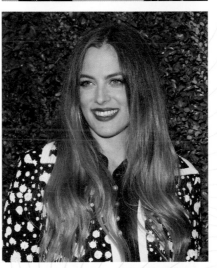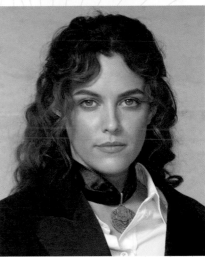

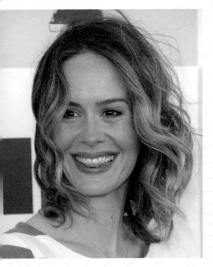

BLONDES

Blonde hair has been around for at least eleven thousand years. And in that amount of time, towheads have managed to signify both sexiness and stupidity, wholesome Americana and the stereotypical politically charged news anchor, especially in our era of twenty-four-hour cable. No other hair color or mark of beauty has such immediate (albeit clichéd and, usually, wrong) connotations as blonde hair. And since only roughly 2 percent of the population has naturally yellow locks, there are a lot of people walking around who have, at one time or another, asked a hair colorist to lend them a hand.

Blonde is the single most requested color that we get at the salon. Who doesn't want to be a blonde every once in a while? And I totally get it—as I said earlier, I used to love Farrah Fawcett and her fellow seventies small-screen flaxen Angels because they symbolized a classic idea of American beauty. Today, of course, we have so many gorgeous, unique, and varied people on our screens and in our magazines— each one of them providing a recognizable glimpse of ourselves and proving that true American beauty encompasses much more than the blonde hair saturating pop culture when I was a kid.

When it comes to becoming a blonde, I always encourage clients to choose a shade that's truly right for their unique skin tone and coloring instead of begging me to make them look like Heidi Klum (again, if you were blonde as a child, bring in your own photo so your colorist can get you to your true color!). I also urge my clients to think about the health of their hair and how going blonde will affect it. The darker your natural color, the more of that natural color has to be stripped away to lighten it. And that means you'll be in the salon more often, spending more money and contending with more potential hair damage. Blonde is also a hard color to maintain because of minerals in water that can discolor and dull it (there's a fix for that in the next section). None of these issues deter most people who are really excited to be blonde, but they are things to keep in mind.

"GOING BLONDE IS LIKE BUYING YOURSELF A LIGHT-BULB."

—Heidi Klum

BLONDES

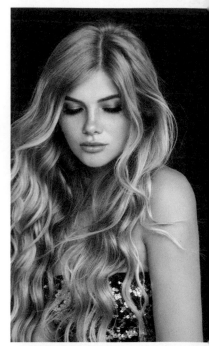

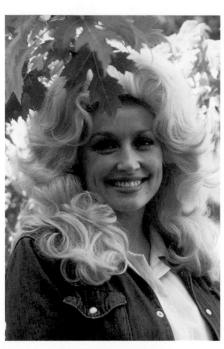

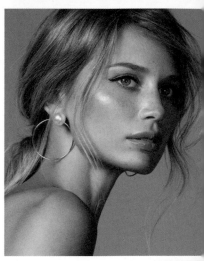

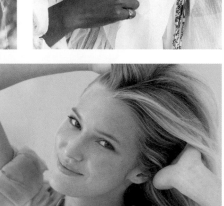

Mega-watt:
Dolly Parton, Heather
Locklear, Anna Nicole
Smith, Cynthia Erivo, Cybill
Shepherd, Grace Kelly,
Ursula Andress, Madonna,
Patti Hansen, and other
blonde bombshells

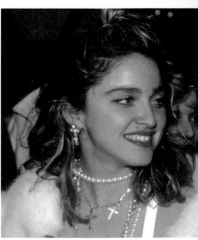

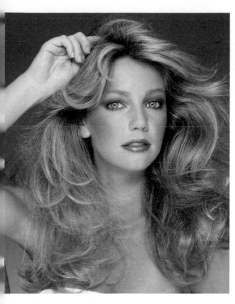

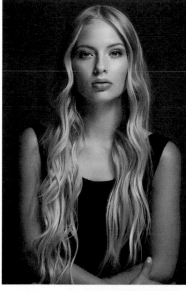

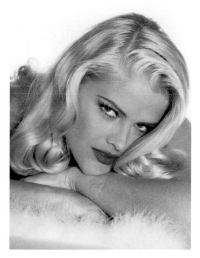

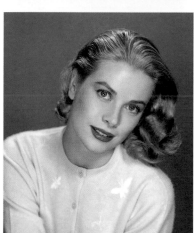

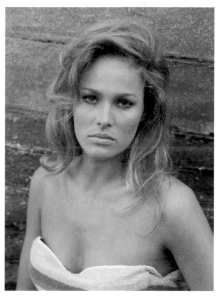

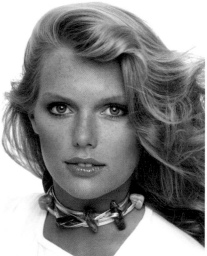

Blonde Ambition:
Soo Joo Park,
Suzanne Somers,
Debbie Harry, Cheryl
Ladd, Laverne Cox,
Catherine Deneuve,
Faye Dunaway, and
Hillary Clinton provide
more blonde inspo.

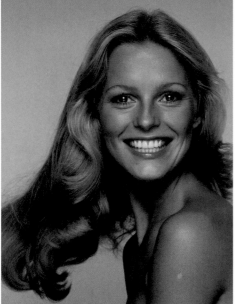

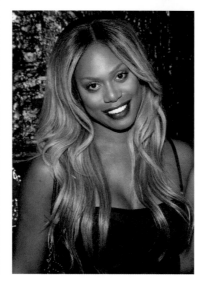

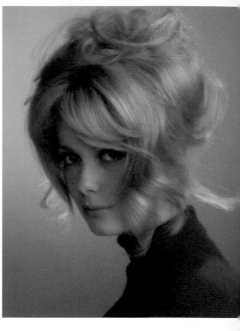

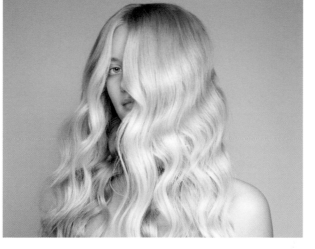

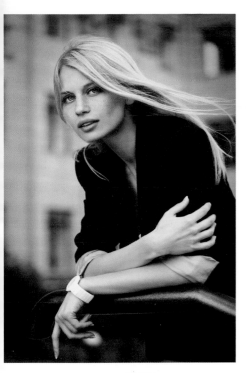

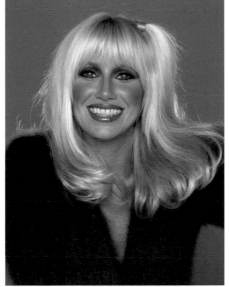

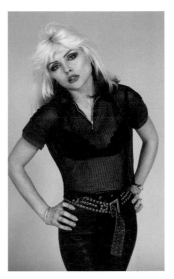

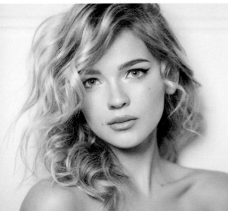

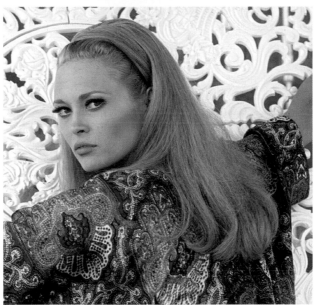

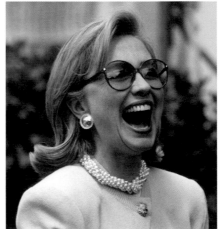

BRING THIS TO YOUR COLORIST:

Natural Blonde Inspiration

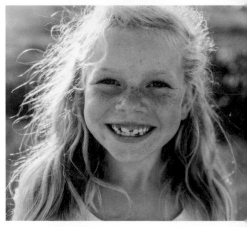

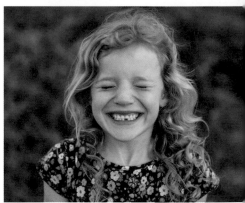

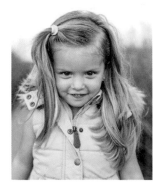

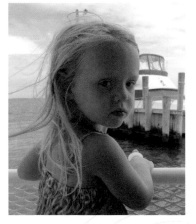

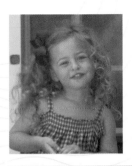

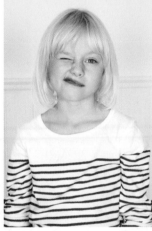
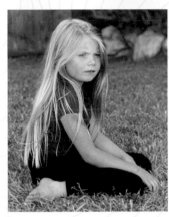
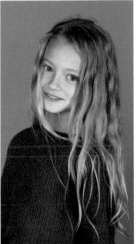
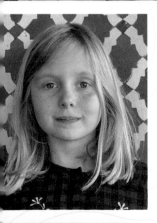

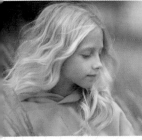

FERGIE

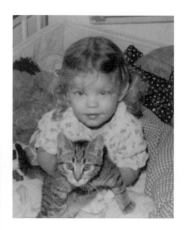

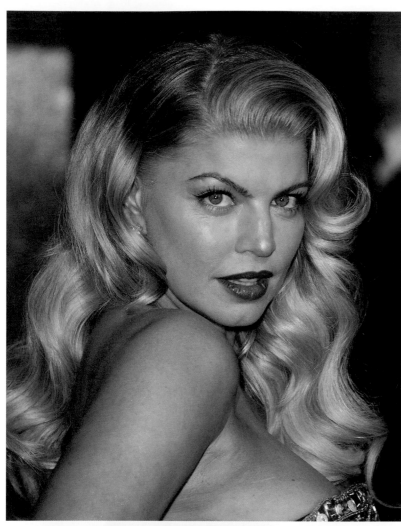

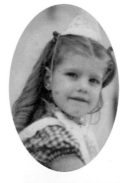

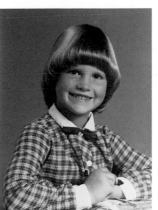

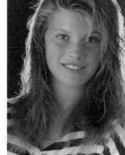

ALI LARTER

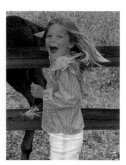

ALI'S DAUGHTER, VIVIENNE

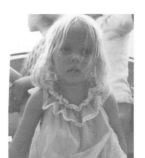

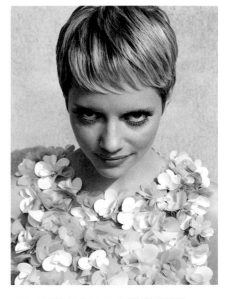

MARLEY SHELTON

TORI PRAVER

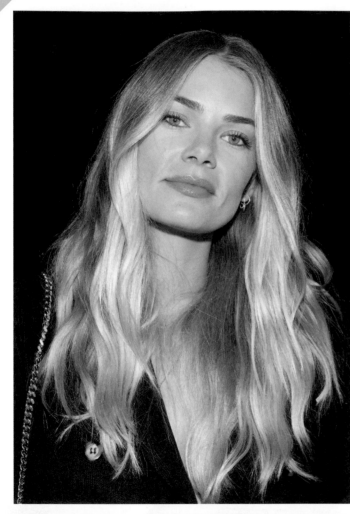

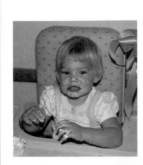

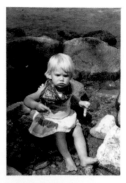

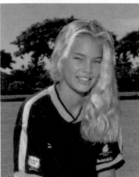

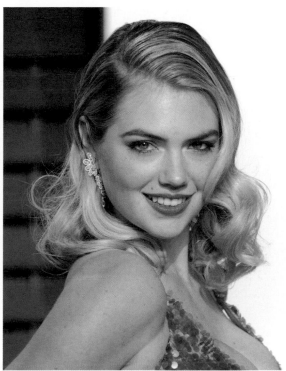

TATUM O'NEAL

KHLOÉ KARDASHIAN

On Being the Blonde Sheep of Her Family

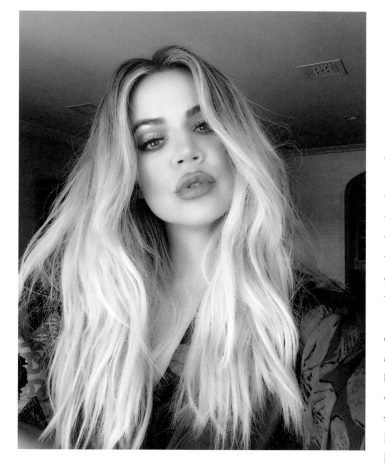

I actually loved growing up the only blonde in a family of brunettes. I don't think I really noticed it—there was no social media or anything like that so the only critique you heard was [my] inner circle of friends. But that's the normal way of living. I just remember when I was first born it was the joke: "Okay, I look like the milkman." Everyone else is so dark and has dark hair and I'm so fair and I have this dirty blonde hair. But besides that it was never really a topic of conversation until I got older. I remember I started dyeing my hair dark when I was in my twenties, right before we started [*Keeping Up with the Kardashians*]. Then I started doing the show and I was dark and I think it was probably visually better that we were all these brunettes. And then after a while I was like f*ck this, I want to go back to being me.

I do love being a brunette—I think brunettes are gorgeous and so exotic. And I did love that moment. But it's just not me. It's just not where I'm comfortable or where I feel like my sexiest. Recently I made [Tracey] take me to brown again. And we called it bronde because I had so much blonde coming through. And you could just see in my paparazzi shots that I'm just not confident. I kept thinking, I just hate this hair color. It was just not me. So I needed to go back to blonde. I think I was brown for five days before I called Tracey, who said, "I knew you were gonna call me."

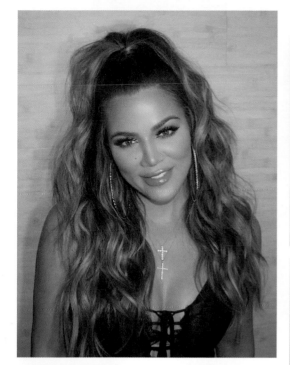
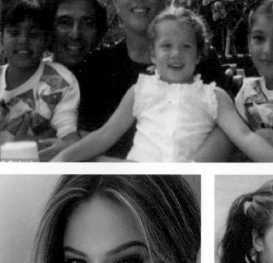
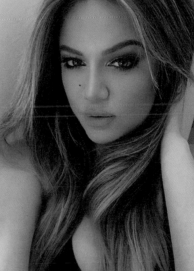

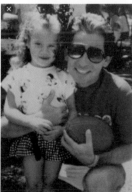
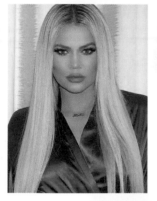

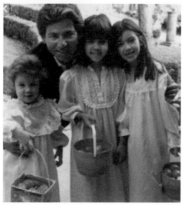

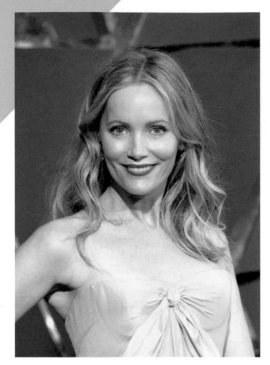

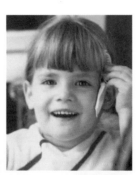

LESLIE MANN

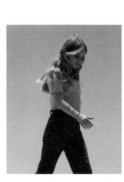

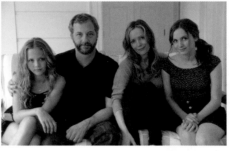

JENNIFER
JASON LEIGH

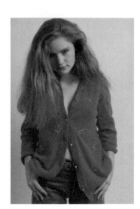

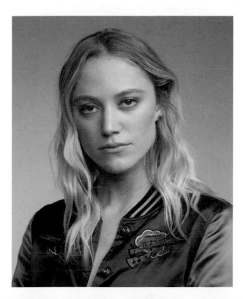

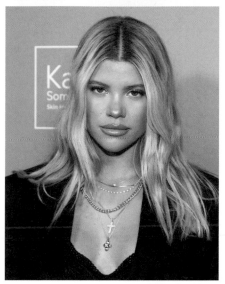

MAIKA MONROE

SOFIA RICHIE

HALEY BENNETT

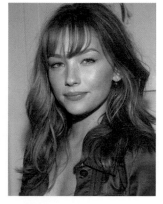

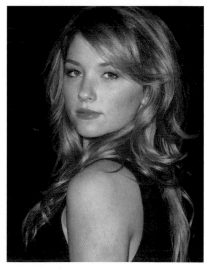

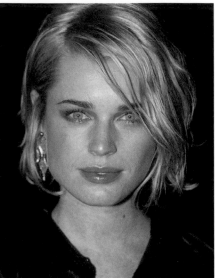

REBECCA
ROMIJN

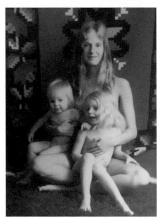

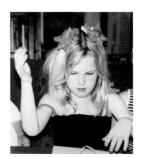

LILY RABE

MARISSA RIBISI

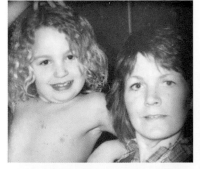

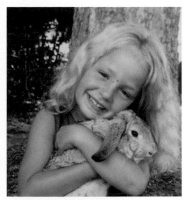

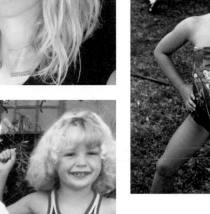

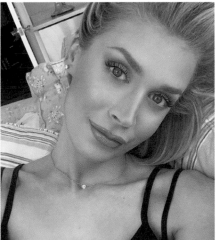

NICOLA LAWTON

JENNIFER LOPEZ EDITION

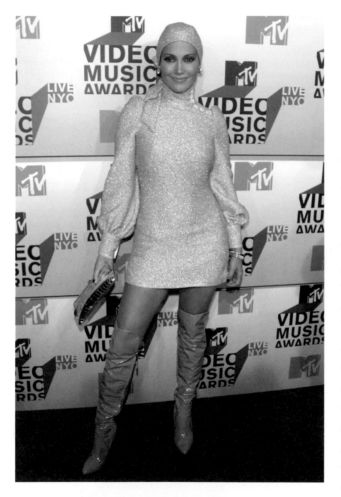

What I'm about to say is going to sound a little bit weird: My all-time favorite red carpet hair look on Jennifer Lopez, my longtime client, is one where her hair wasn't even visible (I told you this was going to sound weird). Back in 2006, it was a week before the MTV VMAs and J.Lo was preparing to introduce the Video of the Year category while also announcing the launch of a new MTV station celebrating Latin music. It was a huge night for her, and when the time came, she practically glowed off the screen. In the days leading up to the awards, I saw her multiple times for various treatments; her blonde highlights needed to be touched up, then two days later she wanted to go back to brunette to shoot artwork for her first-ever Spanish language album, and then we had to take her lighter with highlights again for the VMAs. It was an epic week of work, and the end result each time was J.Lo with envy-inducing hair, no matter the color. When she walked out on the 2006 VMAs carpet in her sparkly Biba minidress and over-the-knee Versace boots, I seriously almost died because I was so blown away by how amazing, strong, and striking she looked. And even though the look covered her hair with a matching head scarf, I knew what was underneath, and her confidence— her true color—shone through.

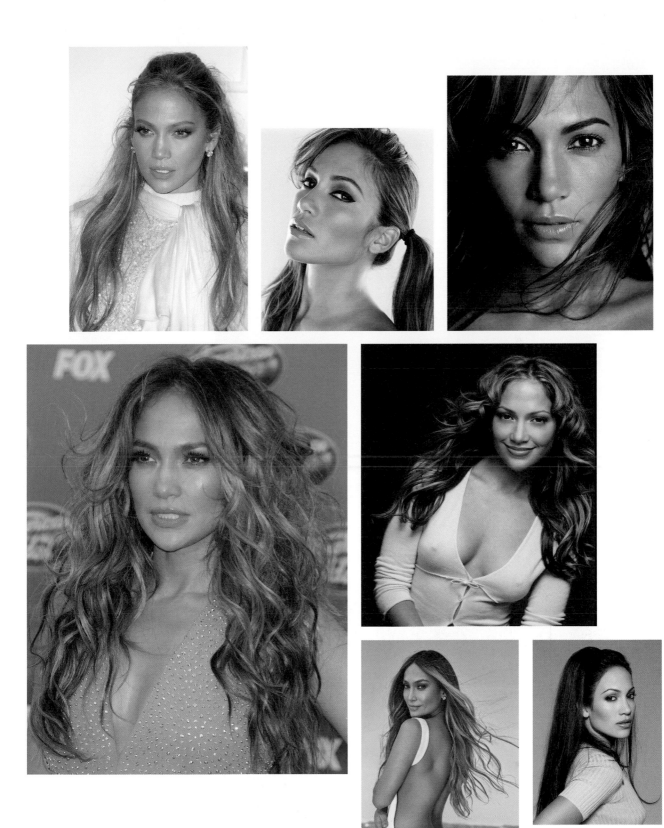

COLOR TRIBE:

CHARLOTTE &
SAMANTHA RONSON

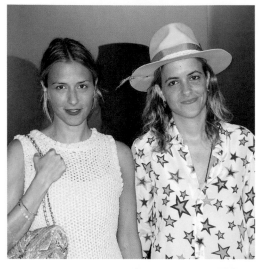

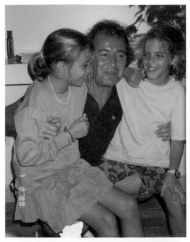

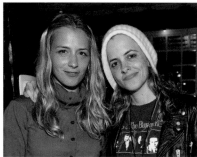

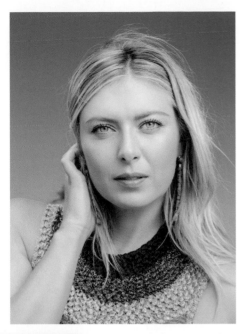

MARIA
SHARAPOVA

VALENTINA
NOVAKOVIC

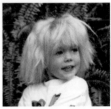

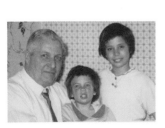

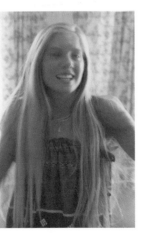

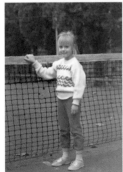

DARNELL DE PALMA

SHANA
ZAPPA

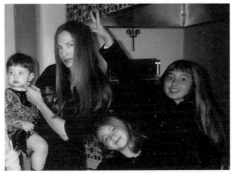

KATHY, PARIS & NICKY HILTON

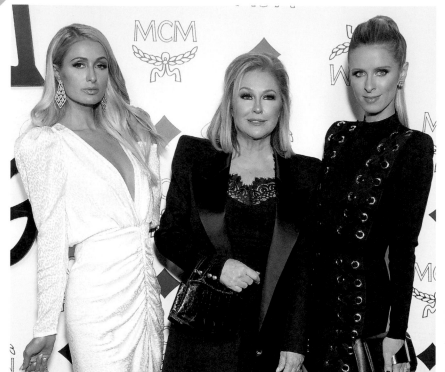

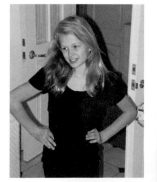

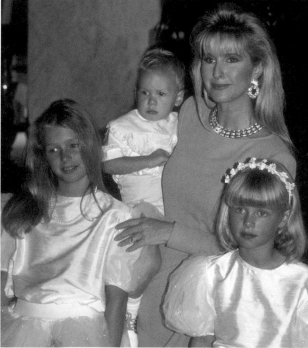

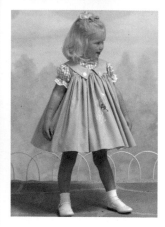

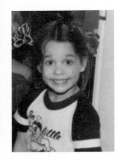

MOLLY SIMS

JESSICA
CAPSHAW

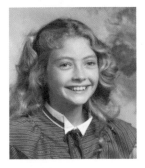

DREA DE MATTEO

REBECCA
GAY HART

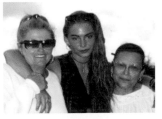

DREW BARRYMORE EDITION

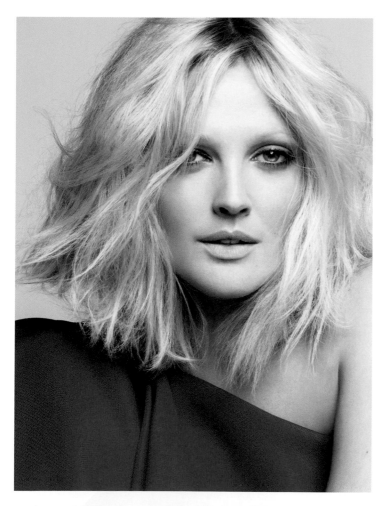

In early 2009, my longtime client Drew Barrymore was getting ready to shoot the April cover of *W* magazine with Mert Alas and Marcus Piggott, two of the most revered fashion photographers in existence. They're really fun to work with because they're so invested in using hair and make-up to tell a complete narrative through their work. Before the shoot, I met Mert and Marcus and Drew at the Chateau Marmont in West Hollywood and we went over all of the looks she'd be wearing in the magazine, which led us to settle on taking her from the brown she had at that time to a bright, beautiful blonde—like really, really blonde — which ended up looking so incredible and striking on the page. We both knew that it was a very hard look to maintain, so after the shoot Drew brought me an inspirational photo of Lily Aldridge and her ombré highlights and said she wanted me to get her as close to that as possible so she wouldn't have to do her hair every five seconds. I couldn't blame her, and the after-effects looked gorgeous too. But that bright Barrymore blonde ends up going down as one of my favorite transformations of all time, even if it only lasted a matter of days.

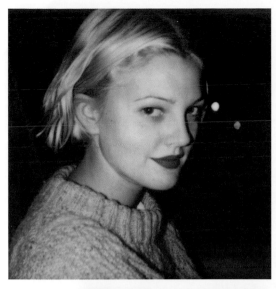
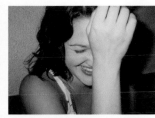
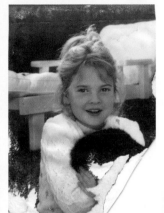
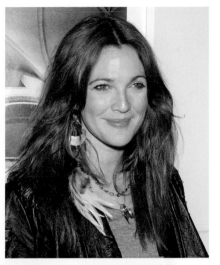
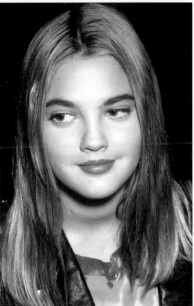

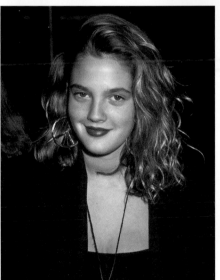

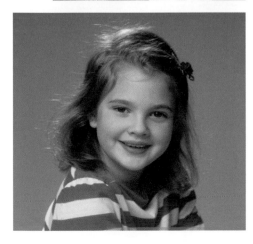
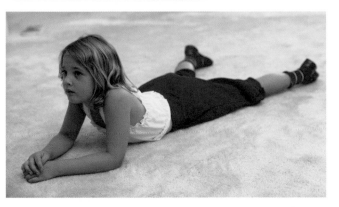

BARBARA STURM

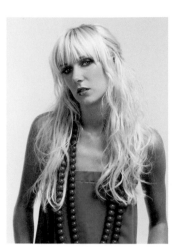

KIMBERLY STEWART

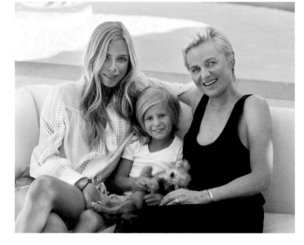

AMBRE DAHAN

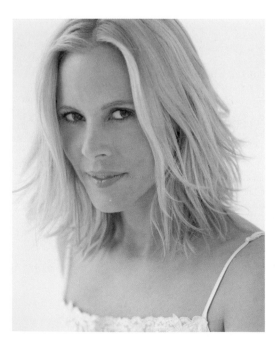

MARIA BELLO

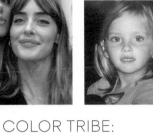

COLOR TRIBE:
SABRINA & JULIETTE LABELLE

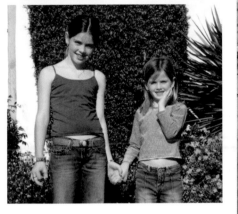

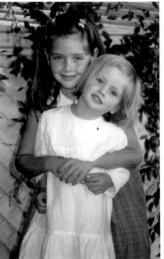

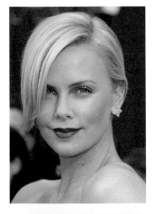

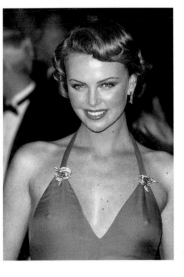

CHARLIZE THERON

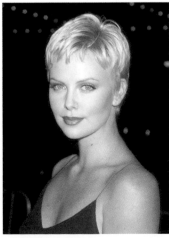

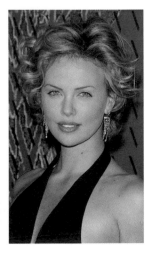

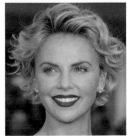

JESSICA ST. CLAIR

On How Having Cancer Doesn't Mean Having to Lose Your Hair

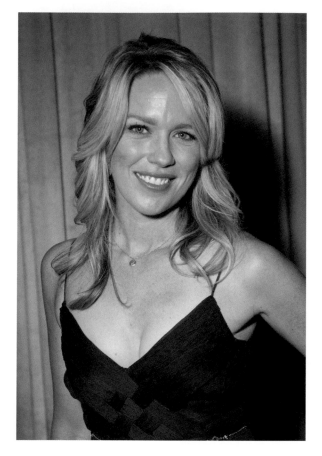

I got diagnosed [with breast cancer] when I was 38. And I had a two-year-old at the time, so my biggest concern—other than staying alive—was that she was too young to understand that I was sick. I wanted to hide it from her as much as possible. I was also in the middle of filming my TV show when I was diagnosed. I assumed I was going to lose my hair. But at my first meeting with my oncologist, she told me about an option to keep your hair—Penguin Cold Caps. Insurance didn't cover it because they consider it "experimental" (which I'm enraged about), but I said absolutely I'm going to do this because hair is so crucial to a woman's emotional health, and your emotions are tied to your physical health. The cap itself is like a frozen rugby helmet and it comes in many pieces, all of which get applied to your scalp very, very tightly so your scalp freezes and the chemo can't get to the cells on it.

Until I got cancer, I had no idea how important my hair was to me. In so many ways, it's your armor. And I happen to have hair that I really like—it's thick. And with the cold cap, you still lose a third of your hair. And even losing a third of your hair is very weird and unpleasant. I would never want to make girls who choose to go bald feel like their choice is wrong. It's a totally individual decision. I know a lot of young girls who didn't want to deal [with cold cap treatments]. I felt I had to do it. I also didn't want to tell people that I was sick. I kept auditioning because I had to work. And for me there was a lot of shame around getting sick, which I definitely worked through. It's so crazy to say because there is nothing shameful about getting cancer. But keeping my hair helped me hide what was happening.

If you can afford it, I recommend hiring a licensed caregiver through Penguin who can help you freeze your cap and apply it before your treatments. You have to ask your hospital if they have a deep freezer

and you get the cap shipped to the hospital. It arrives in an enormously heavy box in many pieces, and each piece has to be deep frozen to a certain temperature and Velcroed together on your scalp. It's very complicated and specific. And because the treatment costs more than ten thousand dollars, I think you should do it the right way—with a licensed caregiver and not your best friend or partner—if you're going to spend the money to do it.

It actually doesn't really feel that bad because your scalp freezes really quickly and once it freezes you don't feel it. You'll want to drug yourself out. I am of the opinion that one should not be conscious—as not conscious as possible—while doing this experience. Because it's horrible. So you're gonna ask for Ativan—as much Ativan as they will give you and you're gonna want it on the reg. Then they're going to put the cap on you and you should get yourself an electric blanket—very important. Put the electric blanket up to your chin so the rest of your body is warm. Then you'll put the cold cap on you and you'll be like "Woo, that stings a little!" (at first it burns), but again you're on Ativan and it's not that bad.

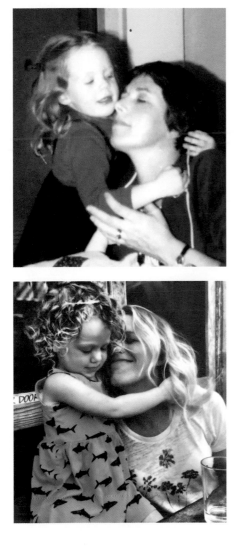

You have to be extremely careful with your hair while you're going through chemo. Go see your colorist two weeks before [you start chemo] and have them color your hair as if you know you're going to be growing out your color for six months. You can only use organic shampoo, you can't stand under the shower nozzle, and you can't have any pressure on your roots because that could make more hair fall out. You only can brush your hair once a day. And you never want to put your hair in a scrunchie or put your hair back. You're gonna live the Parisian girl life.

You can also save your eyelashes and your eyebrows. This is a crazy hack: order the eye ice pads that you'd order if you got your eyes done surgically, then take some Ace bandages and have your girlfriends wrap them tight so the ice touches both your eyelids and your eyebrows. I didn't lose my eyebrows, which was huge because losing your eyebrows is really strange.

I now have more hair than I used to have. It's insane. So not to worry. And for those out there who do lose their hair, the benefit of not doing the caps is that all of your hair grows in at once.

JANUARY JONES

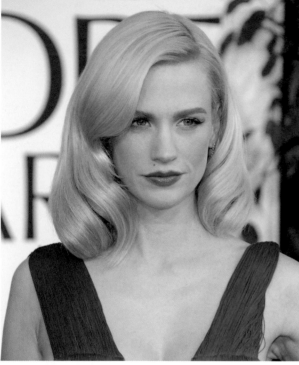

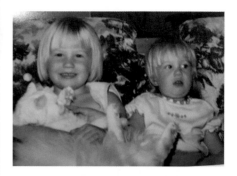

GISELE
BÜNDCHEN

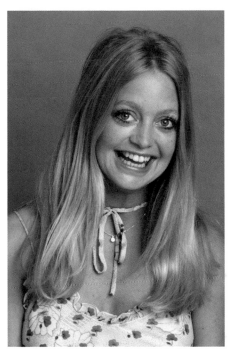

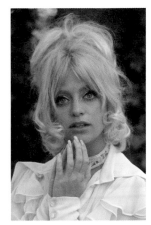

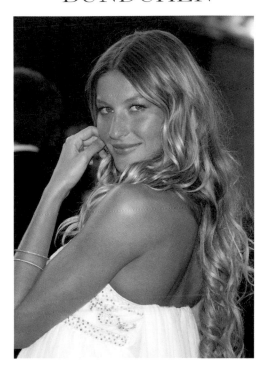

GOLDIE HAWN

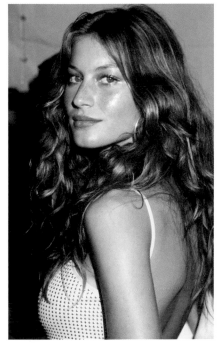

JANE
FONDA

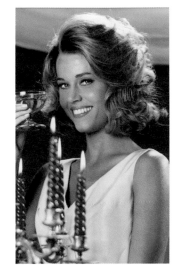

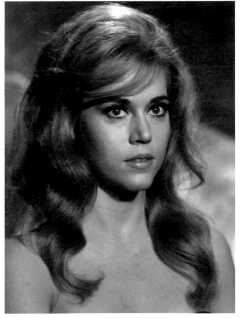

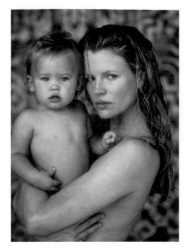

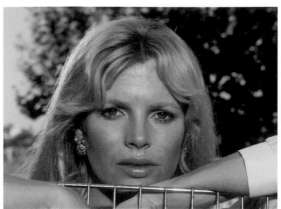

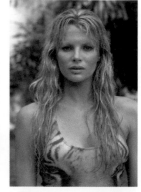

KIM BASINGER

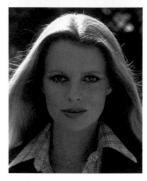

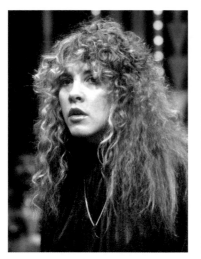

STEVIE NICKS

SARAH
JESSICA PARKER

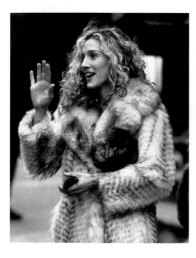

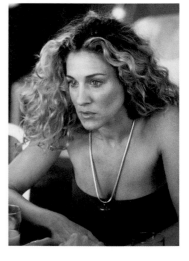

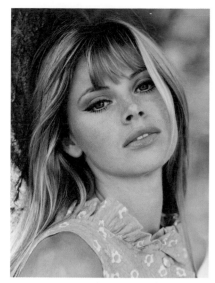

BRITT
EKLAND

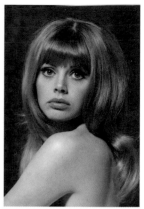

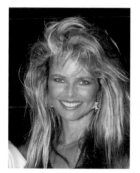

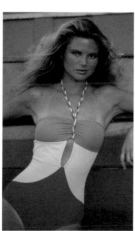

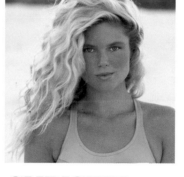

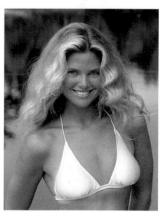

CHRISTIE
BRINKLEY

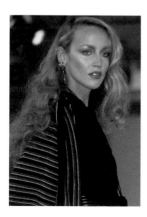

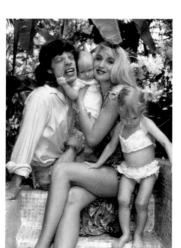

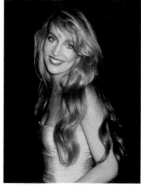

JERRY
HALL

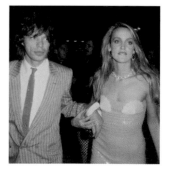

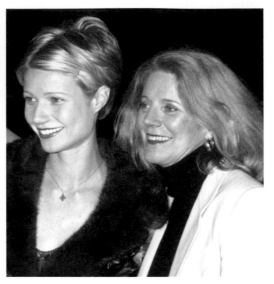

COLOR TRIBE:
GWYNETH PALTROW
& BLYTHE DANNER

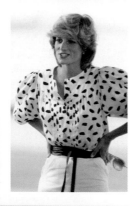

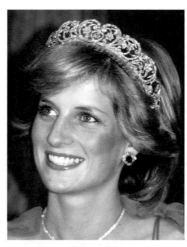

PRINCESS
DIANA

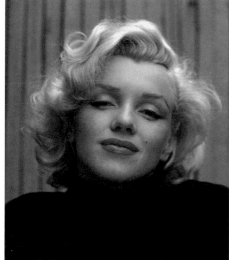

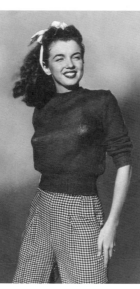

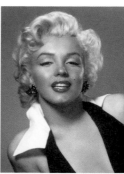

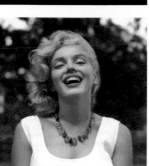

MARILYN
MONROE

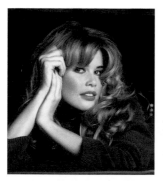

CLAUDIA
SCHIFFER

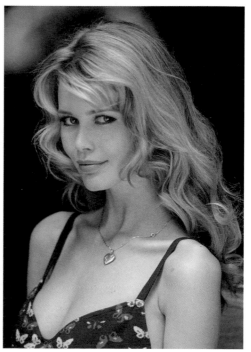

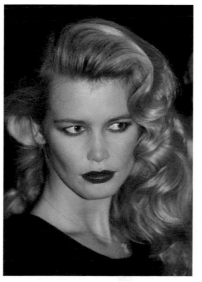

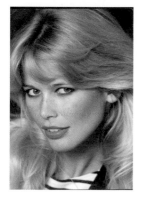

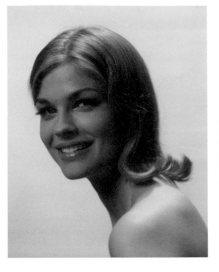

CANDICE BERGEN

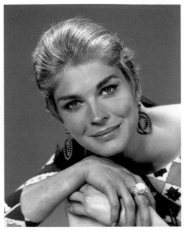

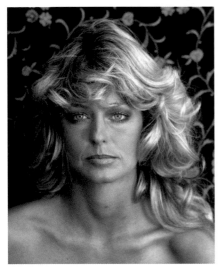

FARRAH FAWCETT

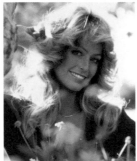

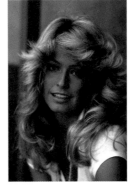

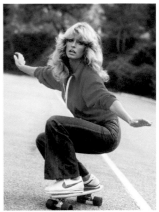

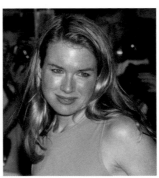

RENÉE ZELLWEGER

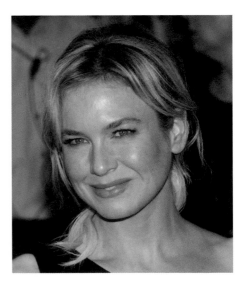

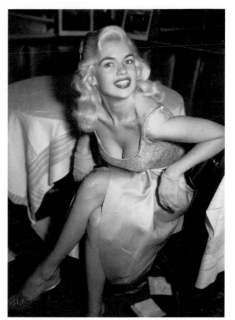

JAYNE
MANSFIELD

MICHELLE
PFEIFFER

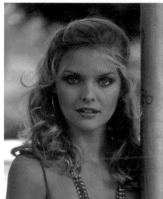

PEGGY
LIPTON

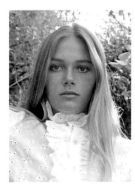

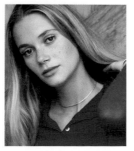

SHARON
TATE

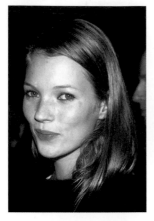
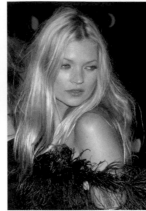
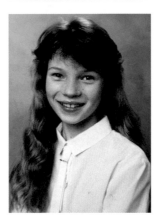

MEL
LONDON

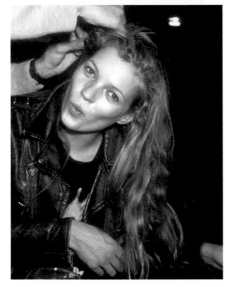
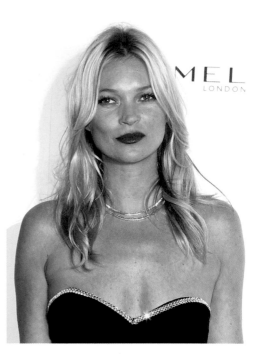

KATE MOSS

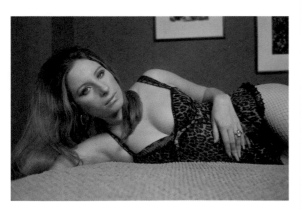
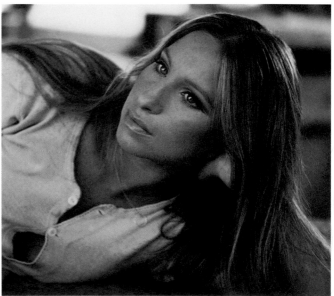

BARBRA STREISAND

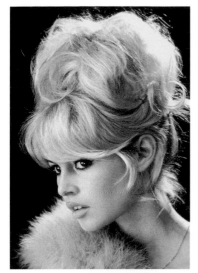
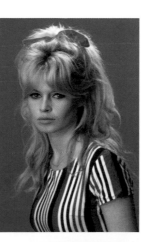
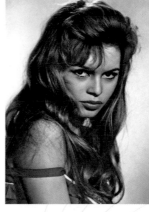
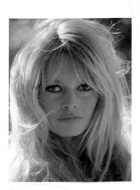

BRIGITTE BARDOT

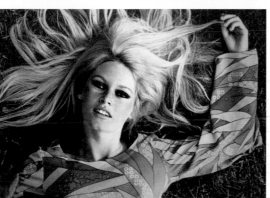
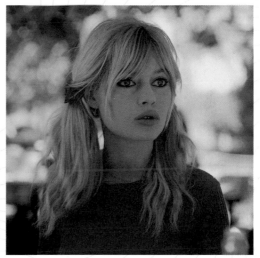

MERYL STREEP

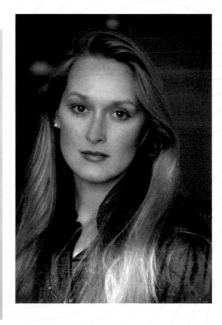
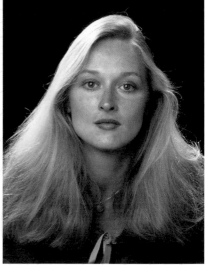

BRUNETTES

If blondes are the "fun" ones, brunettes are their sophisticated, bespectacled, scholarly rivals who are taken more seriously and hired more often and make much better significant others. I'm obviously kidding. But just as with their towheaded counterparts, being a brunette comes with some serious stereotypical baggage. Back in 2005, *Allure* reported that 76 percent of American women thought the first female president would have brown hair (at this point I think we'd all be happy if she just hurried up, regardless of hair color). And in a 1996 study that appeared in *Psychology of Women Quarterly,* 136 college students were given identical resumes of women applying for an accounting role—only one resume had a blonde photo attached, while the other showed a brunette. Who got the job? The brunette applicant was not only deemed more capable, but assigned a higher salary, too. And I'm sure you've seen *Legally Blonde* (spoiler alert: the "fun" blonde happens to be really smart). Outdated typecasts aside, I personally think that brunettes are some of the most beautiful women in the world. Yes, brown (or black) is the most common natural hair color across the globe, with more than 90 percent of us having the high levels of the eumelanin pigment that dark hair is made of. Even though it's "common," dark hair is so classically timeless and rich. From Dorothy Dandridge to Jackie O and everyone who has come after them, brown hair exudes an effortless grace. And though brunettes are supposed to be the "serious" ones, I find them to have some of the most head-turning and wow-inducing colors I see (and you know I see a lot). I already told you that blonde is the most requested color at my salon. But not everyone is clamoring to cover their brown. My client Minka Kelly is a natural blonde who loves being a gorgeous brunette—and is willing to do the never-ending root touch-ups that staying one requires. As you'll read soon, another natural brunette—Lily Aldridge—is my absolute most requested celebrity of all time, no matter where in the world I happen to be. But regardless of what color you want, don't forget that the undertone of your skin and your natural coloring play such a huge role in how your new hair color is going to look (which is why you should bring your colorist your childhood photo and get back to your roots!). If you're considering a new brunette shade (or any color, for that matter), do the undertone trick: Look at your wrists and check your veins. If they look green, you have warm undertones. If they look blue or purple, you're cool. A mix of both means you're neutral, and that's very valuable information for you and your colorist (or for Google if you're researching drugstore shades) to have.

"GENTLE-MEN MARRY BRU-NETTES."

—*Anita Loos*

BRUNETTES

Dark Matter:
Eartha Kitt, Courteney
Cox, Awkwafina, Diahann
Carroll, Jaclyn Smith,
Amy Winehouse, Iman,
Cindy Bruna, Jaqueline
Bisset, and Diana Ross,
among others

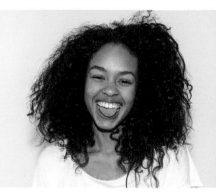

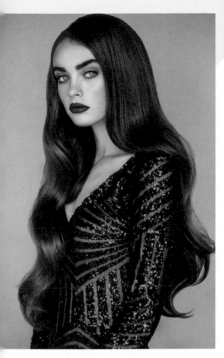
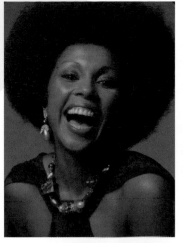
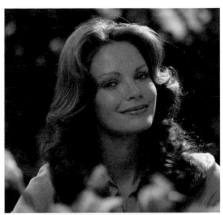
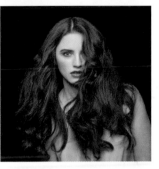

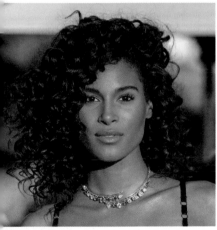
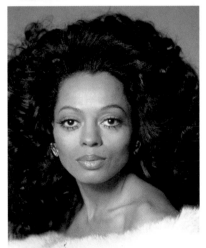

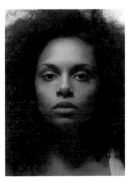
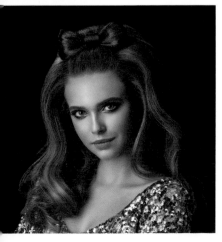

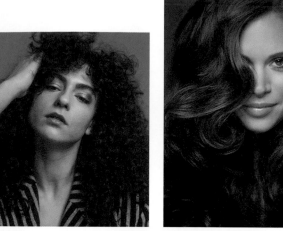

Warm Up:
Monica Bellucci,
Shakira Caine,
Michelle Obama,
Padma Lakshmi,
Lois Chiles, and
other brunette
beauties

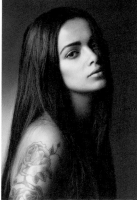
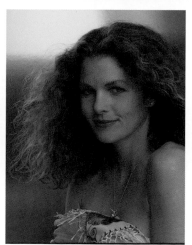
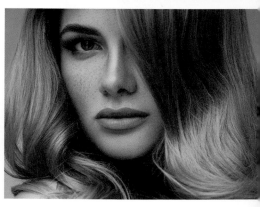

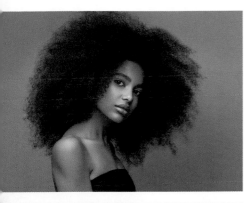
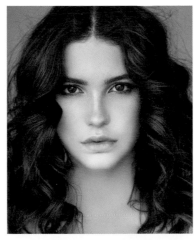
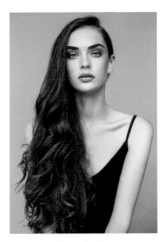
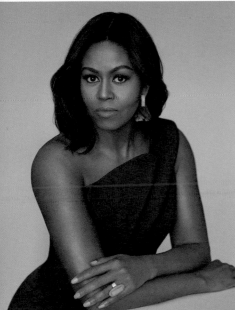
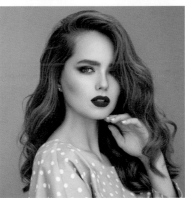
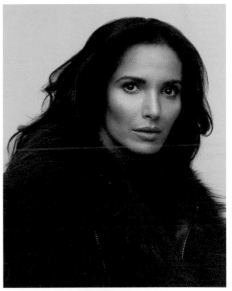
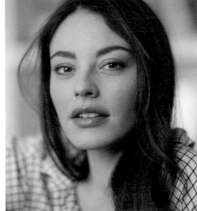

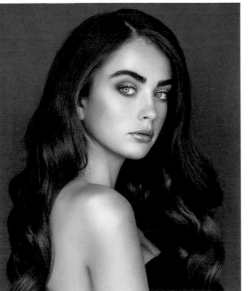

BRING THIS TO YOUR COLORIST:
Natural Brunette Inspiration

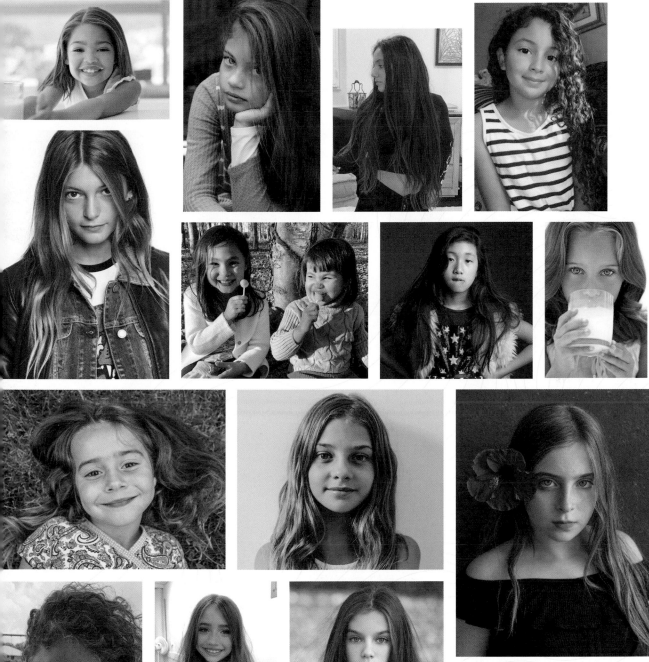

CHRISTINA RICCI

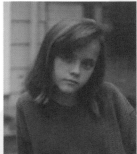

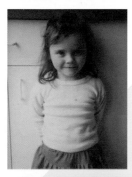

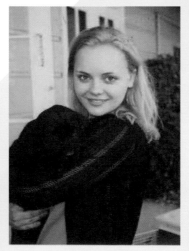

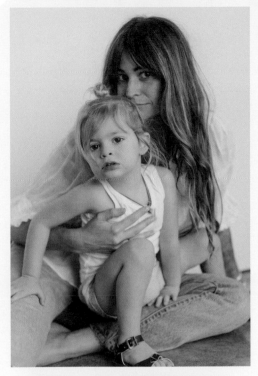

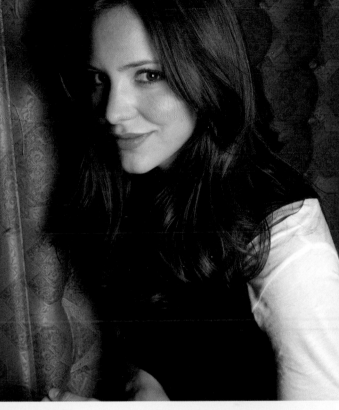

MARGARET
KLEVELAND

KATHARINE
MCPHEE

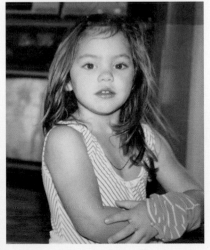

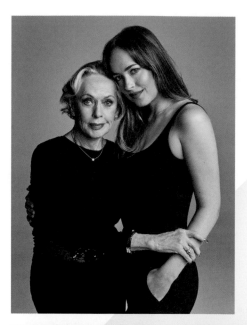

COLOR TRIBE:

DAKOTA JOHNSON,
MELANIE GRIFFITH,
TIPPI HEDREN &
STELLA BANDERAS

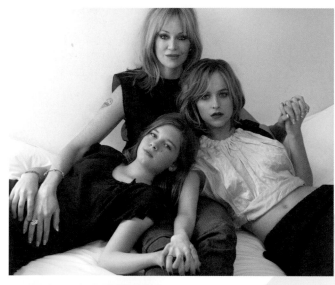

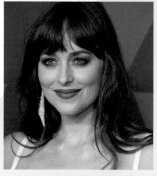

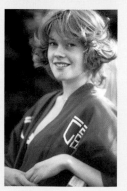

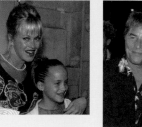

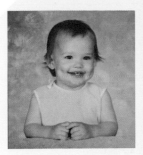

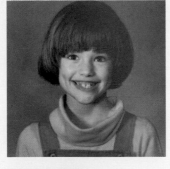

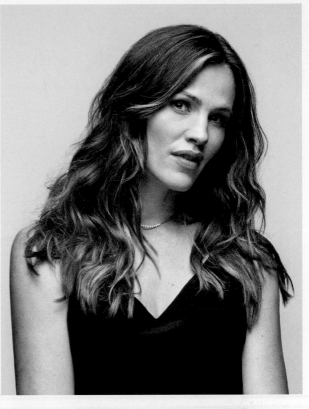

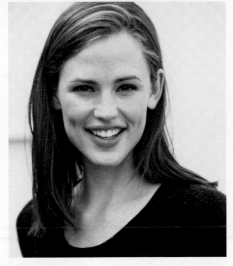

JENNIFER GARNER

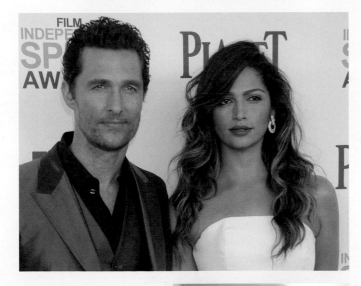

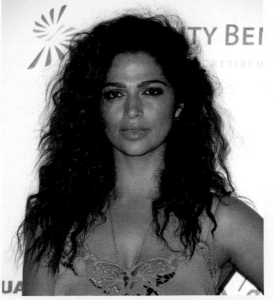

CAMILA ALVES

HOW THE MOST POPULAR HAIR INSPIRATION OF ALL TIME HAPPENED

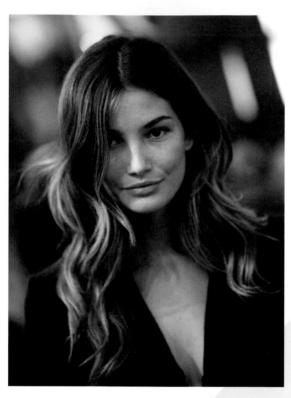

Whether I'm at my salon in Beverly Hills or doing a temporary residency with Jen Atkin in Dubai, the number one person that clients say is their color inspiration is Lily Aldridge. All day long, clients sit down in my chair and show me their saved Instagrams, screenshots, and magazine spreads while gushing over her ombré, asking me to help them get their very own version. I could never have imagined the fanfare her hair would cause. I've been friends with Lily's mom, Laura, for years because of all of the Aldridge house playdates I attended with Bette Midler's daughter, Sophie. I watched Lily grow up. So when she started modeling and wanted to color her hair for the first time, she came to see me. She begged me to take her lighter than her natural brown, and I refused, telling her that going too light with her base would be a huge mistake. After all, I knew just how gorgeous the natural color she was born with looked. But she kept begging. So we compromised a bit and gave her a full head of highlights with shadow roots so her base still looked like her natural color. In 2008, she landed the cover of *Vogue* Mexico and they dyed her a lot darker than normal. As soon as Lily got back to LA, she again tried to get me to take her light. And again, I said no. So I ended up doing the same thing I'd done before—highlighting her and rooting her to mimic what her hair had looked like when she was a kid. Next thing we knew, it blew up and clients started coming in asking for this new, natural, effortless-looking ombré. Soon my client Jaclynn Jarrett, one of the founders of *NYLON* magazine, was sitting in my chair to get color and asking about color trends that she could use for an upcoming article in the magazine. So I told her about Lily Aldridge, the cool new model with the ombré hair that everyone was talking about. Jaclynn had never heard of Lily or of ombré, but she did bring her own inspiration photo—a magazine clipping of a hair look she loved that she wanted to mimic. As it turns out, the inspirational photo happened at be a picture of none other than Lily and the ombré highlights I gave her. Neither of us could stop laughing. Lily-mania still hasn't died down more than ten years later. Giving Lily her ombré is one of the most defining moments of my career.

LILY & RUBY ALDRIDGE

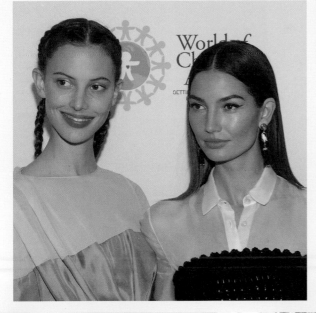

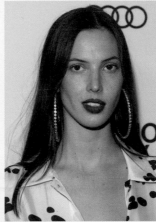

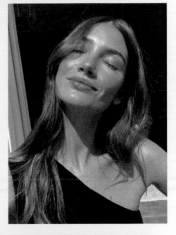

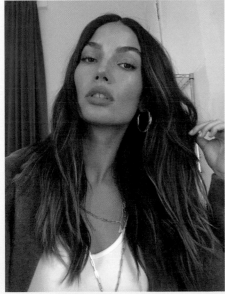

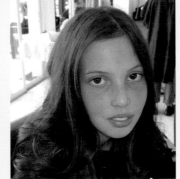

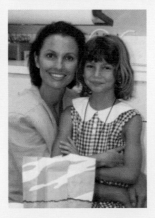

MAYA RUDOLPH

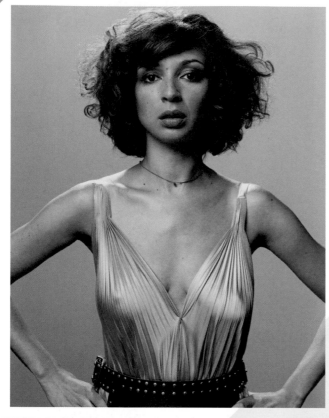

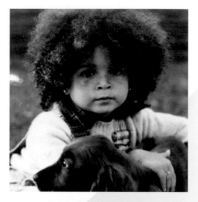

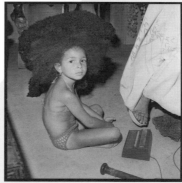

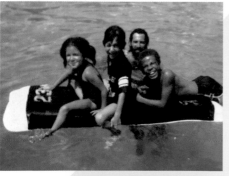

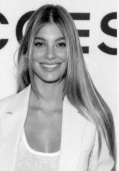

CAMILA
MORRONE

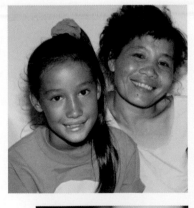

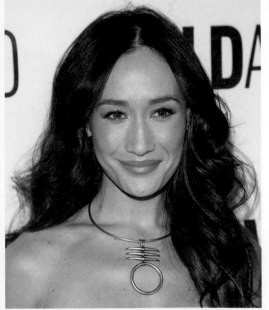

MAGGIE Q

AMANDA PEET

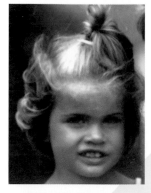

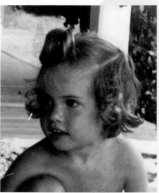

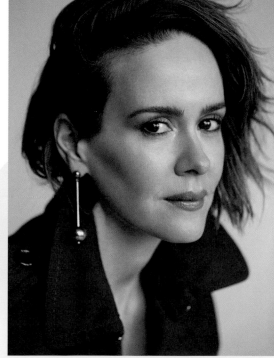

SARAH PAULSON

MINKA KELLY

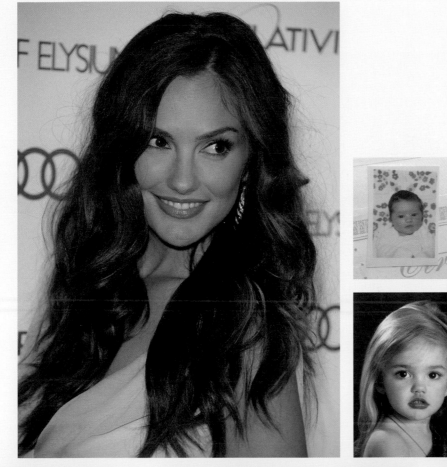

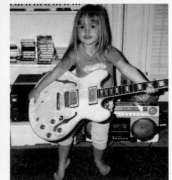

JESSICA BIEL

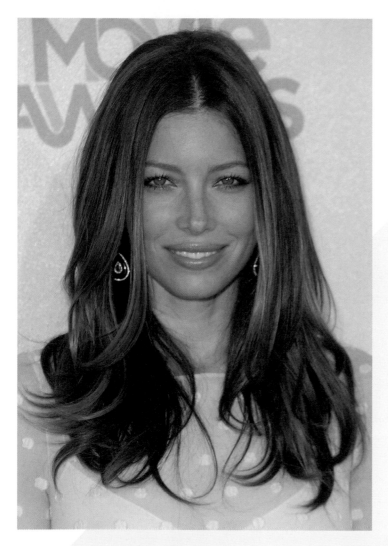

As you just read, everyone wants ombré. But sometimes, as with some of the best things in life, the best ombré can be an accident. Years ago, Jessica Biel—who's a close second in the most-requested-hair-inspo depart-ment—came to the salon for a touch-up because she hadn't been in for a few months and her roots were majorly growing out. Her hair looked so gorgeous to me that I honestly didn't understand why she was there. I told her I didn't want to touch it and finally convinced her to leave her roots alone, so she left without me doing anything. And soon she was being photographed everywhere and the beauty press was freaking out about her "new" ombré hair. She must have gone at least six months without coloring her hair at that point, and all the "new" ended up being was me not doing her hair!

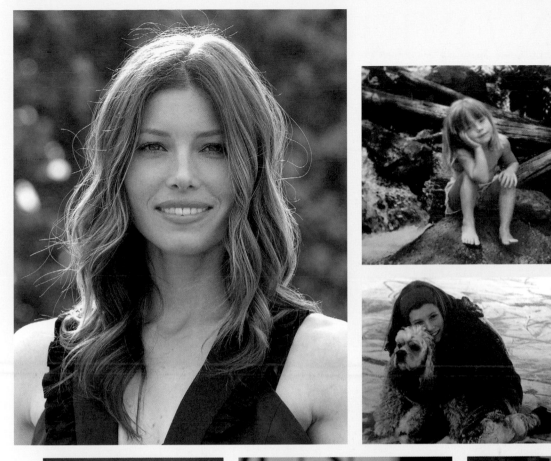

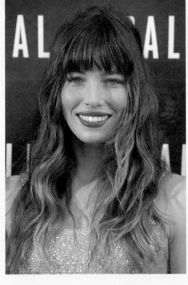

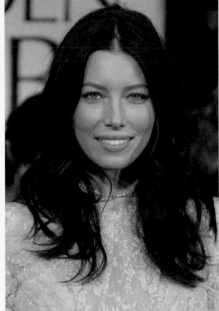

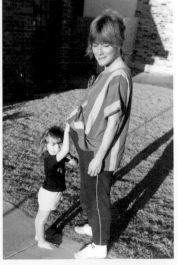

AN OVERTURE OF OMBRÉS

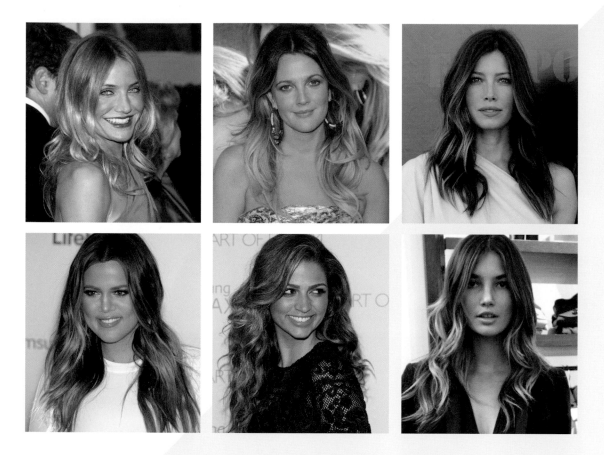

Lily Aldridge, Jessica Biel, and Cameron Diaz have all put ombré hair on the map in a major way. But in my opinion, ombré is actually the most natural way to describe how hair grows. Which means there's a really good chance that if you dig through your old childhood photos, you'll realize that you had a version of ombré at some point, too. Natural hair doesn't grow in a single, uniform color on our heads. And as you may know from your own experiences, hair color changes as we get older, and during that change you may find yourself with a set of natural highlights that differ from your base. I think the unadulterated ombré I see on kids is some of the most gorgeous, striking color in the world, and as I've told you (and will continue to tell you) throughout this book, I'm really inspired by the natural highlights and gradients that I see in my clients' children and in their own personal photos—which is why I encourage my clients to bring me their childhood photos, so we can give them a color that's actually theirs.

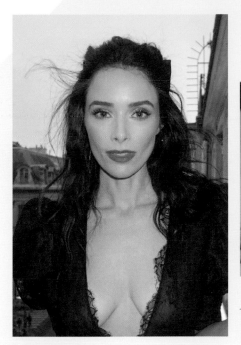

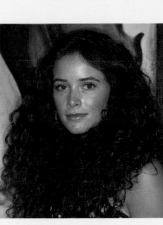

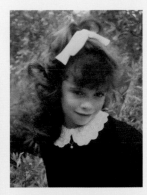

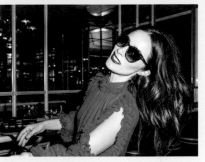

ABIGAIL SPENCER

CHARLENE ROXBOROUGH

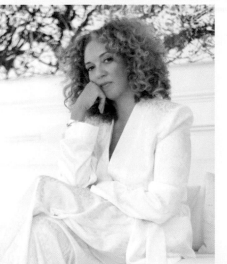

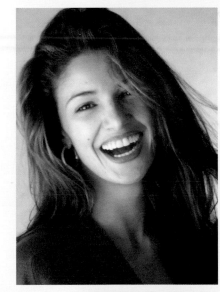

NADIA FARÈS

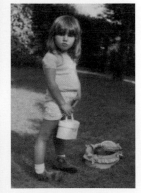

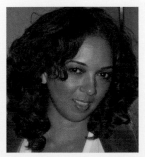

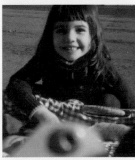

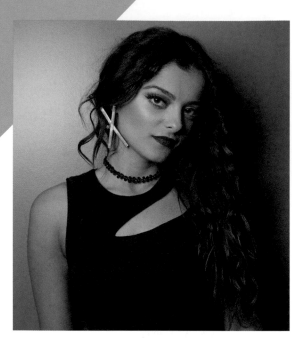

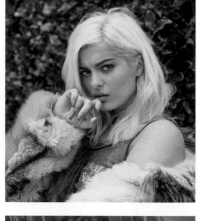

BEBE REXHA

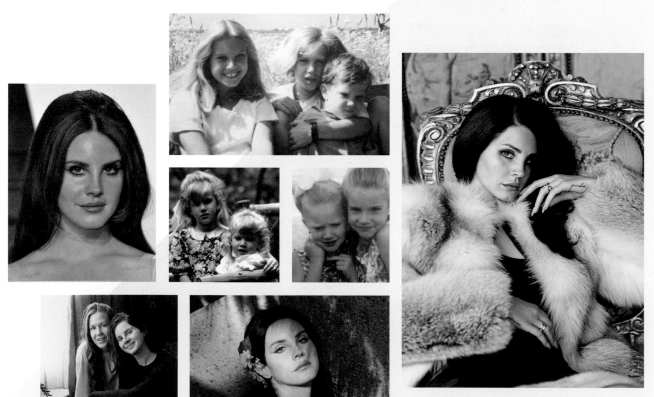

LANA DEL REY

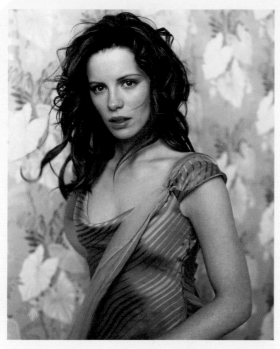

KATE BECKINSALE

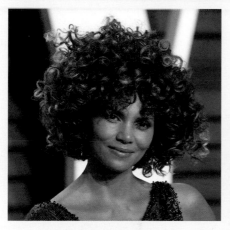

HALLE BERRY

CHRISSY TEIGEN EDITION

I still talk to Chrissy Teigen about one of the biggest color regrets—and biggest hair traumas—we've ever experienced together: the Mexico photo shoot, an infamous 2015 event that still, to this day, leaves us shaken to our cores.

Chrissy's mom, Pepper, once showed me a picture of Chrissy as a kid with much lighter hair, and I became a little obsessed with taking her back to that version of blonde she was born with. We kept taking her lighter and lighter and worked really hard to keep her hair healthy along the way. And the results were front and center at the 2015 Oscars, where she paired her golden hue with a modern, Veronica Lake–style finger wave that blew everyone away. We were so proud of that color.

Right after the Oscars, Chrissy went to Mexico to film a commercial, and the client wanted her hair dark, so the stylist on set went to the supermarket for a box of dye and colored her hair back to dark brown. That was bad enough on its own, but as soon as Chrissy got back to LA, she decided she wanted to be blonde again (as you'll read in the next section, drastic transformations—especially when bleach is involved—are an art and a science that can go horribly wrong if not done impeccably). Since I wasn't in town, she went to someone else. And that someone did what I would have suggested we wait to do: they bleached on top of her existing color. In Chrissy's words, her hair's health was taken back "to square one. Not even square one, square negative 1,000." All of the care we had taken to preserve it, undone in a matter of days! We still reminisce on this hair disaster every now and then and laugh at the lessons we sometimes have to learn the hard way.

Chrissy at MéCHE in 2013

A Proust Color Questionnaire:

When did you start coloring your hair?
I started coloring my hair around freshman year of high school. It was out of a box and called "chocolate cherry," I believe. The entire bathtub would turn a reddish black, like a horror movie. Mom wanted to kill me.

What was your first hair color experience like?
A MESS. Forehead stains, long-lasting damage. Not to mention completely uneven, since I couldn't ask for help (as it was done in total secrecy!)

As a child, how did your natural hair color make you feel?
I loved it! When I was around eight years old, my hair started to shift from a mousy brown to almost blonde! Once Tracey saw a childhood photo of me, she was determined to take me back to that color. We did it for the ESPYs in 2014 and it is still my most favorite hair color I've ever had.

What hair color do you find you most identify with as "you" now?
I love a good beachy highlight. Luckily I'm never forced into doing anything different than what I like.

What secret tips and tricks have you learned from Tracey about managing your color?
One word: OLAPLEX.

What advice would you offer to your daughter when she's old enough to decide whether or not to color her hair?
I don't want her to ever feel like she has to do it in secret! I want to let her be her own person and let her make her own decisions and help her make the healthiest, best conclusion—which will definitely be Tracey. The saddest day will be when Tracey retires from the chair! What's more important to me with Luna is that hopefully, she loves and embraces her beautiful curls!

COLOR TRIBE:
PRISCILLA PRESLEY, LISA MARIE PRESLEY & RILEY KEOUGH

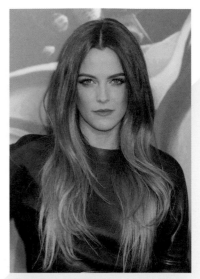

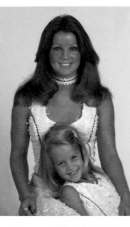

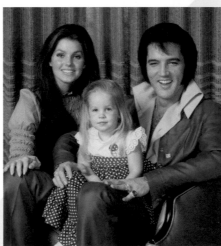

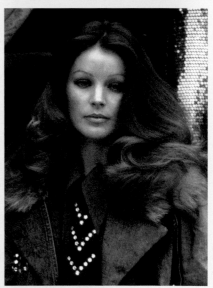

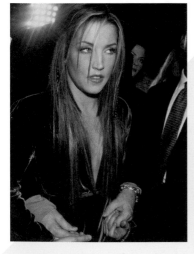

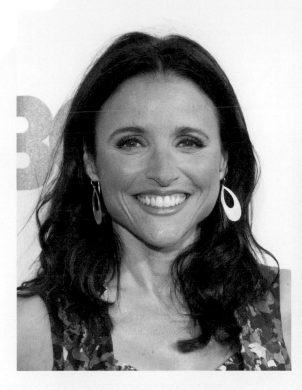

JULIA LOUIS-DREYFUS

TONI BASIL

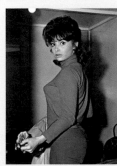

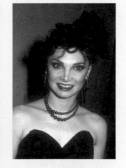

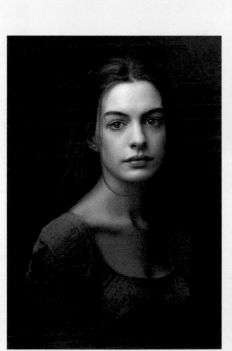

ANNE HATHAWAY

RITA WILSON

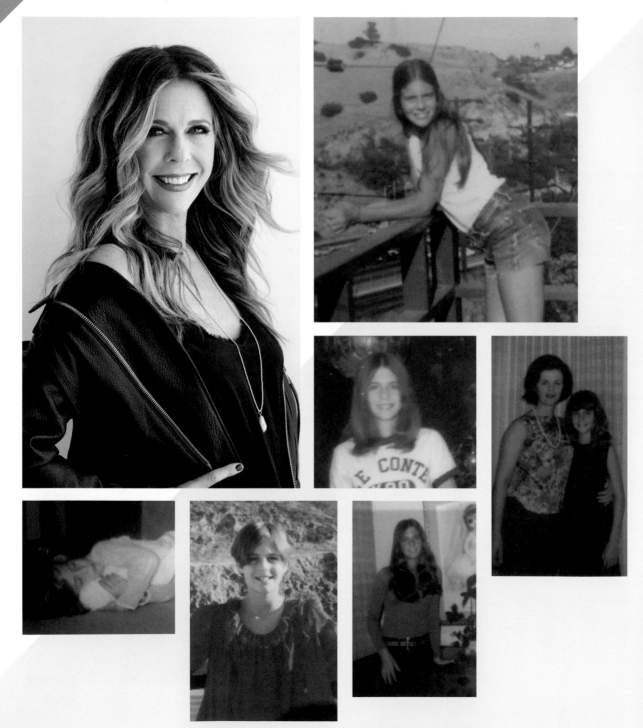

JENNIFER
GREY

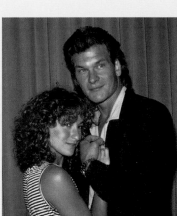

SHIRI
APPLEBY

MEGAN
HENDERSON

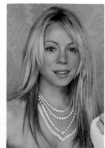
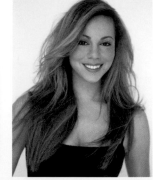
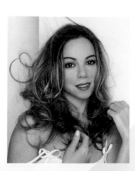
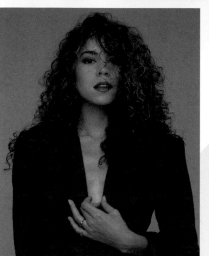

MARIAH CAREY

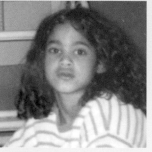
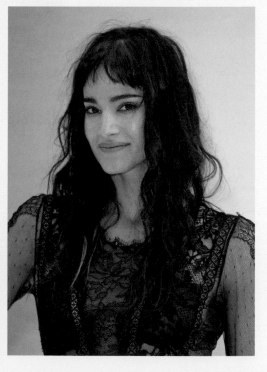

SOFIA
BOUTELLA

HAIR COLOR:

BETTER THAN BOTOX

The real reason that hair color is a multi-billion-dollar industry is because hair is one of the first things that gives away our age. And that doesn't just mean covering grays—I have so many clients who want me to take their teenage daughters back to the bright blonde they were born with, which tends to get darker as they age , as you can see here with my friend's beautiful daughter Chelsea Ivy (above, top row) and my friend Shana Zappa's daughter Halo (above, middle row). This natural darkening happens to almost everyone—even if you're a bit beyond your teenage years—and the jury's still out on exactly why. But I think enhancing your natural hair color by going back to your childhood roots is the best way to reinvigorate yourself in a graceful, seemingly effortless way (no sharp objects required). Just look at my client Christina Jeffs (above, bottom row), who I took back to her blonde roots. Yes, I'm biased, but I also see the results: Hair color should be your first stop on the turn-back-the-clock tour.

BRUNETTE INSPIRATION

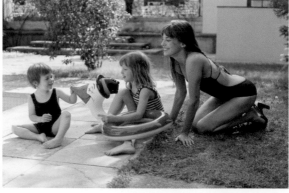

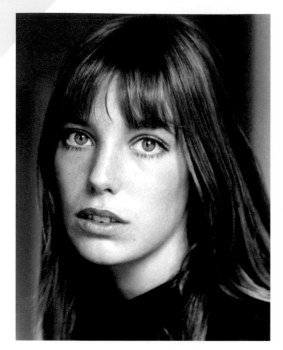

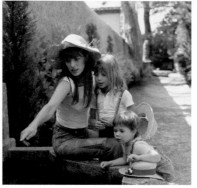

JANE BIRKIN

DEMI MOORE

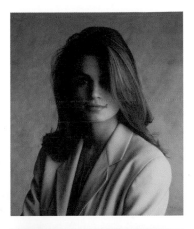

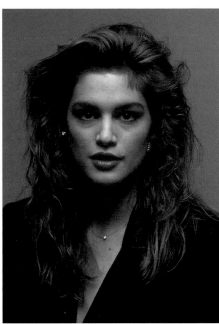

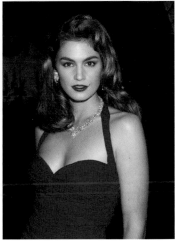

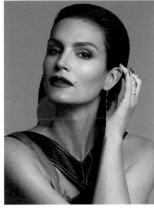

CINDY
CRAWFORD

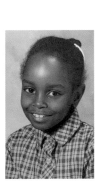

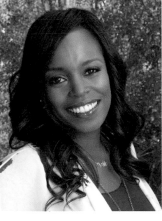

NYAKIO
GRIECO

AUDREY
HEPBURN

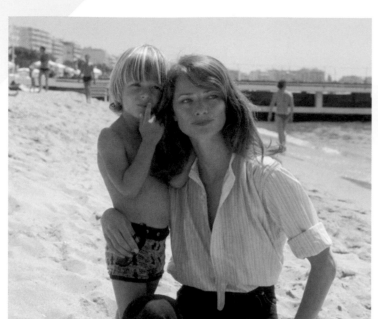

CHARLOTTE
RAMPLING

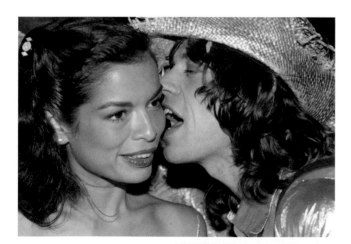

JEN
ATKIN

BIANCA
JAGGER

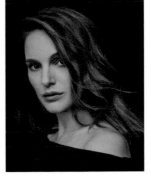

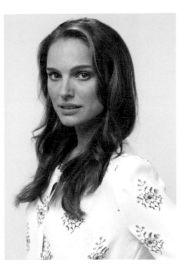

NATALIE
PORTMAN

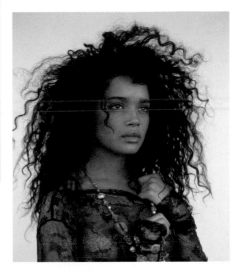

COLOR TRIBE:
ZOË KRAVITZ
& LISA BONET

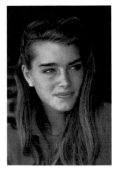

BROOKE
SHIELDS

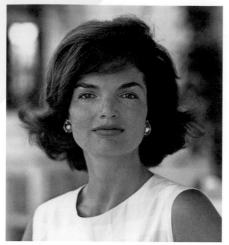

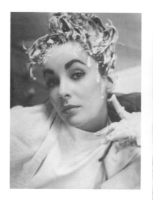

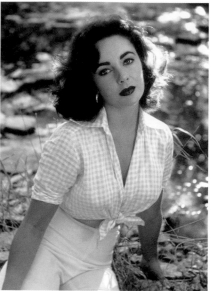

JACQUELINE
KENNEDY
ONASSIS

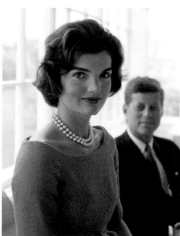

ELIZABETH
TAYLOR

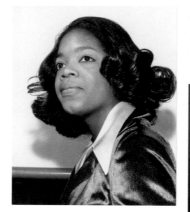

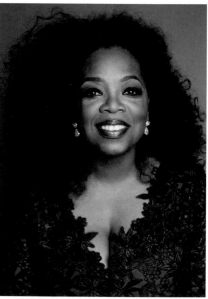

LIU WEN

OPRAH
WINFREY

JANE SEYMOUR

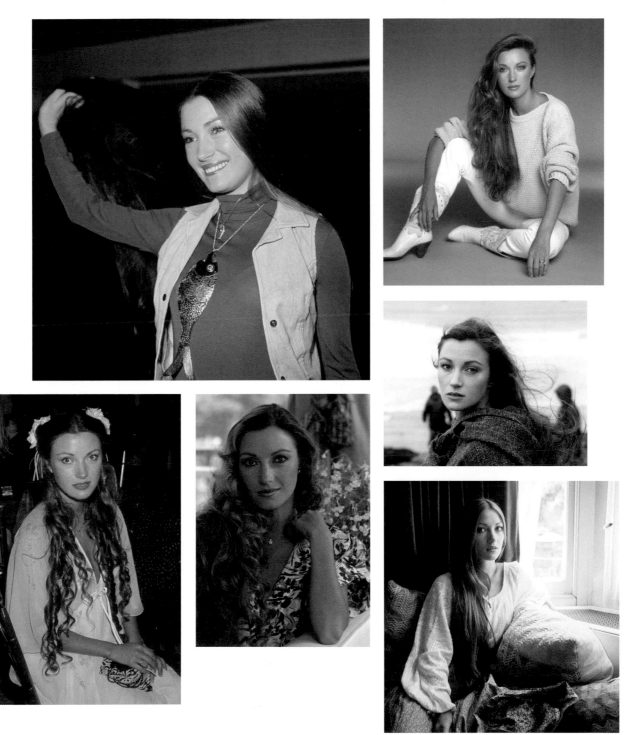

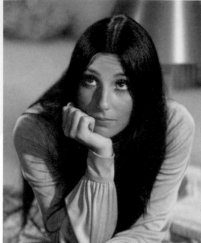

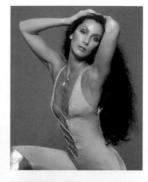

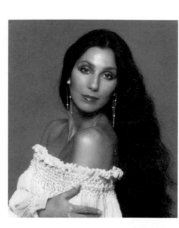

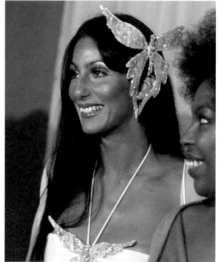

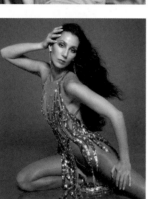

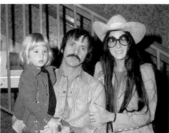

CHER

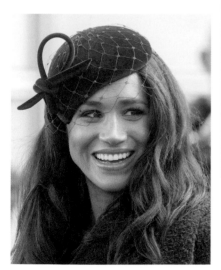

MEGHAN
MARKLE

PAM GRIER

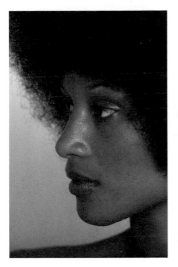

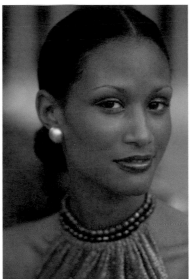

BEVERLY JOHNSON

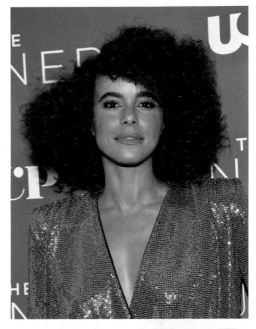

PARISA FITZ-HENLEY

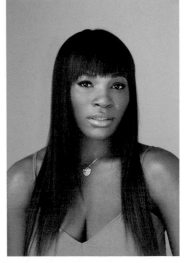

COLOR TRIBE:
VENUS & SERENA WILLIAMS

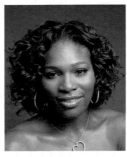

REDHEADS

Redheads are so special. They're a different breed. Rare and striking, they have a reputation for being opinionated, fiery, and spirited (and that may be putting it mildly). Lucille Ball, who got her red hair courtesy of Max Factor (whose Hollywood makeup museum contains the "redhead" room, where he first colored her naturally blonde hair, intact and open to the public), famously suggested that every man should be lucky enough to fall in love with a gorgeous redhead just once. They're portrayed as both vixens (hello, Jessica Rabbit) and the funny best friend (think Kathryn Hahn in *How to Lose a Guy in 10 Days*). Even Emma Stone, a natural blonde, has been quoted saying that she feels like she can be funnier as a redhead.

Like being a blonde or brunette, having flame-hued hair comes with a very distinct state of mind. I find that redheads deeply identify with their hair color as a huge part of what makes them who they are, and they play up their personalities to go along with it.

But when it comes to creating red in the colorist's chair, it's actually the hardest hue to achieve and the hardest color to get out—something I remind my Color Chameleons who I know will want to go back to blonde in a week, which isn't an option when red is involved. Shades of ginger are also really easy to screw up because they can look so unnatural unless they're created with precision and artistry. I always like to paint the hair of a redhead in an extremely natural way that evokes her youth. To achieve the effortless red that dreams are made of, I often highlight a would-be redhead's hair all over and blend it with the client's natural brown or blonde. Then I do a red rinse on top so it looks subtle and real. Once you're sufficiently in Julianne Moore territory, it's important to note two things: You'll have to touch up your red a bit more than you would other colors as it fades faster, so plan on seeing your colorist once a month; and switch out your makeup bag for an earth-toned palette that suits your new scarlet tresses. Warm-toned redheads with cool-blonde-girl makeup don't mix.

"I LIKE TO HAVE HAIR THAT LOOKS LIKE A VOLCANO IS ERUPTING."

— Karen Gillan

REDHEADS

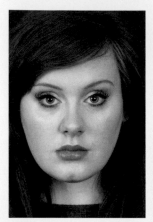

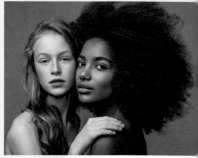

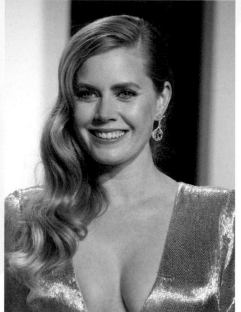

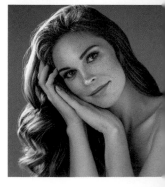

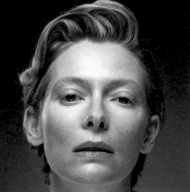

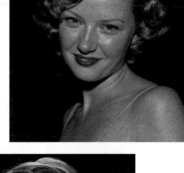

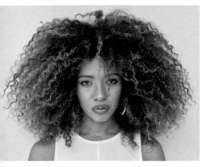

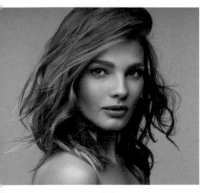

BRING THIS TO YOUR COLORIST:
Natural Red Inspiration

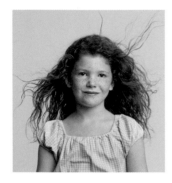

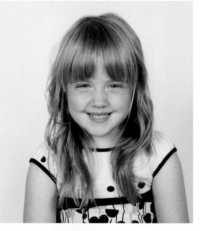

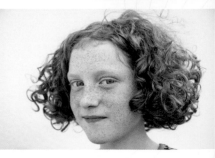

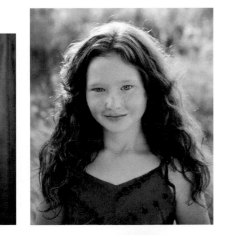
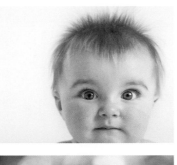
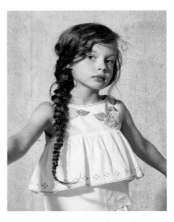
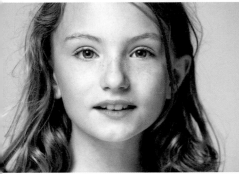
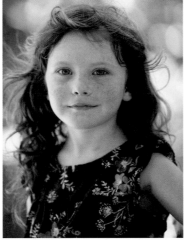

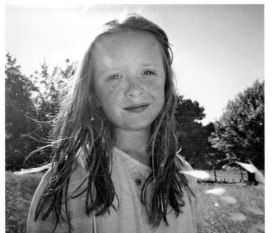
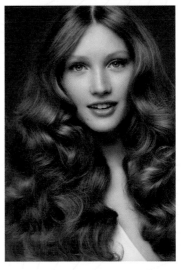

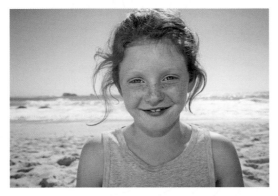

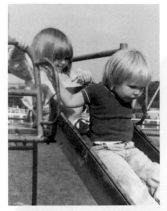

ISLA FISHER

ALEXANDRA CHERKASHINA

@ALEXANDRA.CHERKASHINA

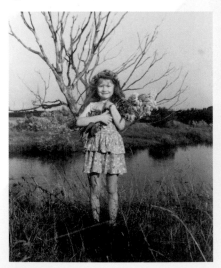

JESSICA
CHAFFIN

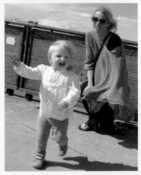

LUXE MOODY
my family friend

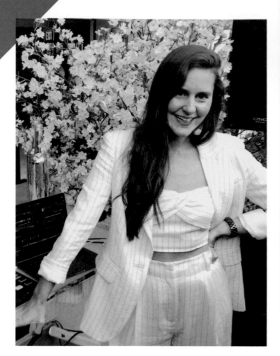

NIKKI PENNIE

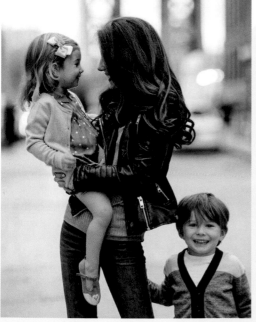

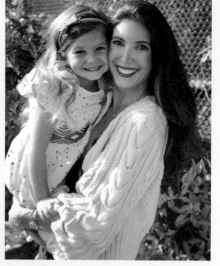

KIMBERLY KREUZBURGER

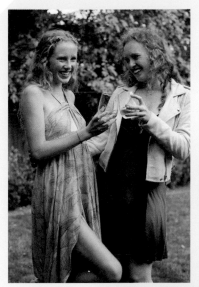

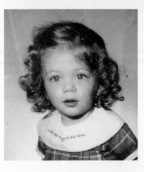

KATE
WALSH

BRYTE
DARDEN

@BRYTEDARDEN

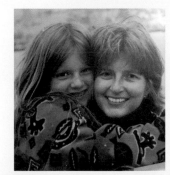

VANESSA
KROOSS

@VBKROOSS

COLOR TRIBE:
ZOEY DEUTCH & LEA THOMPSON

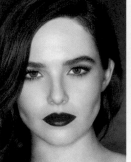

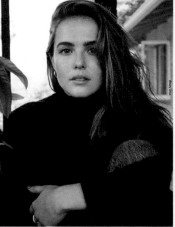

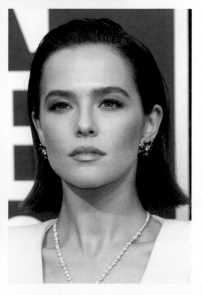

THIS IS HOW TO DO IT AT HOME

I know this book has a major focus on what to do before, during, and after an appointment with a professional colorist. That's who I am, after all. But I fully realize that seeing a hair colorist on a regular basis is an expensive, time-consuming pursuit that isn't always an option for everyone—not to mention that DIY hair color can actually be really convenient and fun. While I'm all for doing it yourself for light touch-ups and gray coverage maintenance, major changes should be left up to the pros (I say this having received many, many emergency calls after a DIY disaster). Regardless of your reason, there are a few things I think you can do to get great results that don't leave you bothering a colorist with an after-hours 911:

1. Pick the permanent base shade you really want, and then buy one that's a shade lighter than that. Often your hair will come out darker than you expect when you're doing it at home.

2. Speaking of going lighter, the hair around your face at your hairline grows in lighter and holds color differently than the rest of your head. And if you use base color at your hairline, it will look a lot darker than expected. Which means you should buy a shade even lighter than the one you're using for your base that's reserved solely for your hairline. You'll only use a tiny bit, so you'll get multiple uses out of that one box, and it will be the best extra money you've ever spent: Mixing this extra hairline shade will be the difference between looking like you're wearing a dark unnatural helmet and, uh, not.

3. As long as you're buying multiple products, pick up a semi-permanent or gloss for your ends. You don't need the strength of a permanent hair color designed to cover grays and roots at your ends, and using one too often will lift out your existing color and cause redness.

4. Invest in good tools. I personally think the squeeze bottles that come with drugstore hair color make things really messy. To get better control and results, order a plastic mixing bowl for your base color, an even smaller one for your hairline color, and some color brushes from a beauty supply store online. You shouldn't have to spend more than ten dollars before shipping. Remember to stick to plastic, never metal, so your dye doesn't oxidize and change colors before it even gets on your head.

5. Once you have your brushes, use the pointed end to part your hair and create sections that you can paint. This will be an easy way to get the areas in the back that are hard to see.

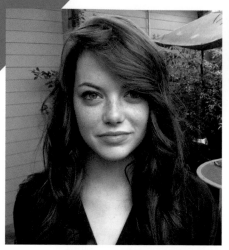
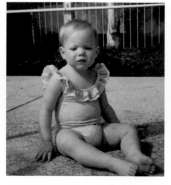
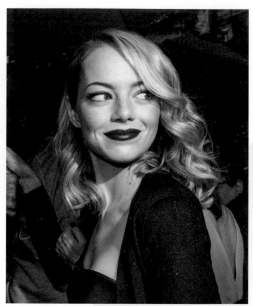
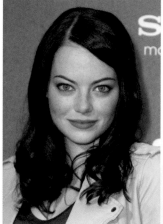
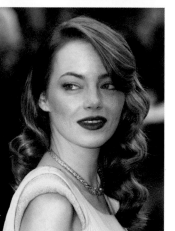
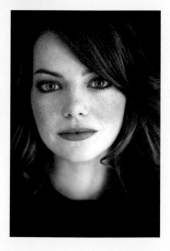
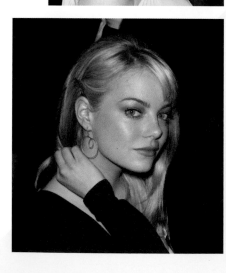
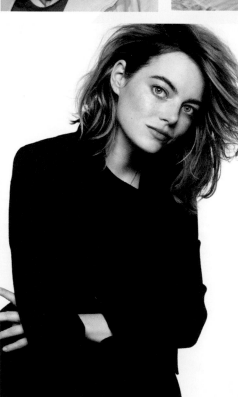

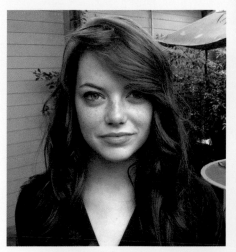
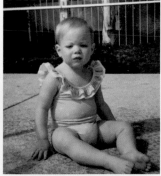
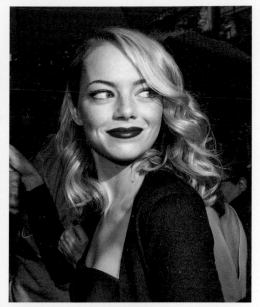
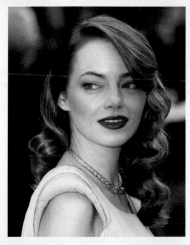
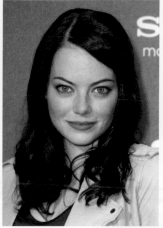
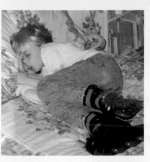
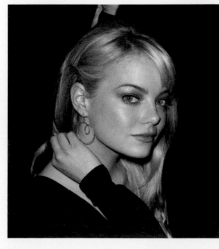
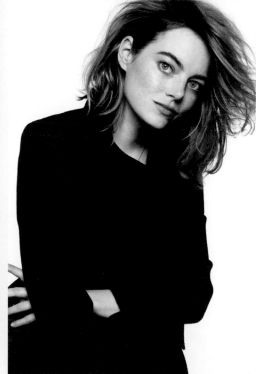
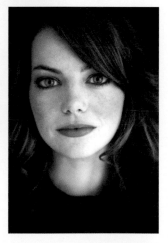

MADISON STUBBINGTON

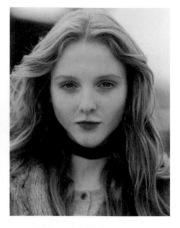

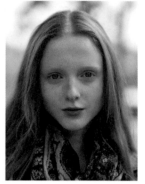

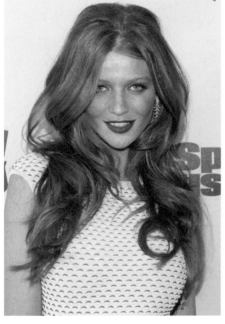

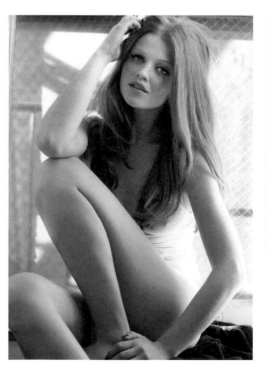

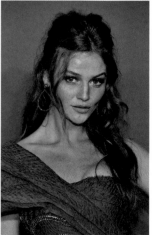

CINTIA DICKER

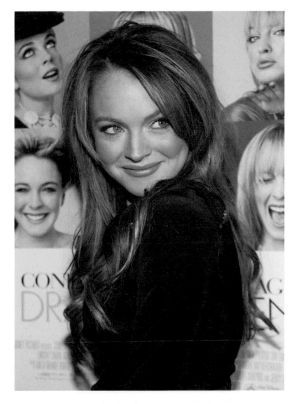

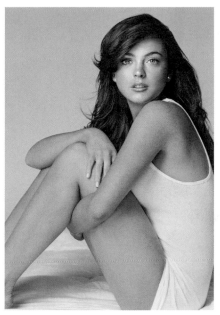

LINDSAY LOHAN

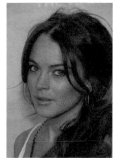

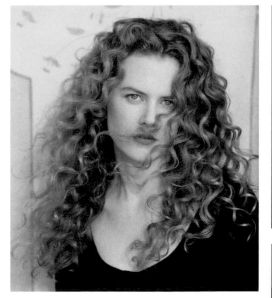

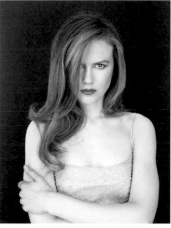

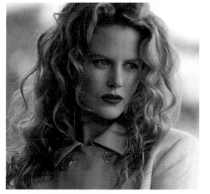

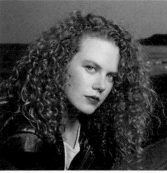

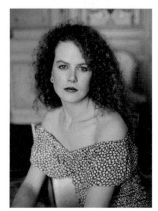

NICOLE KIDMAN

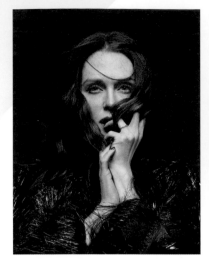

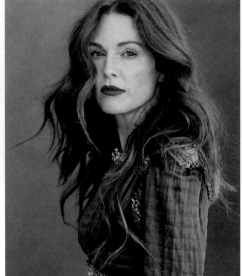

JULIANNE
MOORE

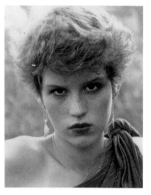

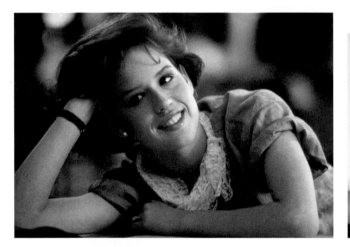

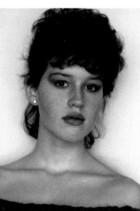

MOLLY
RINGWALD

JULIA ROBERTS

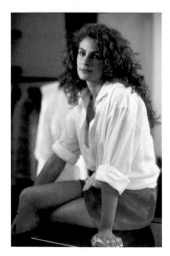

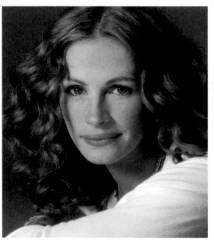

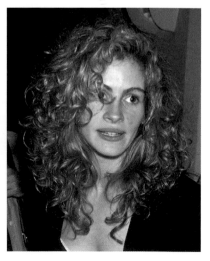

BONNIE
WRIGHT

GRACE
CODDINGTON

EPOCA

100 lire

RITIRATA IN RUSSIA

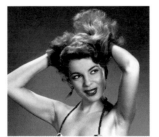

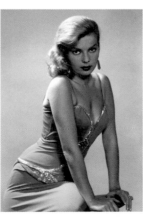

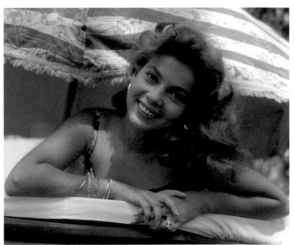

ABBE LANE

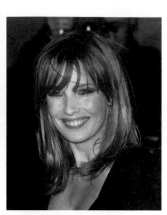

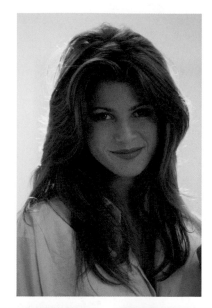

KELLY REILLY

LILY COLE

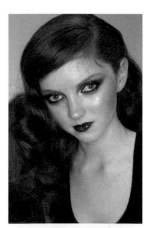

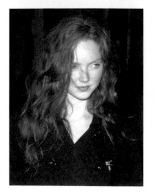

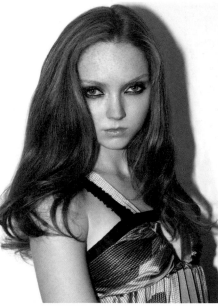

ANGIE
EVERHART

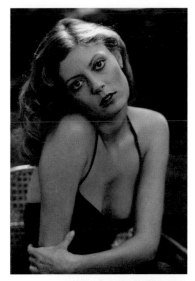

GEENA
DAVIS

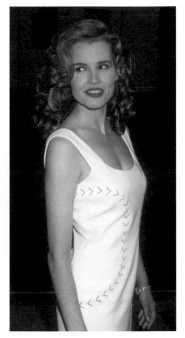

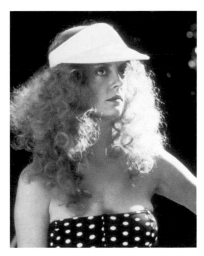

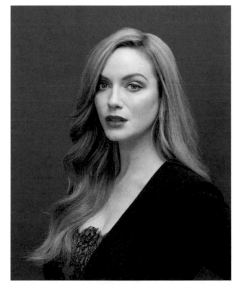

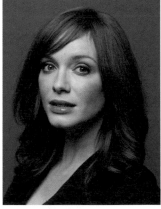

SUSAN
SARANDON

CHRISTINA
HENDRICKS

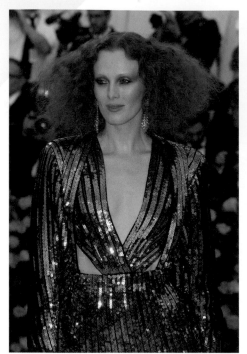

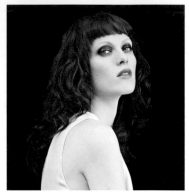

KAREN ELSON

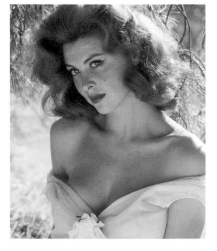

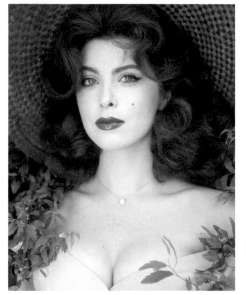

TINA LOUISE

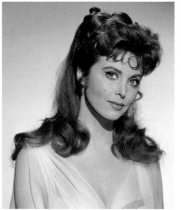

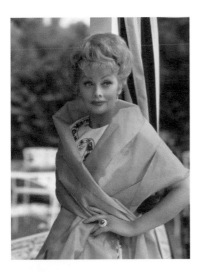
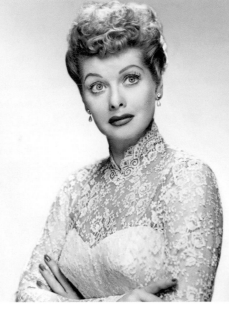

LUCILLE BALL

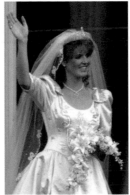

SARAH
FERGUSON

GILLIAN
ANDERSON

BETTE MIDLER

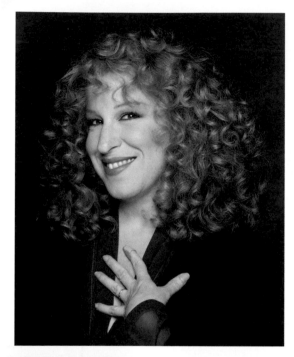

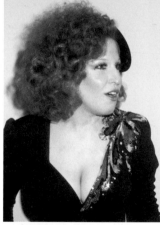
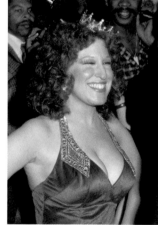
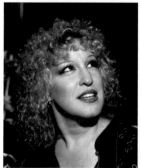
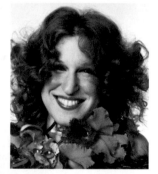
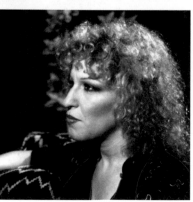
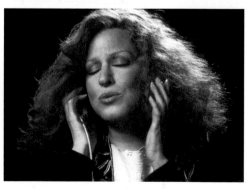

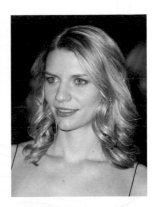

CLAIRE
DANES

BONNIE
RAITT

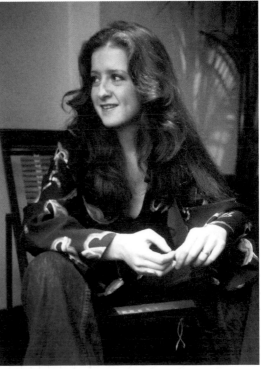

SILVERS

This might seem like a surprising chapter to encounter in a book about hair color written by a professional hair colorist. But I'm obsessed with silver and gray hair—no matter your age. As you hopefully realize by now, my mission is to help my clients achieve the best, most authentic-looking version of themselves through their hair color. And that's why I'm incredibly encouraging of women who embrace their natural gray and make the choice to put down the hair dye and transition to their natural hue full-time. I don't think that gray hair should contribute to the stigma of aging, as I know so many confident, vibrant, gorgeous women of all stages of life—from their midthirties to their nineties—who have embraced their silver hair and haven't once looked back. I even encouraged my mom in her decision to stop coloring her hair and go completely silver. It's such a personal choice to make, and I'm not here to tell you what to do, but I would like to offer some words of encouragement!

During the COVID crisis, I heard from countless friends and clients who began thinking about growing out their gray. It blew my mind and also made me so excited in the hope that new beauty ideals could be born from such a tumultuous and dark time. In my experience, when you really pay attention to a woman who is growing out her natural gray, you can notice her skin change—it's as if she begins glowing from the inside and she acquires a powerful, newfound spark of life that comes from the feeling of freedom and confidence to be her complete self. This may shock you, but I'm constantly using natural gray growth patterns as inspiration for my work. It's true! If you look at the way natural silver is lighter and face-framing in the front, it's the same way a child's natural blonde grows. I'm very often thinking about the brightening and feature-framing qualities natural silver can provide when I'm creating blonde highlights.

Believe me, you can certainly continue to touch up your gray roots every three weeks if covering them is what allows you to feel your best. Only you know the intimate relationship you have with your hair color and how that color makes you feel inside. But I will say this: We are so lucky to live in a world that sees natural beauty at the forefront and more and more women embracing their natural curls, textures, and—yes—natural gray hair. There are entire communities on Instagram and Facebook devoted to gray hair and transitioning away from colored hair. My point in all of this is that no matter what your age, you definitely shouldn't feel alone on your gray hair journey.

You can absolutely go cold turkey if you want (Agnès Varda rocked this look). And I personally encourage you to just bite the bullet and go for it if that's what makes sense for you. But there are ways you and your colorist can make your silver transition less jarring and sudden, too:

"THE COLOR OF TRUTH IS GRAY."

—André Gide

Talk to your colorist about a transition plan. It's not going to happen overnight (some clients take a year or longer to transition fully away from color). But your colorist can formulate a plan for you that will lighten your hair at the roots as you go and create a dimensional look that is soft, natural and moves toward the gray underneath.

Because you'll technically be lightening your hair as you go, taking great care of it is key. Ask for Olaplex treatments and glosses in between sessions, and make sure you're conditioning. If possible, keep the use of hot tools to a minimum so you don't stress out and break your hair along the way.

When your colorist says that your hair is healthy enough, you'll want to get balayage highlights that mimic the pattern of your natural gray growth. Your colorist may want to follow it up with a silver gloss for a bright, dimensional look that will allow your natural gray to grow out seamlessly.

Bring your colorist a card and some flowers, because you won't be seeing them nearly as much as you're used to.

SILVERS

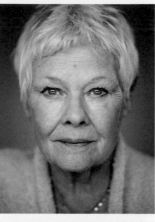

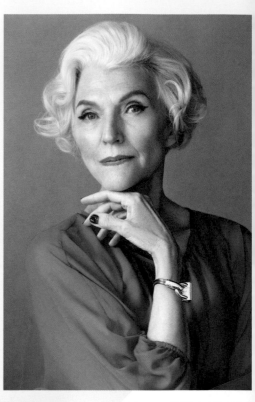

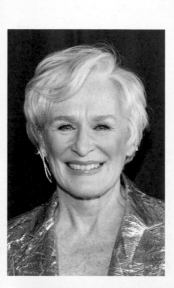

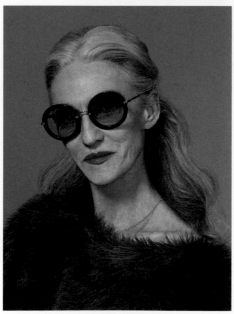

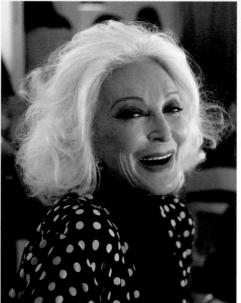

Silver Linings:
Judi Dench, Glenn Close,
Maye Musk, Eryn DeSomer,
Helen Mirren, Vanessa
"Redgrave, Linda Rodin,
Carmen Dell'Orefice, Stacy
London, Kiki Smith, Blythe
Danner, Erin O'Connor,
Polly Mellen, Nichelle
Nichols, and Cicely Tyson

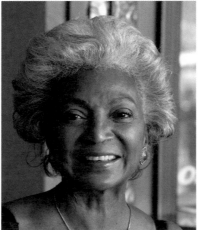

JUHÁSZ SZÉP ANNA

@PRETTYSHEPHERD

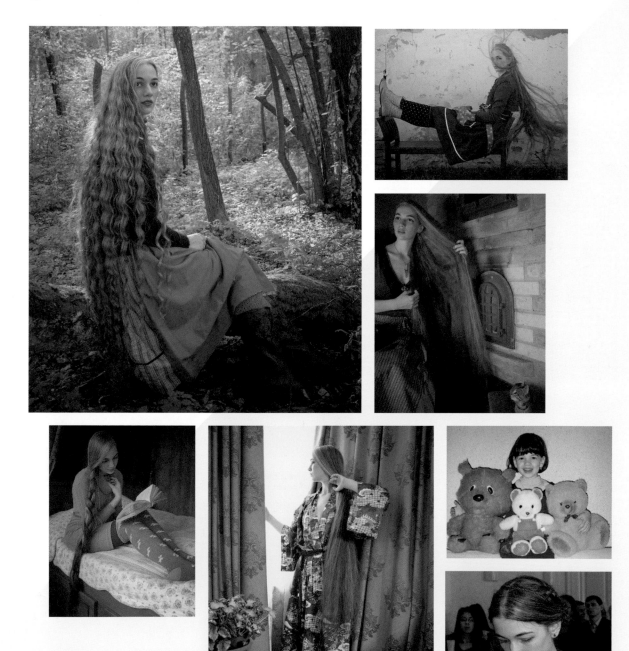

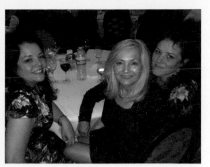

ANITA LOUISE PEDERSEN

my mom

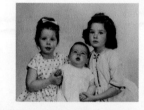

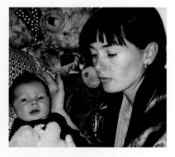

SUSAN CUNNINGHAM

my stepmom

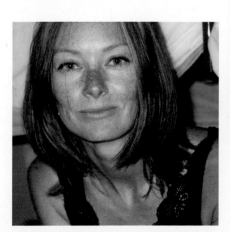

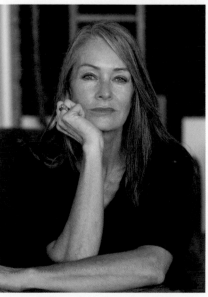

MICHELE AIKEN

GORGEOUS GROMBRÉS

Whitney
@SILVERSTRANDSOFGLITTER

Sumaira
@GREYSIAN_

Fransje Leering
@SILVER.ISTHENEW.BLACK

Remember the Instagram communities I mentioned devoted to the celebration and support of women who are embracing their gray? Well, @Grombre is one of the most notable, with more than 200,000 followers at the time of writing (I also love @silversistersinternational and so many other engaged social media accounts that help women celebrate their gorgeous gray). But "grombre" is more than a social handle; it's a movement. I've connected with so many incredible silver-haired women on Instagram while writing this book, and I asked them to show me their own empowering journeys as they've grown out their color to let their natural silver shine. As they prove, it's not that scary or impossible—it's amazing!

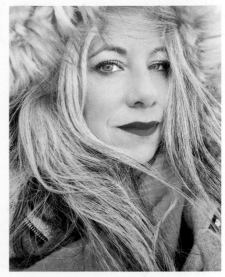

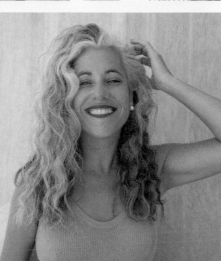

MARINA GARCIA-TREVIJANO

@MARINATREVIJANO

NICOLE FREEMAN

@NICOLE.LEIGH- MOONLIT.MAMA

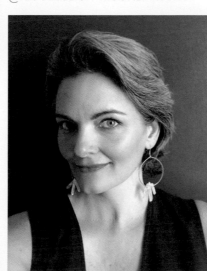

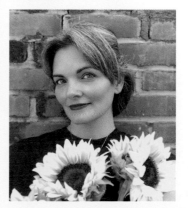

HOW TO TRANSITION TO SILVER FULL-TIME

If the day comes when you decide to embrace your natural gray, you can absolutely go cold turkey if you want (Agnès Varda rocked this look). And I personally encourage you to just bite the bullet and go for it if that's what makes sense for you. But there are ways you and your colorist can make your silver transition less jarring and sudden, too:

• Talk to your colorist about a transition plan. It's not going to happen overnight (some clients take a year or longer to transition fully away from color). But your colorist can formulate a plan for you that will lighten your hair at the roots as you go and create a dimensional look that is soft, natural and moves toward the gray underneath.

• Because you'll technically be lightening your hair as you go, taking great care of it is key. Ask for Olaplex treatments and glosses in between sessions, and make sure you're conditioning. If possible, keep the use of hot tools to a minimum so you don't stress out and break your hair along the way.

• When your colorist says that your hair is healthy enough, you'll want to get balayage highlights that mimic the pattern of your natural gray growth. Your colorist may want to follow it up with a silver gloss for a bright, dimensional look that will allow your natural gray to grow out seamlessly.

• Bring your colorist a card and some flowers, because you won't be seeing them nearly as much as you're used to.

METAL MAMA
GONE GREY

SANDRINE PICARD

@GREY_SO_WHAT

HAYLEY WILLS

@HAYLEYSILVER82

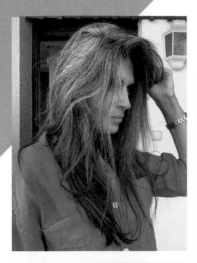

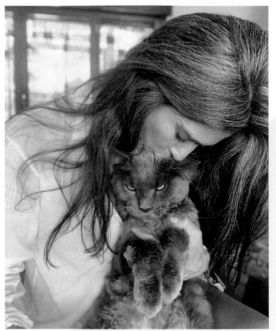

PILAR ARAGON

@MI_RATON

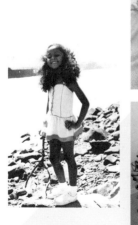
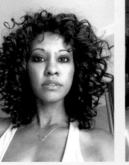

TENNILLE MURPHY

@THETENNILLELIFE_

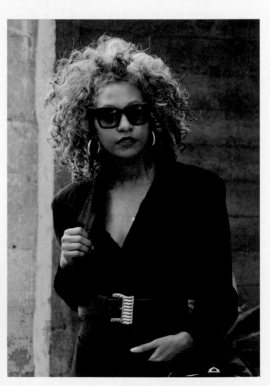

ONDINE RUMER

@ONDINE_RUMER

JIN CRUCE

@AGINGWITH_STYLE_AND_GRAYS

FELICIA COCOTZIN RUIZ

@KITCHENCURANDERA

PRISCILA BAVARESCO

@GREYNPROUD

DIANE KEATON

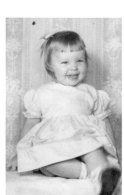

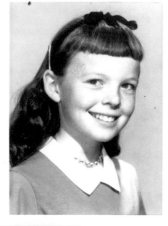

SARAH HARRIS

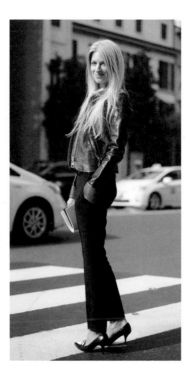

QUEEN ELIZABETH II

KRISTEN MCMENAMY

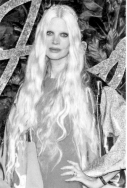

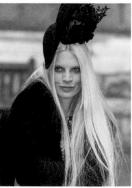

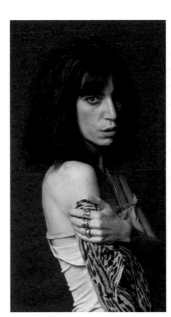

PATTI SMITH

BARBARA
BUSH

ALI MACGRAW

True
Precis

Color
ion

*How to Achieve the Hair
(and, Potentially, the Career)
of Your Dreams*

GETTING YOUR TRUE COLOR AT THE SALON

Getting your hair professionally dyed is a highly emotional process that takes a ton of time, skill, and expense to maintain. In 2018, *InStyle* magazine conducted a national hair survey and found that 81 percent of women reported feeling most confident when their hair looks great. Well, duh! When you feel confident that your hair looks awesome, you truly feel like you can take over the world. The same survey also found that women across America each spend an average of $930 on their hair annually—with the majority of that figure being spent in the salon. For most people, who are trying to keep their families afloat, that's not a small investment.

Your hair is your finest accessory, and as such I want to make it as easy as possible for you to get exactly what you want out of your salon appointments so you always feel as great as you can about your hair, and never like you're wasting time or money.

It's easy to show up at the salon with ten Instagram photos of people whose hair you wish you had, plop down in the chair, and spend the next two hours texting and scrolling while your stylist goes to town. But guess what? If you want the best outcome, we need you to be just as invested in your appointment as we are. And we need you to be our partner in helping you leave with exactly what you want. So here's your homework *before* you come in for your coloring appointment:

BOOK THE RIGHT KIND OF APPOINTMENT. When you call your salon to schedule a color appointment you have to be very clear in what you need and want. If you make an appointment for base and then decide to add highlights the day of, there won't be enough time to do both. And guess who's going to leave disappointed? Hint: not your colorist. If you don't know what kind of appointment you need, don't be afraid to ask to speak to a colorist at the salon for some advice. When a potential client at my salon calls with questions, the receptionist will come speak with me,

and even if I'm elbow-deep in highlighter, my assistant can easily act as a messenger so we can all figure out how to properly book you in. Another pro tip: If you know you're planning on making a dramatic color change, be sure to give us a heads-up when you call. Your colorist might be willing to come in after hours or on an off day so the time and focus is on your big undertaking alone. And if you're a new client *and* making a big change, consider booking a separate consultation so we have time blocked out specially to discuss your needs and how we'll get there.

PREP YOUR HAIR. If you decided to paint your kitchen, you wouldn't start painting over dirty walls with oil and cooking grease splattered everywhere, would you? I really hope your answer is no. Think of your hair in the exact same way. Why would you want to spend hours of your time and hundreds of your dollars to paint something that is fried, has split ends, and is coated with the minerals found in your shower water? Before you come in for your color appointment, make sure your hair is trimmed (or at least isn't six months overdue for one). If you have curly or textured hair, your color will accentuate split ends and tangles in a big way, so make sure you have a blunt-end trim before sitting down in the colorist's chair. A day or two before your appointment, use Olaplex or a similar treatment to repair any damage. Around that same time, settle in with a Netflix show and leave a deep conditioner or natural oil treatment (which we'll dive into more later) on while you binge. To finish things off, use a product like Malibu C's weekly treatment packets to clear your hair of the hard water minerals, makeup, and any medications that could be lurking there, making it harder for color to take (more on that later, too). If you come in with a perfectly prepped canvas, you'll leave with a work of art that you love.

TAKE YOUR INSPIRATION PHOTO SERIOUSLY. This one is so important that it almost deserves its own chapter. A photo is worth a thousand words, especially when you—the client— could be saying a bunch of different words that don't always give us any clear insight into what color you actually want. Because we're not mind readers, and we have no way of knowing that your version of "golden" could actually be our version of "chestnut," it's much better to leave the heavy lifting up to the mighty inspiration photo. But choosing the right one is an art form in itself.

A few months ago, I was working with one of my longtime clients, who I have a great relationship with. We'd been taking her blonde for years, so I knew she'd want a version of that. But when we sat down to start working, she had a few different inspiration photos to show me—all featuring a different shade of color and a different subject who each had a different haircut. Two of the photos were even in black-and-white. It's so great and helpful to your colorist if you know what you want. But unless you narrow that down for us, it gets really confusing really fast. I had to input all five photos (including the black-and-white ones) into my brain and spit out one version of what I thought my client wanted. And guess what? We weren't on the same page, and I haven't seen that client again.

I'm going to ask you for a favor on behalf of all hair colorists everywhere: Pick a single color photo. Yes, *one*. I don't care if you have to narrow down one hundred saved Instagrams you love to find the one

image that features the exact shade of dirty blonde you're dying for. Do it. Hair color has so much depth and dimension, and there are so many variables that create an exact shade. If you bring in multiple images, it's confusing for everyone. Choose one photo with a color that we can replicate *exactly* and call it a day. And yes, the photo must be in color (I can't believe I just had to type that).

Second rule of the inspiration photo: Haircut and texture matter. If you have fine, straight hair that's a uniform length, highlights are going to lie completely different on your hair than on that of someone whose hair is thick, textured, and layered.

Shai Amiel, a curl-styling expert known as "The Curl Doctor," owns Capella Salon, his curl-focused LA space where the likes of Tamera Mowry, *Dear White People* front woman Logan Browning, and *The Bold Type* star Aisha Dee get their gorgeous curls cut and coiled to perfection. He seconds the above, and recommends going a step further by finding inspirational personalities who have cuts, shapes, and curl patterns similar to your own.

Just as you're looking for a photo featuring a hair color you love, that color will work best if it's on hair belonging to a head that somewhat mimics your own. So find a photo of a person who has both qualities and get to screenshotting. Unless you're contracted for a movie role or you've spent the last year begging me to make a major color change, it's best if you stay within two levels of your natural color. This rule of thumb works because it looks better with your natural coloring and is also much easier to maintain.

If you are fair-skinned and have blue eyes and want to change up your chocolate brown, bringing in a photo of Kim Kardashian and her brown eye/olive skin combo isn't going to help anyone. Her hair color is going to look completely different on you—and not necessarily in a good way. For the best results, you want to find someone who has a similar color composition to your own.

IF ALL ELSE FAILS, BRING IN YOUR BABY PICTURE. I've explained why I'm so in love with consulting childhood photographs for true color inspiration. Sometimes you don't have to look any further than your own family photo albums to discover your perfect shade. Find a great childhood photo featuring the towheaded look you naturally sported when you were ten, or even a photo of your own child and his or her unscathed milk-chocolate shade that you envy. You can have that color, too, and the inspiration photo to help your colorist give it to you is probably already on your phone.

If you do all the homework and prep above before your appointment, not only will you get the best results possible, but your colorist will also really, really like you.

If you've spent time to get ready for your appointment, there isn't a whole lot for you to worry about once you're in the chair. But there are a few dos and don'ts that you can pay attention to so everything goes as smoothly as possible on appointment day.

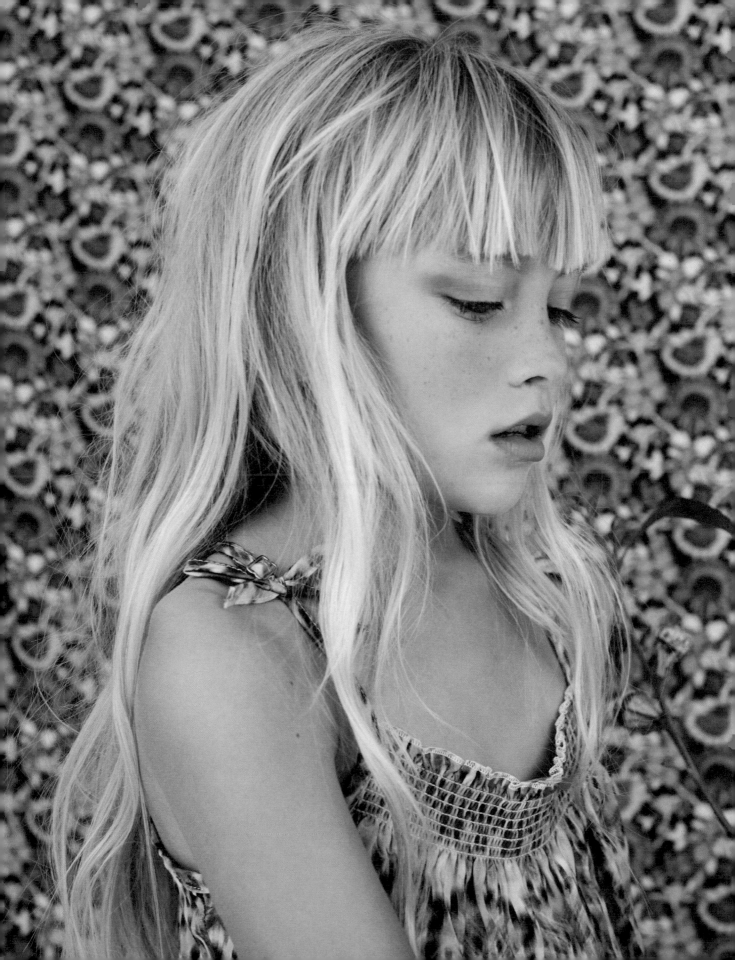

DON'T show up to your appointment with wet hair. Unless you've specifically told the receptionist to block out time for a precolor blow-dry, drying will majorly eat into your color time, and the colorist may not be able to do everything you're expecting.

DON'T come with sweaty, dirty hair straight from the gym (or straight from a week of dry shampoo). It's gross. Your hair doesn't have to be sparkling clean. Just do your treatments the night before, as described above, and shampoo before bed. Thank you in advance.

DON'T decide in the middle of your appointment that, in addition to your base, you think you might actually want to squeeze in highlights after all. Your colorist might not have time.

DO be realistic. Your hair may not be able get to the white blonde of your Deborah Harry dreams without breaking off in your colorist's hand. Even at a slightly more manageable blonde, your new shade will still require major maintenance and upkeep to ensure your hair stays healthy. This is why most of my clients have to beg me for a year to make a major change, so I know they're serious about wanting it and serious about taking care of it in a way that won't completely destroy their hair. Listen to your colorist—I've had enough nights and weekends interrupted by clients freaking out when the hair they begged me to give them starts to break, just like I said it would. And in addition to being realistic about what your hair can actually handle, you also have to be realistic about what your new shade is going to do for you. Yes, Cameron Diaz's eyes totally pop when she goes slightly darker. And while you are a gorgeous, beautiful, unique human, you very likely don't see Cameron Diaz looking back at you in the mirror. Manage your expectations so you're not disappointed when your new look doesn't yield you a $20 million movie deal. Instead of looking like a movie star, your goal should be looking like the most confident, radiant version of yourself.

Congratulations! You've done your homework, acted like a model client, and achieved the hair color of your dreams. But the process isn't over just yet. When you buy a beautiful cashmere sweater at Bergdorf Goodman, you don't throw it in the washing machine, do you? (Please, please say no.) You likely hand-wash that expensive sweater with baby shampoo, lay it flat to dry, and make sure to keep it neatly folded and stored so it looks beautiful for years to come. Pretend your new color-treated hair is a cashmere sweater and do these things after your appointment to get the most high-quality mileage out of your appointments.

SHAMPOO LESS OFTEN. The natural oils from your scalp will condition your treated hair, and if you wash too often you won't get that benefit. Try to leave a day or two in between washes, and make dry shampoo your friend for the in-betweens.

TURN DOWN THE TEMPERATURE. Super-hot water can open the cuticle of your hair shaft and allow color molecules to escape. Wash your hair in cooler, lukewarm water to prevent this from happening. In addition to the temperature of the water that you're putting on your hair, you also have to be careful of the hot tools you're using to style it. Flat irons and curling irons can fade your

color, and if you're using them without a great heat protector and on bleached hair that's already been taking a chemical beating, you're basically begging for breakage—especially if you're using them often. As the great Toronto-based hairstylist Tony Pham says, "Honey, a flat iron is a BBQ for your hair!" Which brings us to my next point . . .

TREATMENTS ARE CRUCIAL. Olaplex is truly your best friend when it comes to treatments. Yes, you need to be using a great color-safe shampoo and conditioner. And a weekly deep-conditioning treatment will go a long way in keeping your color vibrant and your strands soft. But to fight the breakage that inevitably happens when you weaken each strand by applying chemicals, you need something to bond and repair that breakage, and that something is Olaplex. I suggest slathering on the stuff once every week and letting it sit on your hair as long as you can. Throw your hair up in a bun and clean your junk drawer or read a new magazine. Just let it sit and do its thing. The company also makes a great shampoo and conditioner that contain the signature bonding treatment, so if a weekly pampering session is out of the question, these serve as a decent substitute. Using these products regularly will build up and strengthen your strands so the touch of hot tools won't be quite as catastrophic.

USE A HAIR TOWEL. I find that lightweight, specially designed hair towels not only feel better on your head and neck, but really do contribute to the health of your hair. They absorb more water than a regular bath towel, cutting down the time you need to use damaging heat to dry. Because they wick water away faster and gentler than looped terrycloth, microfiber towels also reduce frizz and breakage—a major boon for curls. You can find microfiber towels at most big-box retailers and beauty supply stores, and I particularly love the ones made by Aquis. In a pinch, an old, oversized T-shirt can be used as a towel wrap, too.

CREATING YOUR ULTIMATE COLOR CANVAS

Healthy Hair

As you've learned throughout this book, I consider your hair to be an exciting canvas just waiting to be turned into a work of art. After digesting the last chapter, hopefully you understand that your hair should be prepped before your salon appointment so you get the most bang for your buck. I can't stress that enough. But all the treatments and mild-temperature shampoos in the world can't get you ready to receive the color of your red-carpet wishes if the hair underneath it isn't in tip-top shape. And that typically starts from the inside out.

If you have a relationship with a hair professional, I'll bet that you'll agree with what I'm about to say: a hairstylist is so much more than just a hairstylist. We're therapists and life coaches; matchmakers and breakup gurus; fashion stylists and best friends—that is, the best friend who's actually honest enough to tell you when a dress looks like a potato sack and the guy begging to fly you to Ibiza for the weekend should be avoided like the plague. We go through diets together, talk about insane new workouts, and advise on the latest crazy beauty hacks you saw on TikTok. The strong connection and trust factor between a hairstylist and our clients—especially the loyal ones who feel like part of the family—is something we love. (You want to gush about a steamy date or bitch about your divorce? I'm great at listening while I highlight.) And perhaps that same trust that allows clients to feel comfortable putting their finest accessories in our hands (hands armed with scissors and molecule-altering chemicals, no less) is what makes them forget that, while we're a lot of things, we're not doctors. Like, at all.

I like to remind my clients that I went to beauty school for 1,600 hours, not Harvard Med. I don't know why you have a rash on your scalp or why your hair is falling out. I wish I could weigh in on whether or not your new antidepressant is reacting with your other medications and causing your hair growth to come to a screeching halt. And I have no idea why the hair that you are convinced has stopped growing on

your head has somehow found its way to your chin. These are all completely valid concerns, of course—especially since we can't do the kind of work we want or get the best color results if you have underlying hair and scalp issues. While I can definitely speak to issues that crop up as a direct result of coloring or share remedies that other clients say have worked for them, my Marinello School of Beauty certificate is probably not enough credential to allow me to diagnose potentially significant underlying health issues based on what's happening with your hair and scalp.

Thankfully, I know and have worked with some very smart medical doctors (some of whom actually did go to Harvard), registered dietitians, and certified hair-loss specialists, and they have graciously offered to teach me about the medical and functional sides of hair and scalp health so I can help answer some pressing questions to get your hair into the kind of fantastic shape that takes color, looks beautiful, and stays. As we pondered a few pages ago, you wouldn't start painting your walls without prepping them, and having a scalp full of strong, healthy hair is the absolute first step to achieving the color of your dreams.

So let's unpack some of the most common underlying hair and scalp issues that crop up so you can get your hair health on track and get the color you want, ASAP.

"Why is my hair thinning and falling out?"

This is the single most frequently asked question we get at the salon—especially from women. According to the *New England Journal of Medicine*, 38 percent of women will experience some form of female pattern hair loss by age seventy. But, at least according to my clients, it can be an issue for women of literally all ages. Hair loss is such a major issue that Beverly Hills–based star dermatologist Dr. Harold Lancer, who counts Beyoncé and Jennifer Lopez as clients, claims that for every fifty patients he sees per day, ten have a query about hair loss. This observation is echoed by Dr. Barbara Sturm, the world-renowned Dusseldorf-based aesthetic physician who got her doctorate in molecular orthopedics and has since developed a line of namesake products and treatments (vampire facial, anyone?) based on cellular regeneration. (She also happens to be a friend and client of mine.) Both physicians agree that hair loss—especially in women—is a hugely complex issue that can have hundreds of causes, most of which don't have a cut-and-dry "cure" or quick fix. And let's be real—if you're already experiencing hair loss, putting less-than-gentle chemicals all over it to change its color isn't going to help things and may cause hair to break, which will only make your hair loss appear worse.

So let's identify the basics so we can get your hair into the best shape of its life and ready for gorgeous color: What makes hair loss happen?

First things first: The American Centers for Disease Control and Prevention says that scalp hair grows an average of 0.34 to 0.36 millimeters per day—or one centimeter per month—with age, hair color, gender,

and ethnicity all contributing to deviations from that average. Interestingly, length also plays a part, with long hair going through more protracted growth and resting phases than short hair and therefore growing more slowly overall. As you're about to learn, there are many reasons why that already low rate may slow or, in many cases, seem to stop.

According to Dr. Sturm, there are two main types of hair loss: scarring and nonscarring. The scarring kind, in which the hair follicle is essentially destroyed and replaced with scar tissue, is much rarer and potentially more serious and permanent than the nonscarring variety. These types of scarring alopecias (the fancy scientific term for "hair loss") can happen as a result of a number of medical situations—folliculitis and lupus included. Other than bald or thinning patches of hair on the scalp and other areas of the body where hair typically grows (think eyebrows and eyelashes), there aren't a ton of across-the-board symptoms associated with scarring hair loss. Some patients experience pain, itching, and redness, and other patients experiencing no other physical symptoms (besides the missing hair) at all. These hair losses can also strike at any age.

Because these often permanent scarring alopecias account for only 3 percent of all hair-loss cases and can often be medically complex, it's best to stop Googling, mark your place in this book, and make an appointment to see your doctor ASAP if you're starting to notice patches of missing hair. Again, I'm not a doctor and definitely can't advise on your specific case, but as Doctors Lancer and Sturm have made very clear, there are many reasons your hair loss could be happening. Don't assume the worst just yet. But do know that if you happen to be diagnosed with alopecia, you have options for changing up your color. Highlights and lowlights with foil ensure that dye doesn't touch the scalp, and some formulas of dye are a bit gentler than others. After getting the all clear from your doctor, talk to your colorist so you can come up with an action plan together.

The second type of hair loss, nonscarring, is far more common and—though treatment may be tricky—can be reversible. (Yes, you can breathe that sigh of relief right about now.) As Dr. Lancer says, there are three main factors responsible for hair loss: genetics, lifestyle, and overtreatment (we'll get to lifestyle and overtreatment—my department—later).

As far as genetics go, they're often responsible for the most frequent type of pattern baldness in women: androgenetic alopecia, which can be hereditary.

Before you call your mom and grandma to show, uh, gratitude for the bald patch that may or may not be on the way (and before you forget all of the other wonderful gifts they've given you throughout your life), it's worth noting that there are underlying causes that may exacerbate this form of hair loss, even when family history plays a part. And once you identify them and work to reverse them, any responsible hair colorist will feel comfortable working on your tresses without fear of fast-tracking your issues.

Culprit #1: Hormones

"A lot has to do with hormones," says Dr. Sturm, who, as luck would have it, has spent years studying optimal scalp health as part of her company's 2019 foray into shampoo, conditioner, and scalp serum. Dr. Sturm uses laymen's terms to explain the role of testosterone, the male sex hormone that serves as the primary "androgen" in "androgenetic alopecia."

"If you have the right amount of testosterone, [the] hair situation is better," she says. (Though testosterone is thought of as a male hormone, people of all genders and sexes produce it naturally.) "And when we get older our testosterone becomes low." A cisgender woman's testosterone level peaks in her twenties and begins declining after that, reaching half of its peak levels by menopause. That's why the US National Library of Medicine's genetics information publication says that this type of hair loss happens most frequently after menopause.

Menopause isn't the only hormonal change women experience, of course. We have puberty and, for some, pregnancy and gender transition to contend with (not to mention menstruation)—all major events that transform hormone levels and can throw hair growth and quality off its game, making it harder for our hair to not only take color, but look beautiful and stay healthy afterward.

As Dr. Lancer points out, estrogen—the female sex hormone—plays a huge part when it comes to hair growth, too, and is a reason why women grow thicker, fuller hair during pregnancy, when estrogen is being produced at bonkers levels, and then experience a hair shed after giving birth, when those levels drop and normalize.

That means that some women may experience hair loss when stopping certain forms of hormonal birth control that allow estrogen to drop, while other women—especially those who have a family history of hair loss—may actually experience hair loss while taking birth control.

Just like you can find birth control with varying levels of estrogen, birth control is also available with differing levels of androgens—some low, and some high. For someone who has a family history of premature

androgenetic alopecia, a birth control method containing high levels of androgens could potentially cause hair loss (which is actually a listed side effect of birth control that most people probably overlook).

Sarah Greenfield, a Los Angeles–based registered dietitian and board-certified specialist in sports dietetics whose company, the Fearless Fig, focuses on functional digestive health, also cites polycystic ovary syndrome (or PCOS for short) as a hormone-disrupting contributor to scalp hair loss. "That's becoming more prevalent or at least better understood," she says. According to UCLA Health, PCOS is the most common hormonal abnormality among reproductive-aged women, with roughly 10 percent of that age group experiencing irregular menstruation, testosterone overproduction, and enlarged, cyst-covered ovaries.

The moral of this story? Hormone balance is very, very important when it comes to the health of your hair. And having healthy hair—your high-quality canvas—that isn't falling out at an abnormal rate is very, very important before getting your hair colored. Dr. Lancer says that hair loss of roughly 100 or so strands per day is totally normal, with 150 strands per day becoming standard during times of higher stress (we're almost at the stress part, I promise!). If it looks like there might be more than this on your pillow, in your shower drain, and in your hairbrush, and you happen to have any of the other symptoms or triggers we just talked about, get yourself to your doctor to investigate what might be happening.

Of course, not everyone who experiences these issues is losing their hair because of an underlying medical condition resulting in hormone imbalance. Guess what? We humans can be pretty terrible

to ourselves despite what our meditation apps and green juice delivery services would have us think. Which takes us to our next hair loss perpetrator.

Culprit #2: Stress, Environment, and Lifestyle

Many of you have definitely liked the "rise and grind" mantras on Instagram, read the books on how to take over the world, or made sure that everyone in your office knows that you'll totally be checking email on your honeymoon, no problem at all. But take it from this self-made girl boss who sometimes works seven days a week (even during the COVID crisis, when I was busy mixing custom colors and helping

clients virtually) and has to hop on transatlantic flights to see last-minute clients before returning later the very same day: Stress sucks. It's great when you're passionate about your career and have scheduled yourself into spin classes every day for the next month. But all the workout classes in the world aren't going to help you—or your hair—if your overscheduled, undernourished, thoroughly modern life is slowly draining you, one lost or thinning hair strand at a time. And if you're so stressed that your hair is falling out, putting bleach on it every other week isn't going to help the situation.

"I'll see sixteen-year-olds who may not have genetic predisposition to hair loss but they have to get straight As," says Dr. Lancer, who asserts that stress-related hair loss is a frequent sight at his practice. While you may not have a parent's Ivy League expectations to live up to, chances are you have your own set of work, financial, and social pressures that can cause anxiety, lack of sleep, restlessness, high blood pressure, poor digestion, headaches, and other maladies that make it hard for your body—and your beauty—to function optimally.

Our registered dietitian Sarah Greenfield says that stress isn't just caused by outside factors. It's also something that we bring upon ourselves in unexpected, internal ways.

"It's not just 'I'm perceiving my environment to be stressful' or 'I have this meeting I'm stressed out about,'" she says. "It's [also things like] not eating enough. That's stressful on the body. So if we're at a calorie deficit, and now we're working out too much, [we're going to be] stressed out." Greenfield also mentions that living in big cities—complete with all of the traffic, noise, pollution, and crowds that they bring—can be taxing on our serenity, which can translate into hair loss. And again, if you're losing your hair, you shouldn't be putting chemicals on the strands you have left until you identify the issue and try to resolve it. "We have to be so mindful of the way that we recalibrate and take a step back, because our body is showing us signs that something is off."

One of the most prevalent kinds of stress-induced hair loss, telogen effluvium (effluvium is yet another fancy science term for hair loss), happens when stress pushes hair follicles into a resting phase, and those hairs ultimately fall out as a result. The stress that causes this type of hair loss can be chronic (think a totally toxic workplace that turns you into a ball of anxiety every single day over a long period of time) or acute (a "shock" such as a breakup, death, or other situational trauma that presents itself as hair loss roughly two months after the initial upset). The good news here is that with most cases of this type of hair loss, the fallout comes as a result of new hair growth happening underneath. So while you hopefully get the proper support and help to deal with whatever's caused the hair loss in the first place, physical medical intervention is rarely required.

Greenfield also mentions stress in the context of gut health and your digestive system. "You have all these tight little cells lining your gut, and when you're stressed out, it can create more permeability. They start to swell and things can get into your bloodstream that wouldn't [normally] be there. And that's when we start to see autoimmune responses." As mentioned above, an autoimmune response can show

up as an attack on the hair follicles. So get thee to a deep-breathing workshop and bottle of essential oil, stat.

While living a calm, balanced, and downward-facing-dog life can help ensure that your locks stay thick and lustrous (and your body stays stroke- and heart attack–free), as our nutritionist noted earlier, your surroundings also play a part in what happens on your head.

A 2015 Indian study in the medical journal *Hair Therapy and Transplantation* found that particulate matter, dust, smoke, and lead in the environment can settle on the scalp and hair, leading to oxidative stress and ultimate hair loss. Indoor VOCs—the volatile organic compounds that usually have a super-strong chemical smell and fester inside as a result of freshly painted walls, new carpeting and furniture, particleboard glue, aerosol air fresheners, dry cleaning, and household cleaning products (just to name a few)—can also settle on the scalp and wreak the same havoc to the hair as the nasties lurking outside.

Does this mean that we should literally be changing our addresses to LEED-certified cabins in the woods? Not quite, says Dr. Lancer (though that daydream actually sounds pretty perfect).

"It's a toxic planet. I don't think moving somewhere is going to help you."

So, as far as your environment is concerned, what exactly will?

"Vitamin E is the royal antioxidant," Dr. Lancer says of one of the most potent anti-cell-damage supplements available. We'll get way more into vitamins and supplements soon, but in the meantime there are ways to mitigate toxins externally, too—which deserve reducing for your overall health whether you're experiencing hair issues or not:

• Try to buy mattresses, rugs, furniture, and any other big, newly manufactured products that are "low-VOC." Do your homework. Google is your friend when it comes to comparison shopping for nontoxic items.

• Get air purifiers for your home and office. According to NASA, houseplants, including the spider plant, Boston fern, English ivy, and variegated snake plant also do a remarkable job at naturally purifying indoor air (while also giving you a fun adulting goal!).

• Swap out your cleaning products for nontoxic versions. While vinegar and baking soda are the simplest and greenest ways to clean, there are a bevy of brands that contain ingredients you can actually pronounce and none of the noxious, VOC-containing toxins you want to forget. Again, do your research. Consumer Reports Greener Choices is a great resource for comparing eco-friendly cleaning products.

• If you didn't already stop using aerosol products in, like, 1993 because of the ozone layer, the time is now.

• Use acetone-free nail polish remover and polishes that are five-, seven-, or nine-free—meaning they're free of certain VOC-containing chemicals, such as formaldehyde.

Now, I fully realize that I spend my days working with chemicals. But even at MèCHE, we try to create as safe and nontoxic an environment as possible, starting with the formaldehyde-free keratin we use and the outdoor station we built to ensure that there's proper ventilation and air flow during certain treatments. We also keep air purifiers at every indoor station and wear gloves during every treatment, which studies have shown helps greatly prevent the absorption of dye compounds in the bodies of colorists. And because I do in fact work with chemical materials indoors (similar to an artist, scientist, or manufacturer), I try to be extremely mindful about reducing my VOC exposure at home by using the above methods.

Another lifestyle choice (or byproduct of other lifestyle choices) that, like stress, is responsible for more modern maladies than I can fit here is something that pretty much plagues us all: lack of sleep—something I see with a ton of my hardworking, time-zone-hopping clients.

"Sleep is huge," says our registered dietitian, Sarah Greenfield. "Sleep is when everything is turning over, even your hair." She goes on to note that hair is made of cells and our bodies undergo a daily cleansing process called autophagy—which is like our cellular waste recycling program. While autophagy happens during both waking and sleeping hours, getting quality uninterrupted sleep is part of how this process works best. So when you're not getting eight hours a night or you're passing out from partying and reducing your REM cycle as a result, you're making it harder for your body to detoxify its cell waste (remember, as much as we love our juice cleanses, our body is actually designed to detox on its own).

"You can't supplement or fix crappy sleep. You have to make time for it," Greenfield says. Another outcome of "crappy" sleep? Hormone imbalances. And like we discussed earlier, those lead to hair loss. "When we're all stressed out our adrenals can be pumping and that can throw off our cortisol which can throw off our weight which can throw off our sleep," she says. "It's not complicated. Your body is screaming at you."

Okay, but what if your doctor confirmed that your hormones are leveled, you're sleeping eight hours a night, you've stopped using plastic packaging like it's 1899, you have a meditation practice that rivals

the Dalai Lama's, and your hair *still* seems to be falling out and thinning? Don't call your colorist just yet (you can book your appointment once your hair woes have turned a corner, I promise). It's time to take a look within.

Culprit #3: Diet and Nutrition

Ah, diet. One of the most polarizing four-letter words in the English language. Most of us have struggled with something food-related at some point in our lives—whether we're eating too little of the good stuff, eating too much of the not-as-good stuff, or feeling anxious just thinking about having to plan nutritious meals for the people we list as dependents on our taxes (never mind making sure we're able to fit in a proper lunch at work). Everyone has their own unique relationship with food. And regardless of what yours happens to be, this simple cliché is generally true: You are what you eat. That rings especially true when it comes to the health of your hair.

Greenfield, who specializes in gut health and digestive issues within her private practice and has given a TEDx Talk on the subject, says that before a conversation on nutrition and diet can truly begin, it's imperative that the gut is healthy and bacteria is balanced so the nutrients you're getting from food and supplements can be properly absorbed. And guess what happens when your nutrients are being absorbed? Your hair gets really happy, and your canvas has the best shot of taking color without breaking off in my hand. Step one of eating for beauty? Get that gut in shape.

As we learned in the section on stress, our gut lining has a network of tightly packed cells designed to keep digestive particles nicely contained. But when a gut is unhealthy, that lining gets inflamed and allows toxins and digested food to leak into the bloodstream. What happens then? Inflammation within the digestive tract and beyond, with the hair follicle–attacking autoimmune responses that come with it.

Greenfield calls the gut the body's gatekeeper. So just how does she recommend getting this vital apparatus in fighting form to ensure our strands (and the rest of our bodies) are as healthy as can be?

GET DIRTY. We live in a highly sanitized world, which, Greenfield says, actually has a negative effect on our gut health: "There's such a delicate balance with bacteria that when you start to kill that off, you start to destroy other things that the body naturally does." She says that our immune system is designed to combat the nasties we're exposed to on a daily basis, so we're doing our gut bacteria a major disservice by acting like a bacteria helicopter parent with excessive hand sanitizer or mouthwash use. In addition to ditching excessive germ-killing practices (normal COVID-times hand-washing not included), she also suggests leaving the plastic packages of triple-washed spinach and frozen blueberries at the grocery store, swapping them for soil-covered farmers' market finds instead. "Any packaged vegetable is going to have a wax coating that's going to take bacteria off of it. The triple washing removes all the bacteria. And you want some dirt."

DIVERSITY IS KEY. "The more diverse your diet, the more diverse your gut. Have a red apple and a green apple and a red pepper and a yellow pepper." Greenfield says different types of phytonutrients found in whole foods that come in a variety of colors can act as a prebiotic and actually feed your gut with good bacteria. Not to mention that whole, colorful foods typically contain high amounts of fiber, which is a must for keeping digestion working correctly (in addition to that magic trick of making you feel fuller, longer). Her rule of thumb? "Just eat the rainbow."

PACK IN THE PROTEIN. FILL UP ON THE FAT. Whether you are vegan or have a freezer full of Wagyu at the ready, protein is crucial to the development of hair. Amino acids comprise the proteins that end up creating keratin, which essentially acts as our hair shaft's shield. Foods high in amino acids include lentils, pumpkin seeds, brown rice, poultry, yogurt, and buckwheat. In addition to adding more strategic proteins into your food supply, don't fear fat. "One thing I see the highest insufficiency with is omega-3s. That is a very important anti-inflammatory fat. We just don't eat enough fat in our diets." Greenfield recommends a diet that is 35 to 40 percent good-quality fat, which means fat sources that are high in omega-3 and omega-9. The standard American diet tends to give us all the omega-6s we need—which, while important, often come from less healthful sources like refined vegetable oils, dairy products, and red meat. They key is to balance out all three types of omegas with a heavy lean on 3s and 9s—groups that include avocados, salmon, hemp seeds, chia seeds, almonds, flaxseed, sardines, and walnuts.

FERMENTATION IS OUR FRIEND. The kombucha craze is not for naught, with Greenfield calling fermented foods and beverages "critical" to help build out a healthy gut microbiome and assist in breaking things down. Yes, kombucha is one way to get a dose of friendly fermentation (your beverage should be of the low-sugar variety), and sauerkraut, miso, and apple cider vinegar are other options. "It's feeding your bacteria like a fuel source."

SUPPLEMENTS ARE SUPER. Greenfield makes no secret of her love for supplements (she works for a nutrition company, after all). And when it comes to gut health specifically, she says fish oil supplements with omega-3s and pre- and probiotics, such as acidophilus, are great for keeping

bacteria balanced. She's into soil-based probiotics that are shelf stable and don't need to be refrigerated, which are perfect for traveling. "Those can actually help make space for healthier bacteria and can help rebalance." There are other supplements and vitamins designed specifically for hair health (and I'd be lying if I didn't admit to popping hair gummies on more than one occasion). We'll talk about those a little later.

The study of gut microbiome is only in recent years picking up steam, and there's a lot still to be learned. But one thing researchers do seem to understand is that each person's gut makeup is completely unique to them. Eating something that makes my blood sugar spike might not affect your blood sugar at all, so I don't want to make blanket dietary statements on what is or isn't best for you to eat—only a registered dietitian or nutritionist can learn what's happening with your body and customize a plan that's perfect for you.

Making sure you're getting proper nutrients plays a huge part in the health of your hair (and its ability to make you a colorist's dream client). And while Greenfield prefers the term "vitamin and mineral imbalance" versus "vitamin and mineral deficiency," she says that too-low levels of certain nutrients can play a major part in hair problems.

"[Hair] needs vitamin A, it needs B vitamins, it needs vitamin D to some extent," she says. That's not an invitation to load up on extra vitamin pills, potions, and powders expecting to see your mane magically transformed into Gisele's. Greenfield cautions that supplements are designed only to fill in any nutritional gaps that you have, and dwellers of developed countries with reliable access to food and water don't actually have as many of these as society would lead us to believe. Vitamin D is starting to be taken by too many people who may not need it and at levels above the American Medical Association's recommended amount—which comes with its own slew of potentially dangerous side effects. One of those side effects, according to the US Centers for Disease Control and Prevention, is—you guessed it—hair loss. Another common oversupplemented substance that occurs naturally in our food supply and can cause hair loss in high doses is selenium. Balance and education on what your own body actually needs are key.

"A really high-quality multivitamin would be a really good thing" for most, Greenfield says. But she cautions: "It's not an easy fix."

Dr. Sturm mentions iron imbalance as a potential hair growth inhibitor, and suggests asking your doctor for laboratory tests that examine iron and ferritin, an iron transporter that can contribute to hair loss when levels are low. She also calls out iodine as a mineral that, at too-low levels, can lead to thyroid problems and hair loss. Seafood, algae, and high-quality sea salt are ways to get iodine into your diet naturally. Zinc is another mineral Dr. Sturm mentions in any hair-health cocktail, with oats, legumes, and nuts being zinc-rich food options.

Dr. Lancer agrees that vitamins can be helpful to your hair when you actually need them. But he, too, cautions against jumping on the oftentimes expensive supplement bandwagon that seems to be

infiltrating every aspect of modern culture. He recommends simple prenatal vitamins for anyone grappling with hair issues—whatever their gender and whether or not they're even thinking about a baby at all—because they supply folic acid and iron, and recommends adding vitamins E and C as well.

And what about the bevy of hair gummies, biotins, and other "hair, skin, and nail" products that seem to be flooding the market as miracle growth promoters? According to a 2016 study by University of Zurich professor and dermatologist Dr. Ralph M. Trüeb, the only proven effect of taking biotin—an enzyme that's frequently marketed as a hair savior—is the correction of a biotin deficiency, a somewhat rare occurrence as we naturally produce biotin in our intestinal bacteria (another point in favor of a healthy gut).

Biotin deficiency can indeed contribute to hair loss, but only 38 percent of the women experiencing hair loss in Dr. Trüeb's study were found to have too-low levels, meaning that for the almost two-thirds of study participants who had normal levels of biotin *and* hair loss, taking extra doses didn't do anything to help them grow additional hair or thicken their tresses. Biotin deficiency can be caused by IBS or the use of antibiotics, seizure medications, or certain acne drugs (we'll look further into the role medications can play in hair loss shortly). But unlike some of the other vitamins mentioned above, taking too much biotin doesn't seem to be harmful in any way. And as Dr. Lancer likes to note, mind over matter can be a very powerful thing. "If there's no harm then there's no foul. What the hell, why not?" In other words, feel free to enjoy those hair gummies, reader. Even if they're just placebos for many users, they're still tasty!

Culprit #4: Medication and Medical Therapy

You're probably starting to notice a pattern as we get deeper into this chapter (and when you look in the mirror): What goes in your body directly affects the hair that grows out of it. And medication and medical therapies can be major players when it comes to hair woes.

It's no secret that chemotherapy drugs are toxic to living cells and cause hair loss in most patients. As you read about in the last section, one of my clients—the amazingly funny comedian and actress Jessica St. Clair—actually managed to reduce her hair loss during her breast cancer treatments in 2015 by using

cold cap therapy, a device that's thought to reduce cellular activity in hair follicles, therefore making them less attractive to chemo, which targets active, rapidly dividing cells (hello, growing hair). The FDA has cleared some newer, computer-controlled cold cap systems for use, and while this therapy won't work for everyone, Jessica still speaks positively about her experience during her salon appointments to this day (if you go back and look at her photos in section two, you'll see the full head of blonde hair I gave her before her chemo treatments).

While chemo makes hair fall out, other medications can send hair follicles into their resting phase, while yet another class inhibits hair growth altogether. These include but are not limited to:

- Blood thinners
- Antidepressants
- Lithium
- Beta-blockers
- Antiseizure medications
- Steroids
- High doses of vitamin A and retinoids for acne
- Anti-inflammatory drugs commonly used to treat arthritis

Please keep in mind, these are just a few medications that can contribute to lost or thinning hair, and I can't stress this enough: If you think you're losing your hair and medicines might be to blame, talk to your doctor before you self-diagnose or change your therapies on your own. And the great news about this type of hair loss is that it's almost always reversible.

Outside of the medications that actually cause hair to thin and fall out, there are certain therapies and surgical anesthesias that actually make it harder for your hair to hold color. As we talked about at the very beginning of this book, oxidation happens when you color hair, and oxidized hair holds a negative charge. Certain medications and surgical anesthesias hold a positive charge, and when they exit the body as sweat, the attraction can cause them to attach to hair. And I can tell you firsthand as someone who frequently sees clients soon after they've had a medical procedure: Color does not like to stick to a brick wall–style coating of anesthesia. I try to use treatments like Malibu C, which we'll talk about more in a bit, to prep my clients after they've had surgery so we can "deep clean" the hair and get it ready to hold color.

Culprit #5: Styling, Overprocessing, and Scalp Issues

I know it seems like we've gone over every conceivable reason as to why your hair could be giving you trouble (I bet you wish you'd never asked, right?). And we're almost done, I promise. But there are a few more reasons why your tresses aren't quite as awesome as you'd like. And one of them has to do with

what I do—or, better yet, what I don't do: overprocessing your hair during coloring.

While we've already established that I'm very much not a doctor, I do work with chemistry all day long and have to mix precise levels of various substances that each react with one another in a certain way to create a substance that changes the molecular structure of hair, turning it a different color in the process. It's my job to get the formulations just right so you get what you came in for, and to do so in a way that won't burn, melt, or otherwise destroy your hair into a ball of fried-out glory. Remember, we're working with chemicals—heavy ones, depending on how blonde you want to go. And it's your colorist's job to know how far to take it.

I'm still haunted by an incident when a persistent client wanted to go from blonde to brown for a movie role and didn't take my advice that her hair couldn't handle it because it was damaged and broken from so much previous coloring (she obviously didn't do any of the hair color prep we talked about at the beginning of this chapter). As we'll go over later, going brown from blonde isn't giving your hair a "break," it's depositing more color on top of hair that's already colored (if you actually want to give your hair a real rest, grow some balls and let it grow out cold turkey). In this particular client's case I was pretty adamant about not wanting to do it because I didn't think her hair could handle the change. But also because she said she wanted to go right back to blonde as soon as filming was over, something I absolutely knew her hair wouldn't be able to safely handle. Attempting to go from blonde to brown and back to blonde in a short window of time can be downright catastrophic, because it takes a lot of chemical action—on top of two previous chemical actions—to ensure the color doesn't end up looking red. I actually suggested she wear a wig, which is something I urge many of my actor clients to do so they don't destroy their hair. But she kept at it, and we very carefully got her to brown. Everyone was happy. That is, until she insisted on going right back to blonde after filming, which I again told her would be a disaster.

Let's just say the results were less than great. And by the end of the night, after a clump of hair ended up in my hand, my client was actually consoling *me* (pro tip #8,276: Stick to your guns and just say no to your client when you know it's the right thing to do, regardless of how much begging there might be). But the disastrous moment has stayed with me. Overprocessing hair is a problem, especially when you have a colorist who is more interested in making you happy in the moment than in looking out for your hair in the long term.

Dr. Lancer has a similar story about a famous patient who, after going shocking white blonde for a film role, ended up with a head of broken, jagged locks (you could call the people who bleach their hair each week—either by choice or for work—hairstyling offenders). He also cites hair extensions, braids, buns, and other tightly woven hairstyles as causing traction alopecia, hair loss that's caused by putting pressure on the hair root, restricting blood flow to the bulb, and causing follicle death.

And when it comes to curly and textured hair, which is naturally drier than straight or loosely wavy hair, overprocessing plays an even bigger role in wreaking havoc.

"Curly hair needs its elasticity healthy so it has the strength to coil," says the acclaimed stylist known as the Curl Doctor, Shai Amiel. "Once curls are [overprocessed] they lose that, causing [them] to look lifeless and limp."

Amiel says people with curly and/or textured hair—myself included!—can't really follow the same rules as straight-haired people when it comes to our color. To prevent the drying, damaging disasters that cause curls to look like frizzy blobs instead of moisturized masterpieces (one spin through his namesake Insta and you'll see what healthy curls are supposed to look like), he suggests the following:

• Avoid going too light. If you have to use bleach, you're most likely going to sacrifice your curls at least a little.
• Follow your color service with an Olaplex treatment in conjunction with a very hydrating mask.
• Wear your hair natural to allow your curls to spring back. Wearing it straight or in a tight bun causes stress and reduces a curl's ability to coil.

Regardless of hair texture, the scalp also plays a huge part in the health of the hair that comes out of it, something Dr. Sturm has been studying at a molecular level for years.

"We take care of our facial skin, we take care of our body skin, but who takes care of the skin where our hair grows? There's so much that goes on your scalp," Dr. Sturm says. She mentions all the styling products and cleansing shampoos we use and the fact that we don't put sunscreen on our scalp as some of the abuses this vital part of the body endures. "There are people who have psoriasis on their scalp. The scalp can be dry. Ingredients in products can create inflammatory environments. There are lots of things going on with the scalp that no one thinks about."

Dr. Sturm, who has developed scalp serum, shampoo, and conditioner specifically designed with scalp health

in mind, says that all these issues can lead to a loss of hair quality. She says to be mindful of ingredients and, when it comes to choosing products and supplements, to think of your face: "If it's good for your facial skin, then it's good for your scalp as well."

Shrankhla Holcek is the founder of Uma Oils, a line of really beautiful essential hair, face, and body oils that we carry at MèCHE. She comes from a very long line of royal Ayurvedic physicians in India and grew up on the same one-hundred-acre farmland estate on the rural outskirts of New Delhi where her family's crop of botanicals helps supply the likes of Tom Ford and Estée Lauder. More than eight hundred years developing hundreds if not thousands of essential oil blend recipes for the royal family and the kingdom have unearthed 350 concoctions devoted to hair.

She mentions lemon juice as a natural dandruff eliminator. "Literally cut up a lemon, squeeze it into your hair, rub it [onto] your scalp. Three washes and all the dandruff will be gone."

As far as essential oils that help promote scalp health go, she says basil oil is clarifying and helps stimulate blood flow to the scalp, while grapefruit oil is another extract that will get your blood pumping and help your hair follicles along the way. Since essential oils are super concentrated and potent and can cause reactions if applied directly to your skin and scalp, it's best to dilute yours with a carrier oil—jojoba, sweet almond, avocado, and rose hip are just a few of the many plant-based options that exist.

But not every natural prescription is quite as sweet.

"This is going to sound gross, but onion juice is really good to apply to your scalp for hair thickness. Onion has growth stimulant properties [and] helps the follicle lock in stronger to the root, so you experience less hair fall and, because of the stimulating properties, more thickness."

Holcek suggests putting an onion through a food processor and wrapping the mush in a muslin cloth. Tie it up and squeeze out a few teaspoons, which can then be applied directly on the scalp. She says the scent goes away after about twelve hours, and it usually requires two separate washing sessions to get things smelling, uh, not like onions anymore (those sweeter essential oils also serve as a fragrant post-treatment pick me up). "I'd apply a concoction like that on a Monday night that you're staying in. But these treatments go very, very far in restoring hair."

For added effectiveness, she says that hair oil followed by steam helps with blood flow to the scalp and opens the hair follicle, allowing nutrients to be better absorbed.

"Steam is not something that everyone can do. So an option would be really soaking up a towel in hot water and then just wrapping your hair with it."

Missy Peterson, the global education and artistic director of hair wellness company Malibu C, agrees on the benefits of clarifying and deep cleaning the scalp, citing hard water and mineral buildup as something that can actually clog follicles. The same Malibu C line of products that I use to preserve blondes amid mineral-heavy, discoloring water conditions can also be used to remove calcium and mineral buildup from the scalp and make it easier for hair to grow.

But don't let the many potential causes of poor hair health freak you out. Pay attention to your body, and, as with anything else that might be going on apart from your scalp and follicles, if you have a gut feeling that something might be off, go see your doctor and get to the bottom of it sooner rather than later.

In the meantime, Peterson has a great and simple trick that she uses when sleuthing the causes of her client's hair loss: "What are your fingernails doing? . . . If the hair and your nails are misbehaving at the same time, that means [it's] systemic—something going on internally and you need to talk to your doctor. If your nails are fine and your hair is not, then we need to figure out what you're putting on your hair that's causing it."

If you've tried almost everything and want a topical solution to address your hair loss, I highly recommend Harklinikken, a Denmark-based line of products specifically developed to address hair loss and thinning at the scalp level. The company's founder, research scientist Lars Skjoeth, expanded his global network of flagship clinics to Los Angeles in 2020 (right down the street from my salon). And I couldn't be more excited to consider the company my neighbor, as I can attest firsthand to seeing the system work to create fuller hair for a ton of my clients.

THERE'S SOMETHING IN THE WATER

It's obvious by now that hair loss and thinning are vast, elaborately entangled problems. And while MèCHE clients are incredibly concerned with the quality and condition of their hair (and ways to optimize both of those things), we also get a ton of clients who are upset that the gorgeous color they just paid a lot of money to get isn't living up to its potential. Highlight fading, brassiness, and green-haired blondes are some of the most common complaints (which occasionally lead to accusatory rants directed at a colorist who—I swear—didn't change your formula). But guess what? These "color mishaps" aren't actually color mishaps at all. They almost always have something to do with a thing that we all interact with every single day: water.

I'm sure you've heard the terms "hard water" and "soft water." Plainly put, hard water happens when water contains calcium and magnesium, which are naturally occurring, nontoxic materials. This type of water is classified based on just how many parts per million of these minerals are actually in water, with very hard water containing the most minerals, and soft water containing the least. The "harder" the water, the harder it is for soap to lather (hence the name "hard water") and you'll often times find white film and spots on your shower door, bathtub, drain openings, dishes, and yes—your hair.

Water hardness and softness have nothing to do with its quality. The World Health Organization even says that the minerals in hard drinking water may contribute positively to our daily dietary needs. But while hard water isn't "dirty" or bad to drink, it definitely leaves its mark on your hair.

"The reason the minerals stick to the hair is because there's a magnetic charge. Minerals have a positive charge, the hair that's been oxidized (dyed) has a negative charge. So it's like putting magnets together," explains Peterson. "Opposites attract. Water can't break that bond; shampoo can't either. You need something that's going to break the magnetic bond so the minerals can be taken out."

What breaks the bond? A cholating compound called disodium EDTA, which Olaplex chemist Eric Pressley describes as "a small molecule that makes a cage around the [mineral], makes it soluble, and pulls it off the hair."

The Malibu C line of products contains this magic ingredient. And everyone at MèCHE—myself included—is obsessed with the company's line because it not only makes it easier for hair to take color, it also solves the problem of unintended fades and changes because of minerals, medications, and other oxidative changes. Thankfully, while these changes can look jarring—especially after you've spent hours in a stylist's chair getting to your ideal shade—it's more of a chemistry trick than a permanent color transformation, and changing the chemical makeup between the minerals and your hair can get your color back to where it was in no time.

Peterson blames four minerals for wreaking visual havoc on hair: calcium, magnesium, iron, and copper.

Calcium makes hair appear darker. "When people say, 'My highlights faded,' that's why," Peterson explains.

Magnesium combines with calcium to create that limescale that makes a shower squeegee your bathroom's best friend. Peterson says that when limescale sticks to your hair, it affects more than your color: "It's not just the look, it's going to change [your hair's] texture too."

Iron, which is more often found in rural well water than city water, is what makes hair appear brassy.

And copper—a very common material used in the pipes throughout your house—oxidizes and builds up in the hair shaft, turning beautiful sun-kissed locks green. And contrary to popular belief, chlorine itself isn't what turns blonde hair a sickly shade after a swim. In that case, once again, it's the oxidation that does the damage. "[The chlorine] literally oxidizes the hair so the minerals are able to get into the hair, and the chlorine also oxidizes the mineral," Peterson says. She also has a trick for remembering which mineral is to blame for the green effect: "Think of the Statue of Liberty. What is it made out of? Copper. What color is it? Green."

You'll be able to see color changes and, in cases of very hard water, may even feel mineral buildup on your hair. And if you're a frequent traveler like I am (or have ever moved counties, states, or countries), you'll know that your hair can look and feel different depending on where in the world you happen to be. That's not because you're jet-lagged. That's because of the water.

"When I travel, the first thing I do is look at the drain in the bathtub and in the sink. If there's discoloration there, that tells me how my hair is going to behave," Peterson says, explaining how her colorist students from Phoenix, Arizona, to Flint, Michigan, each have to formulate their hair colors differently because the mineral makeup of the water is so vastly different in every place.

According to the US Geological Survey, parts of New England, the Pacific Northwest, South Atlantic-Gulf states, and Hawaii have the softest water. Streams in Texas, New Mexico, Kansas, Arizona, and parts of Southern California tend to have some of the hardest waters in the country. Again, this doesn't mean "good" or "bad" water, it simply means that there are different ways of dealing with your hair depending on where you might be.

Before you start buying dry shampoo in bulk or start showering in Evian, know that you have options for keeping color-messing water minerals at bay.

FIRST STEP: TEST THE WATERS. Water testing strips specifically designed to test the hardness of your home water supply exist and can easily be found online. (Malibu C happens to make this test, too.) Peterson suggests running a test and letting your colorist know the results so he or she can make a note on your color card and better gauge the necessary frequency of your mineral-removing treatments and how long they need to stay on your head to do their thing. If you have hard water and wash your hair every day, you'll need more frequent and longer treatments than someone who has soft water and only shampoos once a week.

FILTERS ARE OUR FRIENDS. From Target to Home Depot to the local hardware store down the street, the world is full of showerhead filters specifically designed to reduce hard water. Buy one. Those looking for something more tricked-out can opt for a whole-house reverse-osmosis or water-softening system, which are more expensive but will help protect your appliances from mineral buildup, too.

TREAT YOURSELF. Peterson recommends doing a Malibu C Crystal Gel treatment once every four months, which essentially opens your hair cuticle and allows the gunk to be removed to leave a blank canvas for coloring. There are other companies who make similar products—German beauty company Urban Alchemy has a Signature Cleanse that I discovered on a recent trip to Munich—so ask your colorist what they use in their salon and opt in. In between your coloring appointments or after a swim you can also use a product like the Malibu C weekly treatment to give things a tune-up.

While water is the main culprit in altering hair color, there are a few other seemingly simple, everyday items that can mess with it, too—or, rather, with your hair's ability to accept it. And like the anesthesia we discussed in the last section that makes it harder for color to "stick," these are all things that can be fixed and prevented by changing up the chemically induced charge of your hair.

COSMETICS AND SKINCARE PRODUCTS. If you use a mineral powder or a mineral-based sunscreen, the same charge that draws calcium from water to your hair is drawing your beauty products there, too. And Peterson describes mineral-based skincare as a "brick wall" for hair color. "Especially when you're going in and lightening, once you activate your bleach and the oxidation starts happening your bleach is spending all of its energy knocking on this brick wall. So the stylist is struggling trying to get it right. We'll push the limits—we'll go under the dryer, do multiple applications, but the fact of the matter is if you would just take the minerals out of the way [the bleach] would do exactly what it's supposed to." Malibu C makes a color-prep treatment that you can do at home the night before your color appointment, tearing down that wall of ineffectiveness.

HEADPHONES AND ACCESSORIES. Do you wear metal sunglasses on top of your head? What about nice headphones with metal parts or metal hair clips? When dyed hair sits on top of metal, it breaks. (Beauty school 101: Don't mix bleach in metal bowls because the ions will change.) If you spend a lot of time outdoors and put your ponytail through a metal hat backing, beware.

THE DREADED
B-WORD:
"BREAKAGE"

If everything you've read in this section thus far hasn't yet made you want to move to Mars, where hormone-disrupting pollution, mineral-festooned water, and the nutritionless standard American diet can't get you, great! We still have more ground to cover.

While I already told you that the question we most often get asked at MèCHE has to do with hair loss, we also get a ton of inquiries concerning my least-favorite B-word in the English language: "breakage." Mainly, how to prevent it.

It's not that weird to think about your hair breaking from all of the things you put on it, dye and bleach very much included. Let's get real—while we've made great technological strides in hair treatments and we're not *quite* using the Jean Harlow cocktail of Clorox bleach anymore, we're not exactly using good vibes and lavender oil, either. Between the chemicals that can weaken the hair shaft, environmental factors, hard water, and hot tools such as flat irons, which I'm sure a lot of you use every day, it's kind of a miracle that any of us have hair on our heads at all. (But don't we feel so amazing when we're loving our hair? Double-edged sword, I know.)

Regardless of whether you're a deep brunette who's been bleaching her hair since high school or you occasionally get just a few amber highlights to brighten your natural deep chocolate hue, breakage happens.

Human hair is mostly made out of keratin, a fibrous protein that relies on chemical bonds to stitch its proteins together. Those bonds, which are known as disulfide bridges, are what gives hair its strength. But when we do all of the things we do to get the amazing hair that makes us feel like rock stars, we

can break those bonds and weaken our hair. Hair dye contains ammonia, which works by lifting the hair cuticle so dye molecules can penetrate and allow peroxide to oxidize your existing color proteins, making room for the new color molecules to take their place. Depending on what color you're trying to achieve, your natural hue, and the chemistry of the formula we're using, we'll leave the dye on your head for a certain amount of time. The longer we have to leave this coloring concoction on your head, the longer your cuticle stays open. And since a smooth, closed cuticle makes for the strongest hair—well, you can do the math.

If you've ever sat in your colorist's chair and talked about whether or not your hair can "handle" the change you're hoping to achieve, you probably already know what I'm about to say: That "handling" part has to do with the current condition of your hair and what kind of chemical processing lies underneath what you want to do. In other words, if you're opening and closing that cuticle every other week because you're a natural brunette who would rather be a platinum blonde, your hair isn't going to be in top fighting form. Even if you're taking care of your color with conditioner and treatments, you still have to do something to keep your disulfide bridge bonds intact. Otherwise, even the most moisturized hair is at risk of a catastrophic crumble—especially if you're seeing a colorist who doesn't mind coloring over damage. (Pro tip #1,956: See a stylist who is honest and wants to make you happy in the long run by leaving you with healthy, beautiful hair—not someone who always says yes just to make you happy in the moment. That's how people end up with a sink full of broken hair.)

And I have to say again that if you think dyeing your platinum locks brown for a few months will give your hair a "break," I have a news flash: That brown dye we use opens your hair cuticle in the same way as bleach (and in fact contains higher levels of PPD, the petroleum-based chemical that allows permanent hair dyes to permeate the hair shaft and work as well as they do). If your hair is chemically fried, putting additional color on top of that damage isn't going to do it any favors. The only true way to take a true color break is to stop coloring your hair. That's not to say that we can't make miracles happen in certain instances. I see a lot of clients that come through the doors of MèCHE begging for help because they've had their hair broken to oblivion by someone at a different salon who was super sure their hair could handle another round of bleach.

There are a few ways you can minimize and prevent breakage, and I could fill many pages telling you to sleep on a silk pillowcase and be religious about conditioning and stop overwashing your hair. And you should do all of those things! But above all else, the one thing that has completely changed the game in my eyes as far as hair condition goes is Olaplex, the hair bond builder you've already heard me (and my clients) mention ad nauseam throughout this book.

Before Olaplex officially launched, I got a call from my friend Lona Vigi, who had worked with Dean Christal, a beauty-industry entrepreneur, on his last product line. He had just created a product designed to make color-treated hair strong enough to handle perms and was in need of a colorist who'd be willing to test it, since it had never before been tested on hair color. He had tracked down UCSB

chemistry professor Craig Hawker to help him with his project, and he, along with one of his former PhD students, ended up creating a formula that rebuilds broken hair proteins from within the shaft.

I've seen so many snake-oil hair products during my career—ones that promise "shine" by doing nothing more than coating the hair with goo; "organic" hair dyes that have the exact same chemicals found in standard hair dye—so I was skeptical when my friend called me and asked if I'd be willing to meet with Dean and Craig to help them develop the best way to use Olaplex for hair color. There was a lot of tweaking involved—when we used too much product, it worked so well that the hair bonds that typically break to allow color and bleach to deposit didn't break at all! Once we got the formula right, I was ready to try it on clients. I didn't expect much the first time I used the Olaplex treatment on my client Angie Featherstone, who was desperate to go blonder but whose hair was damaged and broken from coloring it for a movie role. We put the Olaplex treatment on her, left her under a dryer, and reexamined her hair, which looked to be much more intact than thirty minutes before. I was still skeptical. So I mixed some Olaplex in with the bleach. And instead of having broken pieces of hair, my client was lighter than before with a head full of strong, flyaway-free strands. I tried the treatment on other clients just to make sure it wasn't too good to be true. And then I called Dean and practically begged him to send me every last drop of the stuff his genius chemists were concocting.

These days I'm an Olaplex ambassador, because I'm seriously obsessed with the results. Sometimes a client's hair is so broken that it can't be bleached, even with Olaplex. And I always honestly tell my clients when I think this is the case. But I've also seen Olaplex work miracles—especially on clients who need quick and drastic color changes for movie roles.

You've already read some of my recommendations on how to use Olaplex before your coloring appointment because I've been shouting them from the rooftops throughout this book. But as a refresher, I love using the Olaplex No. 3 Hair Perfector as a weekly thirty-minute mask at home. Use it on dry hair (or, if you have a ton of hair, you can dampen beforehand). I know people who sleep in it and work out in it, too. Afterward, shampoo. Olaplex is going to strengthen your hair, not condition it. If you feel like you need to soften your hair, use Olaplex No. 5 and leave it on for fifteen minutes after your strengthening treatment. If your salon carries Olaplex products, ask your stylist what they think about getting an in-salon treatment and what the frequency should be. You can also ask if they're adding Olaplex to your hair color formulation, which I do for all of my clients. I promise that the results (and the compliments you'll get on your healthy hair) will speak for themselves.

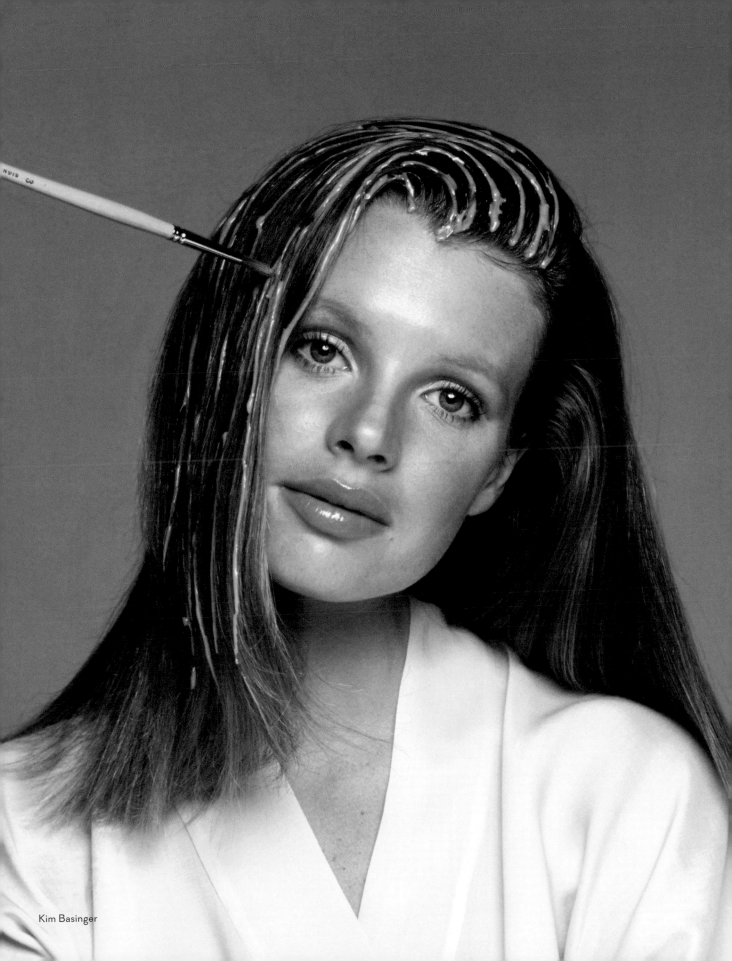

Kim Basinger

SO YOU WANT TO BE A COLORIST

In addition to running my salon and meeting my clients wherever they are for house calls (or on-set or yacht calls, depending on the time of year), there's another aspect of my work and my business that's incredibly meaningful and important: education and training. I work as an ambassador and celebrity colorist for both Redken and Olaplex, which means I create educational videos and travel around the world teaching master classes on product use and techniques so other colorists can learn and grow in their own careers. Teaching and meeting stylists and colorists is one of my absolute favorite parts of my job because I love swapping stories and learning from them, too. And though I know it might not seem like my day-to-day reality has much in common with that of, say, an independent salon owner based in Kansas City, we still face many of the same challenges that come with working on dozens of unique heads every day.

One of the reasons I love Instagram so much is because it's a way for me to connect with all of the colorists I meet during these classes and also allows me to interact with ones who weren't able to physically be there. I literally get hundreds of DMs and pings asking me questions—sometimes super-specific ones about client formulas, which I'm almost always happy to share—about exactly what goes into my work. In addition to fielding correspondence from colorists all over the world, I also hear from a ton of aspiring colorists asking how they can have a thriving client book and business one day, too. I love helping these new colorists find their way. And that's why this has been my favorite chapter to write in this book.

As I mentioned at the beginning, I've been into hair since I was a kid. I was always super into doing my friends' hair, happened to sweep up in a salon after school as a teenager, and to this day remain inspired by the *Charlie's Angels* locks I saw on TV when I was growing up. But beyond always knowing that hair was something I loved and just happened to be good at dealing with, I never imagined or planned that I'd make my dream career out of it. Hair was my hobby. So obviously I never even thought about going to beauty school.

You likely remember me mentioning that my entrance into the beauty business was a bit, uh, *untraditional*, with my first big L.A. job working as Bette Midler's nanny. And you probably also remember me saying that Bette ever so graciously put me through beauty school. Bette had always been there for

me (as I mentioned earlier, she was even my Lamaze coach when I was pregnant with Max), but having someone whom I truly wanted to make proud believe in me enough to invest in my education was unlike anything I'd ever experienced before (pro tip #2,983: Find someone who is smart enough to believe in you and hold on to them very, very tight).

I quickly discovered that beauty schools aren't dissimilar from four-year universities, in that they all seem to have reputations and stereotypes with corresponding price tags to match. At that time, you had your Yale—Vidal Sassoon—which came with a hefty twenty-five-thousand-dollar tuition. And then you had the Marinello School of Beauty—very much not Yale. Like, at all. But Marinello was close to home and happened to have the least expensive tuition of the programs I found. And as someone who still struggles with her self-esteem and can feel super uncomfortable accepting gifts, I decided that taking the least amount of money from Bette made me feel the most responsible.

COLORIST CAREER LESSON #1:
It Doesn't Matter Where You Go to Beauty School

Another thing you already know: I didn't love beauty school (that's putting it mildly). Even as a kid, school was never my thing. I'd complain to anyone who would listen at Estilo as often as I possibly could about how I wanted to drop out. But as I told you at the beginning of this book, my mentor Robert Ramos pleaded with me to stick it out. And it wasn't until a little bit later that I realized the true importance of beauty school: to learn just enough to pass the state licensing test so you can get an assisting job with a stylist who you *actually* want to learn from. The salon is where the real education happens.

Today, whenever someone asks me for advice on finding a beauty school program, I tell them to do a program that's affordable, because it's not the name of your school but what you learn as a salon assistant that really makes or breaks your career. Getting an assisting job at a top-tier salon is incredibly cutthroat and competitive, but it's not like applying to be an associate at McKinsey. No one cares where you went to school, I promise. There's no transcript we're looking at, no thesis paper to mull over, and certainly no alumni network that's going to do your dad a solid and find you a summer spot in the mailroom. We care about your skills as an assistant—a very different skill set from the ones acquired at even the fanciest and most expensive of beauty schools (more on that in a second). I'll say it again: Beauty school exists to prepare you to take a licensing exam with your state Department of Consumer Affairs (or whichever government department handles cosmetology and barbering licensing where you'll be working). That license lets you assist and work on clients. The assisting is where you'll learn, network, and—if you're good—eventually get a spot on the floor so you can start building your client base and make money. If you want to spend thirty thousand dollars on a beauty school education, go for it. But my advice is to find a program that you can afford so you're not in debt afterward and paying off school loans as you're trying to build a career.

As for my own beauty school experience, I listened to Robert Ramos and reluctantly stuck it out so I could get the 1,600 hours of training I'd need to get licensed to work. I was miserable in school, but I had my eye on the prize. Soon I was ready to find an assisting job.

COLORIST CAREER LESSON #2:
Be the Best Assistant Who Ever Lived

W magazine wasn't kidding when it called Art Luna the hottest hairstylist in Hollywood. Art was an incredibly strict teacher and mentor (he even made everyone wear a uniform because he didn't like the outfits his staff would put together on their own), and he expected greatness from everyone who worked for him—me, his assistant, very much included. A lot of people couldn't take it, but having such a tough boss really made me stronger. Even at a buzzy celebrity-filled salon, assisting a stylist isn't a glamorous job. You work ridiculously long hours, have to greet clients with a smile even when you're having the worst day ever, and get stuck sweeping up piles of hair. You're expected to get whatever your stylist needs— lunch, coffee, a different hairbrush, money for the parking meter, even cigarettes—the second they need it, all while making sure their station is spotless for each arriving client. Thirteen hours on your feet, six days a week. Or, if your salon is flexible with your schedule, you might be working multiple jobs to make ends meet. You might get yelled at by stressed-out stylists. Clients might be nasty and rude to you because you're "just" the assistant. It's not for the faint of heart.

Before you make a career U-turn and decide you want to teach English after all, let me just say that this real talk isn't meant to deter you from pursuing a career in hair. Quite the opposite. I just want you to be ready for what it's going to take to get where you want to go. You have to *really* want it and not be able to imagine yourself doing anything but this, because it's going to be hard. Sometimes so hard you'll wonder what would ever prompt you to get into it in the first place. And you can't give up or take that smile off your face or show up late for work because you stayed late the night before and are exhausted. You have to be curious and not only want to learn but ask to be taught. I'll repeat it again: You have to want to be a hairstylist so badly that you can feel it in your bones. Because only then will you be the kind of kick-ass assistant that will allow you to have a truly great career.

On top of really wanting it, being an amazing assistant who gets hired over the other people vying to assist (and there will be plenty of others) requires a few other nonnegotiables: You have to have an unwavering work ethic with no trace of arrogance or a bad attitude, be curious and excited to learn, and demonstrate that you genuinely have the ability to make a stylist's life easier. Make yourself absolutely indispensable. When I was an assistant, I would write down personal notes about each client on their color cards so my bosses knew someone's favorite drink, where they just went on vacation, and who was going through a divorce and might need a little extra TLC. Those details are what will make you stand

out. Show that you're reliable, accommodating, and able to think on your feet to solve problems. Be productive, especially when you think you have downtime. You're not there to make friends with the clients, but you are there to be friendly and personable so they feel welcome and comfortable from the second they walk through the salon door. Be communicative with your stylist and ask them how they want and need you to work so you can be the most helpful to them. Ask for feedback and don't take criticism personally but use it as an opportunity to grow and be better at your job. I'm saying this again because it is *so important*: Use criticism as an opportunity to grow and be better at your job!

No matter what line of work you're in, it can be really hard to receive critical feedback. It's never fun to hear that your blowout made your client look like a very old lady, or get a talking-to from your boss because the highlights you just posted on Instagram look kind of terrible. These are only crappy moments if you make the feedback personal and walk away dejectedly without turning them into learning opportunities. Ask your boss why they thought your blowout looked like your great-grandma Yetta's wig and how you can do it differently to get a better result next time. Dive deeper into the Instagram highlights. Did they not work because of your hair technique, or do you need better light in your photo? What does your boss think you can do better—on both fronts—for next time? As a boss who loves her assistants, I can tell you that it's not always easy for me to give critical feedback, either. I hate even the remotest possibility that I might be hurting someone's feelings. But I know that the best thing I can do is be honest when I think there is room for improvement, so my assistants learn and keep growing. Your boss and other people you respect might be too shy to give you unsolicited feedback, so you should always ask for it if you genuinely want to keep getting better.

Of course, before you can show a salon that you're the answer to their prayers, you have to actually find your opportunity.

It may not seem like it in the age of Instagram, but the way I found my assisting job in 1995 still works today, whether you live in Los Angeles or Lacon, Illinois (population 1,781): good, old-fashioned research. Do your homework on the salons in your area and figure out which ones have the kind of talent that you think will teach you to be the kind of stylist you want to be. If you're not super familiar with which salons have good reputations, look for client reviews on Yelp and Facebook and do a quick Google search to see if they've received any press in local newspapers or magazines. Are you dying to work on editorial photo shoots in addition to working with clients in the salon? Read the staff bios on a salon's website to learn about the résumé highlights various stylists have. If there are people working there who seem to have career points that align with your goals, you know that you'll be able to network with and learn from specific colleagues, which could be a huge help in your future.

Once you find a salon you'd love to work with, literally call and ask if they have an assisting program. Some actually have formal programs designed to mentor aspiring hairstylists while others don't. Regardless, non-annoying persistence will be key—keep calling until you find someone who needs help. If no

one does when you call, ask when they expect to need someone and make sure you follow up. If you're able to financially, ask them if they'd be open to letting you shadow someone as an unpaid apprentice for a period of time. Send thank-you notes to everyone you meet with as soon as your meetings are over and say specifically why you want to work with them.

Matt Rez was sent away the first time he tried to get a job at MèCHE because we didn't have a job to give him. But Matt's dream was to work with us, and he wasn't going to give up after the first no. So he waited outside the salon for six hours just to introduce himself to me and my partner, Neil. It was a little crazy, but after we met him and realized his talent (not to mention his persistence and willingness to get the job done), we figured out how to make space. Matt is now a full-fledged, full-time colorist at MèCHE and counts Eiza González, Lili Reinhart, and The Blonde Salad helmer Chiara Ferragni as clients.

I'm not suggesting that sitting outside of a salon for six hours is the best way you get yourself hired (in some situations it may even get you arrested). My point is this: Pick up the phone, ask the questions, send the emails, and keep going until you land somewhere that you think will really teach you how to be the stylist you want to be. You have to be persistent, and you have to show them that you want it.

One thing I always tell my assistants is, "I hope you're watching me and thinking you can do it better." And I actually truly mean that! Because when I was an assistant, I would watch and pay attention to the stylists and that's what I thought. Not because I was full of myself, but because I thought about ways I could improve and build upon someone's process. It's important to really pay attention to the way other people work. You'll get ideas and learn tips and tricks that you can incorporate into your own practice, and you'll also realize how not to do something, which is a major lesson in itself.

Art and Sheri, the other stylist at Art Luna who I was assisting, decided to take Saturdays off. Instead of joining them, I decided that Saturday would be the day I would go in and practice my skills on models. It was while I was busy working my ass off that Art noticed it was time for me to start seeing clients on the floor.

COLORIST CAREER LESSON #3:
Strategically Create Your Own Destiny

Once you prove that you're insanely good at being an assistant and show the maturity, confidence, and promise of someone who can handle clients on their own, it will be time for your own spot on the salon floor. This can happen a few ways. It can either be offered to you as a natural next step and reward for a job well done, you can ask the salon owner to give you a chance, or, assuming there's no room for you at your current salon, you can look for a stylist job elsewhere. I feel super grateful that Art saw promise in me and offered me a spot on his floor (despite the fact that I was terrified!), where he gave me an amazing group of clients, including Portia de Rossi (during *Ally McBeal*'s heyday) and Renée Zellweger,

both of whom are MèCHE clients today. I realize this kind of kindness and opportunity doesn't happen to everyone every day, which is why—and I can't stress this enough, even if it means repeating myself fifty times—it's so, so important to be a good assistant, which I was. I loved everything about being on the floor at Art's salon. Working there is what really allowed me to understand how to develop my own working style and client book, and I learned the importance of creating a salon vibe with music and atmosphere—something that would come in handy years later when I opened MèCHE.

Now, everyone's version of destiny looks different. For me, I was super lucky to work at a great salon where the owner and staff worked to build me up, train me, and give me clients. But there were definitely times when I worried about my ability to build my book and make ends meet. Being an assistant is a more stable, steady job, in that you have set hours you're being paid to work and you get tips, which for a young mother like me at the time was crucial. When you're on the floor of a salon, you're working on commission—assuming you have clients to work on. Again, I was lucky that I had clients off the bat who helped me get even more clients through word of mouth. But there were days at the beginning when I had only one or two clients per day. And the fear was real.

After a few years of really honing my craft, I finally had the confidence and restlessness that signaled it was time for a new challenge. And this is where "create your own destiny" comes in.

I am a firm believer that you don't get what you don't ask for. And at this point, I knew I wanted to make moves. So I called Sally Hershberger at John Frieda, one of the buzziest salons on both coasts at the time (remember Meg Ryan's famous shag? Sally is who she got it from), and asked them for a job. I thought that because I was coming from the hottest salon in L.A. and had a quickly growing celebrity client list, they were going to be thrilled to give me a job. Not so much. Only after I proved my value by putting together a list of my celebrity clients (which, by this point, also included cool fashion designers like Rozae Nichols and the late L'Wren Scott) was I offered three days a week at the salon—including Monday, the salon equivalent of TV's "death slot" in the pre-Netflix days.

Now, this is where the "strategy" begins.

I could have easily been arrogant and rude, not taking the job and letting them know that I would find a salon that already knew I was better than a mere three days a week. But I knew that Sally Hershberger at John Frieda—which was quickly gaining a reputation as *the* place to go for hair color among the clientele I worked with—was an opportunity that would allow me to continue the upward trajectory of my career. So I sucked it up and graciously accepted my Monday time on the floor. Knowing how busy I was at Art Luna, I was strategic in asking for some flexibility should any of my A-listers need appointments on different days of the week, which I knew would happen immediately. I had people asking for me every single day, and salon management saw me become so busy that I very quickly outgrew my Monday slot. I was in the salon working not only Mondays but four other very busy days of the week, too, in no time.

Matt, the now–MèCHE colorist who sat outside for six hours in hopes of landing an assisting job, had a similar situation in that we didn't have room for him to work on the days he'd hoped for. But he, too, graciously took what we had and worked his ass off building a client list that soon made it impossible for us not to notice that he needed more days at the salon.

COLORIST CAREER LESSON #4: *Build Your Buzz*

You need buzz to get big. I personally didn't get successful through the Internet because it didn't exist when I was just starting out in the mid-1990s; I got successful through word of mouth, client referrals, and organic press. And in the age of Instagram, it's easy to think that you can spin up a handle, hashtag like crazy, and be the next Jen Atkin. Guess what? It doesn't quite work that way. Social media is a very important and incredible marketing tool when you use it correctly (more on that soon). But guess what again? There are other ways to market your services outside of social media, and some of them might actually be a better fit for the types of clients you want to be serving. Whether you're the queen of Beautycon or haven't checked your email since last week, there are so many different ways to market yourself—which is a vital component to building your career. Here are a few ways to do it:

WRITE A CLIENT MISSION STATEMENT. Like any good project—your career included—you can't get to where you want to be if you don't have a very clear picture of what your destination looks like. Nothing could be truer when it comes to the kinds of clients you want to be cultivating. Do you live in a college town and hope to serve students and professors? Do you live in New York and want to work backstage at fashion shoots? Are you in a large Midwestern city and think you can make a name for yourself doing wedding-day hair? Get really clear on who you want to work with so you can come up with a strategic plan of attack to find them and get them in your chair.

Sometimes the clients that will actually really help build your business won't be the most obvious choices, either. I notice a lot of up-and-coming stylists who are incredibly excited to work with the newest It Girls and latest Instagram models. But I suggest building a clientele from a diverse age group. The clients who will best sustain you financially are the ones who are going to be loyal and not jump ship at the first opportunity to see someone who has more Instagram followers than you. You also want to make sure you have clients who can afford to continue to see you on a regular basis, a group that typically includes people who aren't just starting off in their careers. I've also found that my clients in their fifties, sixties, seventies, and eighties have given MèCHE the most referrals, sending in children, grandchildren, and friends who have the means to see us every few months for color. These types of clients will give you stability and be the ones who actually book back in—the number one marker of a successful hairstylist. And who doesn't want that?

YOU DON'T NEED A PUBLICIST TO GET PRESS. I didn't have a publicist when I was starting out, and my first big piece of press happened to happen naturally in the form of an *Allure* maga-

zine directory inclusion for "Best Blowout" a few years in a row. Sure, if you don't work at celebrity salon in New York, L.A., or London, the chances of a Condé Nast editor walking in the door "just because" are slim to none. But that's okay. Do your research and make a list of local magazines, websites, and influencers who might need your services. Is the local dining magazine doing a shoot that could use a hairstylist on set? Does a local newscaster need a personal hairstylist to help them before events (and, if they already work with one, do they need an understudy)? Would a local blogger be willing to write about you and your services in exchange for new highlights? Get creative and, if you can, don't be afraid to work for free or for the cost of products. Those free gigs will very often lead you to the ones that pay. And when you're busy and have things happening (e.g., a salon opening) that warrant some help, you can decide if hiring a publicist to assist you with promotion is right for you.

FOLLOW THE EYEBALLS. Think about the behavior of the clientele you want. Are they sitting at the veterinarian's office waiting for an appointment? Getting a manicure at a nearby nail salon? Shopping at the coolest boutique in town? Waiting for a table at a popular restaurant? Make old-fashioned flyers or business cards and offer management a treatment discount if they'll help promote you. Too lo-fi for you? Use your Instagram grid as your flyer art. Another great lo-fi way to attract eyeballs? Offer your most popular friends and family a free or discounted treatment for every three referrals they bring you. Within no time you'll have your very own marketing army helping you spread the word.

USE INSTAGRAM THE RIGHT WAY. I'm not going to get too deep into the specifics of the 'gram game here (though I'll show you some examples of good hair pictures soon), because you guys probably know the ins and outs of audience growth better than I do. There's the obvious: Tag every person, place, and thing you're posting, and make sure you're posting to both your grid and Stories on a regular basis. But the best piece of advice I can offer is this: The hair you're posting is the product you're selling. You need to feature it as such. Show clear, bright photos that unmistakably showcase the hair and use your caption to explain what you did to get it that way so your audience begins to think of you as a trusted hair expert. Show before and after photos so they understand the magic you're capable of making. And make sure the receptionist at your salon knows your handle and is giving it out to new clients who call looking for a stylist. Whether you have sixty followers or sixty thousand, your Instagram is your portfolio. So even if your follower count seems stuck and you don't have the budget for a proper digital marketing growth campaign, you should still treat your account like it's the most popular one in the world. Plan your grid and participate in the community. This is where people will see what you're made of, and if all you have are dark, dingy photos of your breakfast, no one is going to want you to touch their hair. And while weekend getaways, selfies, and boyfriends all make for adorable photos (and juicy stories to tell in the salon), those aren't the shots that bring clients in. If you need a handle that's just for professional pursuits, go forth.

Remember, once you get your clients, the real work starts—you have to keep them. You might be the most talented hairstylist who ever lived. But if you're not genuinely interested in forging a connection and relationship with your clients, you'll find yourself wondering why they stop coming back. It's so important to not spend the entire appointment talking about yourself. You have to show that you actually care about the person in your chair—when I was an assistant, I made client cheat sheets with fun facts about people's families, trips, love lives, and jobs for my bosses, so they had an easier time having a real, meaningful conversation in the midst of seeing thirty-five other people a day. You can't really teach emotional intelligence or how to act interested in another human being if someone genuinely isn't. Just know that I've seen so many talented stylists not be able to make it because they didn't have that special spirit that made people want to spend hours with them multiple times a year.

COLORIST CAREER LESSON #5: *Don't Screw It Up*

Once things are under way and you're working in your dream salon with a solid clientele streaming through, you're done and can just bask in your success, right? Hell, no! I see so many stylists screw it all up so badly that I wanted to share a few tips in hopes that you'll make different choices that truly lead you to a long, stable, successful career.

DON'T ACT LIKE A MOVIE STAR. Even if you spend all day touching their hair (or the hair of other VIPs, or just people who act like them), you must realize very early on that you are not your clients. You are not their peer. You work for them. If you realize and understand this very early on and remain grounded and in love with what you're doing, you probably won't max out your credit card to buy a Tesla even though you can only afford to rent a studio apartment outside of town. If you stay humble and present, live within your means, and remain true to who you really are, it's much less likely that you'll spend your days comparing yourself to your clients and trying to replicate their lifestyle—something I can honestly tell you just doesn't work. It's amazing that you work for them! You're great at a job that you love, and people rely on you to help them feel good. Enjoy that and build a life for you, not for other people who you're trying to keep up with.

GET YOUR SHIT TOGETHER LIKE AN ADULT. Hairstylists often work as contractors, which means we don't get 401(k) accounts, health insurance, or taxes taken out of our paychecks. So no, the ten thousand dollars you made last month isn't pure cash that you can spend on a TikTok-worthy vacation. Take out a slice of the pie for your health care (even if you're twenty-two and healthy and don't want to spend five hundred dollars a month on an insurance plan you think you'll never use), consult a financial advisor about how to put money aside for retirement, and save some money to pay your quarterly taxes. Trust me, you don't want to wake up one day and realize you owe the IRS hundreds of thousands in back taxes.

SAVE YOUR MONEY. Once you start gaining buzz and traction in your career, you'll start getting opportunities outside of the salon. These include but are not limited to: wedding and event work,

endorsement deals, teaching opportunities, product lines with your name attached, investment deals, book deals, and so forth. My rule has always been very simple: Any money I make outside of the salon goes right into savings. And when the time comes to buy a house or send your child to college and you wish you had rich parents to help you, you'll realize that the money you saved from your outside work is actually the trust fund you never had. I actually play a game with my assistants (this is totally true!) where I ask them what their version of "success" specifically looks like. How much do they want to spend on their first condo? What kind of car do they want to buy? Then we look up state and federal tax calculators, figure out what their mortgage is on that dream condo and what kind of property tax they'll expect to pay, and subtract it all from their pay. Once they see what's left over, they can figure out what they need to save to make it come to life (and they usually knock a zero or two off that fantasy pad, quick).

WORK TO BUILD THE LIFE YOU *ACTUALLY* WANT, NOT THE ONE YOU THINK YOU SHOULD. When I'm teaching a colorist master class and a fellow colorist comes up to me afterward to ask about the "secrets of my success," I always tell them the same thing: Don't ask about my success. My career looks glamorous and interesting on Instagram and in magazines. And while I am grateful for every second of it, I have also given up any semblance of a normal life to have it. Instead of letting my career inspire yours in a realistic way, you should find a salon owner or stylist who has the things that you actually, truly want in life (a family, your own business, a lake house and the time to enjoy it), and ask them for their secrets. Learn from and emulate not only the people you respect, but those who have the kind of success that looks like the success you want. You can still be a great colorist and get home by 6:00 p.m. for dinner with your family every night, if that's what happiness looks like to you.

COLORIST CAREER LESSON #6:
When It's Time to Become a Boss

We've gone over the basics of how I personally think you have the best shot of becoming the colorist you always wanted to be. I know a lot of you probably have other dreams and plans that likely involve a name of your choosing hanging on the door of your very own salon. And that's great! You should always be thinking big and going after your dreams. But—fair warning—owning a salon is no joke. Not only is it an incredible amount of work—a lot of which involves skill sets far, far beyond beauty school—but it also has to be timed to the right moment in your career to make sense. This section isn't meant to crush your dreams (I genuinely hope you DM me from your salon's Instagram next year and show me how amazing you're doing!), it's more about being realistic so you don't end up with a million-dollar loan you can't pay back and a group of employees who are suing you for nonpayment.

For me, opening MèCHE, my Beverly Hills salon, in 2012 really boiled down to timing. I had already spent my career working at five different salons, each of which benefited from the buzz generated by my celebrity clientele. I felt ready, for once, to put myself on the map. But my divine timing didn't come from my gut check; it came from the state of my finances. As you've likely gathered, I like to have my shit together and have all my adulting buttoned up. And in the year before opening MèCHE, I realized that all of my prudent saving and planning had allowed me to get to a place where I was able to build a salon without taking out a loan, something that was really important for me as a new small business owner: not starting with debt.

Once I realized I was in the right place financially to open my salon, my friend and colleague Tyle reminded me that Neil Weisberg was also ready for his next thing. I was excited to work with Neil because he not only had business experience and had already owned salons, he was also a hairdresser and therefore had both the understanding of and the passion for the business we'd be building— something that I think is absolutely mandatory when finding an actual partner, instead of merely someone who is willing to write you a check.

Once we found a location we loved, Neil and I each put up $250,000 of our own money to gut the space and redo it. But as I quickly learned, opening a business comes with surprises. And remodeling a commercial building in Beverly Hills is not the HGTV fairy tale I imagined it to be. We were $500,000 short, and despite my financial preparedness, we realized we needed a loan after all.

I was really lucky in that I banked with a small, family-owned institution that believed in me and my vision for MèCHE instead of a large, commercial bank. And that personal relationship is a huge reason we were able to secure our loan and finish the space. But opening a salon is so much more than picking out bathroom tiles. As we got closer to opening, I realized just how expensive it is to run your own salon (hint: very). You need a bookkeeper, a CPA for taxes, a manager to run everything, housekeepers to keep everything tidy and wash towels every day, a front-desk staff, assistants, flowers, beverages for the clients, lawyers, and, of course, supplies. I'll say it again: It is *so expensive* to run a salon.

I'm so happy that I own MèCHE, even though we've had our ups and downs. But as I said earlier and can't say enough, it's really hard work. Cutting hair is the easiest part; firing employees and actually keeping the lights on are much, much harder. I'm lucky that I have a business partner who oversees our day-to-day operations, which isn't my sweet spot (oftentimes I don't even know which clients are scheduled until I get to work in the morning and my wonderful team lets me know). Because Neil and our team keep things running like a well-oiled machine, I get to focus on doing what I love. (Neil will tell you about all the sleep he loses because he's so stressed about running the operations.) So I always tell anyone who wants to open a business that they have to treat it like a marriage: Enter into it for the right reasons (no, being able to post your new logo on Instagram is not a good reason) and have implicit trust with your team and your partners.

I will also say this: I don't think everyone should open a salon. I don't care how busy you are. Just because you're busy does *not* mean you should open your own salon. On top of all of the things I just mentioned, you have to get stylists for your salon and add marketing and press and social media to your to-do list so you actually build a client book. Then you have to keep training your staff and your stylists to be the best that they can so those clients keep coming back. All of these things take strategic thinking, time, and money (so much money). You have to really know that your destiny is to be a salon owner and either figure out how to do these things for your business, or have the resources to outsource them to people who know how to do them better than you.

Having millions of Instagram followers does not mean you should open your own salon (Jen Atkin, who as of this writing has 3.6 million Instagram followers, her own global agency, Mane Addicts content studio, and a bestselling product line called Ouai, doesn't have her own salon). Feeling like you need more time to hone your skills as a hairdresser away from your "day job" working for someone else does not mean you should open your own salon. And again, being really busy where you currently are doesn't mean you should open your own salon. It might. But it could also mean that your packed schedule and burgeoning stellar reputation mean that it's the perfect time to explore ambassador deals with hair product companies and look into teaching opportunities that bring you even more recognition, opportunity, and income. There are many paths to bosshood—not all of which require a building lease.

Another thing Neil and I both feel very strongly about is this: Don't have a salon if you're not going to be there. I know your Instagram is full of stylists posting from private planes and Paris Fashion Week hotel rooms and other glamorous, exotic locales. But the truth is that no one is going to care about your salon as much as you. You might have the best manager in the entire world who feels like family, and they *still* will not care about the business you have poured your life savings and dreams into as much as you. My travel has picked up over the last few years, but I try to be at MèCHE as much as I possibly can. Not only do I love being there, because in my heart I am and always will be a salon worker, but also, when an owner is at their salon, it's busy. That's dozens of clients coming through the door to see you every day, which—brace yourself for this insider confession—is much more lucrative than spending twelve hours on a fancy magazine shoot set or spending two days to travel across the world to see a client (though I'm always happy to see my faraway clients when they call!). If you are one of the 99 percent of stylists who work outside of London, Los Angeles, or New York and you want to build a strong, solid business, you should plan to be in the salon you own.

INSTAGRAM 101:
This Is How You Take a Hair Picture

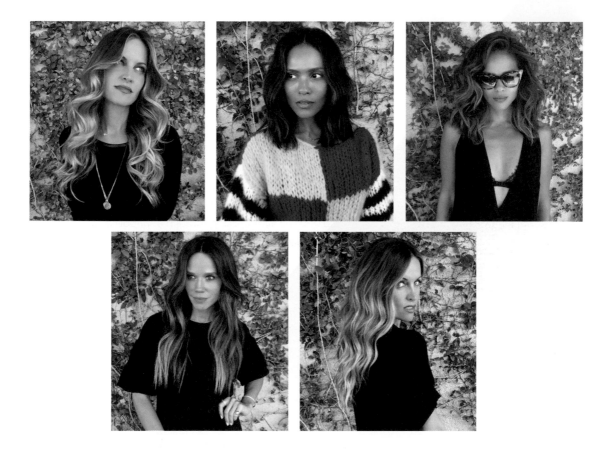

I don't need to tell you this, but I will anyway: a good social media game can change your life, and what I'm about to share with you proves why. Back in 2014, a hairstylist named Chris Greene from the small Canadian province of Newfoundland was following me and a bunch of the MèCHE staff on Instagram. He commented on one of my posts, and when I took a deep dive into his feed, I saw a ton of really amazing, clear hair photos that showcased his strong work. So I followed him back, we commented back and forth, and I told him that if he was ever in L.A. he should stop into the salon and say hi. Within a few weeks, Chris "just happened" to be in L.A., and soon he was interviewing for a job at the salon. My business partner, Neil, was skeptical—we don't usually hire stylists who haven't assisted with us. But at the end of the day, Neil was introducing Chris to our manager, and she screamed with excitement: "You're @ChrisGreeneHair! I love your Instagram!"

The rest, as they say, is hairstyling history. Chris has always taken his Insta incredibly seriously, building a portfolio of work that actually showcases his most valuable product: beautiful hair. And those beautiful hair photos that communicate your vibe and your talent are what get you clients. But I can't stress this enough: You have to start by posting hair photos that don't look like shit. Thankfully, Chris—who is still one of the busiest stylists at MèCHE today—shared his pro tips for getting the best shot:

CLEAN YOUR PHONE LENS. Simple but true!

MAKE YOUR CLIENT FEEL REALLY COMFORTABLE. Be warm and inviting and let them know that you think they look great.

GOOD LIGHT IS EVERYTHING. For me, perfect light is indirect natural light—something that softly diffuses the image. Don't put your subject in a direct sunbeam, but rather bathe them in a nice wash of sun—think light coming through a window or bouncing off a wall.

STICK TO WHAT WORKS. It can be hard to find a spot with perfect light, so when you do, make it your "thing." Continuity of background is a really good way to build a visual identity, and people will start to recognize your background in their feed.

WHEN IT COMES TO THE HAIR, THE MORE THE MERRIER. Don't hide strands behind ears— show everything off, bring it all to the front (or the back or side, depending on the photo), and let the world see your work!

TREAT IT LIKE A PHOTO SHOOT. Bring a wide-tooth comb and hairspray for flyaways. Take it seriously.

RELY ON YOUR WORK, NOT A FILTER. If you edit or saturate your photos too heavily, you'll have to break that news to clients when they tell you they want the look you posted last week. Be truthful in your photos so you can actually deliver.

NOW GO FORTH AND COLOR!

I know we've covered *a lot* of ground since page one. So what does it all mean? For starters, I want you to know that this book—the writing of which has been a years-long dream that I still can't believe is finally real—is designed for *you*. Sure, it's given me an opportunity to look back at some of my favorite career moments with clients who, after decades together, feel like family. It's allowed me the chance to learn everything from how I, too, can be kinder to my body so my hair looks its best to the specific chemical makeup of Olaplex and why it actually works. And looking through all of the incredible childhood photos that my clients sent to me and corresponding with new hair friends through Instagram over the last couple of years has been more fun than I can adequately say. But above all, the very best part of writing this book is that it's given me the hope that I've created something you can actually use in your own life.

It is my sincere wish that you feel compelled to dog-ear your favorite inspiration photos and show them to your colorist next time you're in the salon. I want you to understand why the hair color you had as a child can be such a beautiful, natural-looking option that's basically a perfect match for your adult skin tone and eye color. I'd love for you to be kind to yourself and make sure that you're getting enough sleep, eating healthy, nutritious food, and taking care of your health so your hair is the most gorgeous it can be when you're ready for your next color treatment. And on behalf of every professional colorist everywhere, I want you to master the art of properly preparing your hair for a coloring appointment so we can have the best chance of making you feel (and look!) incredible when you leave our chairs. There is no

greater reward for a hair colorist than knowing we've helped someone feel their best, and all of the pre- and between-appointment prep work I've outlined in this book will help you on your way to ensuring that happens.

I want you to have finished this book knowing that no matter what your hair color, texture, shape, pattern, density, or length, you are unique and beautiful—which is why I urge you to call your mom, dig back in your photo albums, and remember what your hair looked like as a kid. You were made perfectly. And while we colorists are happy when you're happy—regardless of what color you want—I hope that this book helps you embrace and celebrate your own specialness (even if that specialness means throwing out the color altogether and letting your natural silver shine!).

Last but certainly not least, I hope that anyone who loves hair as much as I did when I was a kid in Seattle watching *Charlie's Angels* (and still do as an adult watching HGTV) knows that they really can have a successful career as a colorist. If you want it badly enough, are curious to learn, and are willing to put in the hard work and dedication, you'll get there. Be patient, keep going, and don't forget to keep doing hair.

Thank you for coming on this journey with me. Hair is a powerful, magical thing, and I'm so grateful I got to share my love and respect for it with you.

SELECTED SOURCES
AND FURTHER READING

HAIR COLOR 101

Mukkanna, K. S., N. M. Stone, and J. R. Ingram. "Para-phenylenediamine allergy: current perspectives on diagnosis and management." *Journal of Asthma and Allergy* (January 18, 2017). https://doi.org/10.2147/JAA.S90265.

Esposito, Lisa. "Are You Allergic to Hair Dye?" *U.S. News & World Report*, May 15, 2017. https://health.usnews.com/health-care/patient-advice/articles/2017-05-15/are-you-allergic-to-hair-dye.

Amay, Joane. "How to Figure Out Your Curl Type." *Allure*, April 8, 2020. https://www.allure.com/gallery/curl-hair-type-guide.

Guenard, Rebecca. "Colour to dye for: how much do we really know about the risks of colouring our hair?" *New Statesman*, December 16, 2014. https://www.newstatesman.com/lifestyle/2014/12/colour-dye-how-much-do-we-really-know-about-risks-colouring-our-hair.

Sherrow, Victoria. *Encyclopedia of Hair: A Cultural History* (Westport, CT: Greenwood Publishing Group, 2006).

Robins, Gay. "Hair and the Construction of Identity in Ancient Egypt, c. 1480-1350 B.C." *Journal of the American Research Center in Egypt* (1999). https://www.jstor.org/stable/40000202.

Walter, P., E. Welcomme, P. Hallégot, N. J. Zaluzec, C. Deeb, J. Castaing, P. Veyssière, R. Bréniaux, J. L. Lévêque, and G. Tsoucaris. "Early Use of PbS Nanotechnology for an Ancient Hair Dyeing Formula." *Nano Letters* (2006). https://doi.org/10.1021/nl061493u.

Sherrow, Victoria. *For Appearance' Sake: The Encyclopedia of Good Looks, Beauty, and Grooming* (Westport, CT: Greenwood Publishing Group, 2001).

Resnick, Brian. "William Henry Perkin: how an 18-year-old accidentally discovered the first synthetic dye." *Vox*, March 12, 2018. https://www.vox.com/science-and-health/2018/3/12/17109258/sir-william-henry-perkin-google-doodle-birthday-180-mauveine-purple-dye.

Hefford, Bob. "Colour and controversy." Chemistry World, October 2, 2012. https://www.chemistryworld.com/opinion/colour-and-controversy/5479.article.

"Allergy to hair-dye 'increasing.'" BBC News. http://news.bbc.co.uk/2/hi/health/6319875.stm.

Sancton, Tom. "The Titan Who Founded L'Oréal Prospered Under the Nazis." *Smithsonian Magazine*, September 7, 2017. https://www.smithsonianmag.com/history/titan-who-founded-loreal-built-his-brand-shoulders-nazis-180964805/.

Orci, Taylor. "The Original 'Blonde Bombshell' Used Actual Bleach on Her Head." *The Atlantic*, February 22, 2014. https://www.theatlantic.com/health/archive/2013/02/the-original-blonde-bombshell-used-actual-bleach-on-her-head/273333/.

Pristin, Terry. "Joan Bove, Who Helped Found Clairol, Is Dead at 99." *The New York Times*, July 23, 2001. https://www.nytimes.com/2001/07/23/nyregion/joan-bove-who-helped-found-clairol-is-dead-at-99.html.

"Our Story." Clairol Professional. https://www.clairolpro.com/inside-clairol-pro/index.

"Advertising: She Does." *Time*. http://content.time.com/time/magazine/article/0,9171,899732,00.html.

Thomas, Robert McG. Jr. "Shirley Polykoff, 90, Ad Writer Whose Query Colored a Nation." *The New York Times*, June 8, 1998. https://www.nytimes.com/1998/06/08/nyregion/shirley-polykoff-90-ad-writer-whose-query-colored-a-nation.html.

"Because You're Worth It." L'Oréal. https://www.lorealparisusa.com/about-loreal-paris/because-youre-worth-it.aspx.

Bibby, Patricia. "Gonna Wash That Manic Right Into My Hair." *San Francisco Chronicle*, August 8, 1996. https://www.sfgate.com/entertainment/article/Gonna-Wash-That-Manic-Right-Into-My-Hair-2971118.php.

Wallace, Alicia. "Walmart CEO says we're in the 'hair color' phase of panic buying." CNN Business, April 11, 2020. https://www.cnn.com/2020/04/11/business/panic-buying-walmart-hair-color-coronavirus/index.html.

Bailey, A. D., G. Zhang, and B. P. Murphy. "Comparison of Damage to Human Hair Fibers Caused by Monoethanolamine- and Ammonia-Based Hair Colorants." *Journal of Cosmetic Science* (2014). https://pubmed.ncbi.nlm.nih.gov/24602818/.

Ngan, V., J. Gomez, MD, A. Oakley, MD. "Allergy to paraphenylenediamine." DermNet NZ, August 2018. https://dermnetnz.org/topics/allergy-to-paraphenylenediamine/.

Scheman, Andrew, Christina Cha, and Manpreet Bhinder. "Alternative Hair-Dye Products for Persons Allergic to para-Phenylenediamine." *Dermatitis* (2011). https://www.researchgate.net/publication/51513962_Alternative_Hair-Dye_Products_for_Persons_Allergic_to_para-Phenylenediamine.

Al-Suwaidi, A. and H. Ahmed. "Determination of para-Phenylenediamine (PPD) in Henna in the United Arab Emirates." *International Journal of Environmental Research and Public Health* (2010). https://www.ncbi.nlm.nih.gov/pmc/articles/PMC2872353/.

"We Asked Women Across the Country All About Their Hair." *InStyle*. https://www.instyle.com/beauty/splitting-hairs-survey-american-women-and-hair.

TRUE COLOR PRECISION

Shapiro, Jerry, MD. "Hair Loss in Women." *The New England Journal of Medicine* (October 18, 2007). https://www.nejm.org/doi/full/10.1056/NEJMcp072110.

Baratz, Robert, MD, PhD, DDS. "Hair Analysis Panel Discussion: Section 2.4." Agency for Toxic Substances & Disease Registry, 2001. https://www.atsdr.cdc.gov/hac/hair_analysis/2.4.html.

Filbrandt, R., N. Rufaut, L. Jones, and R. Sinclair. "Primary cicatricial alopecia: diagnosis and treatment." *CMAJ* (2013). https://doi.org/10.1503/cmaj.111570.

Sillani, C., Z. Bin, Z. Ying, C. Zeming, Y. Jian, and Z. Xingqi. "Effective treatment of folliculitis decalvans using selected antimicrobial agents." *International Journal of Trichology* (2010). https://doi.org/10.4103/0974-7753.66908.

"Hair loss and lupus." Lupus Foundation of America. https://www.lupus.org/resources/hair-loss-and-lupus.

"Types of Hair Loss." NYU Langone Health. https://nyulangone.org/conditions/hair-loss/types.

"Cicatricial Alopecia." National Organization for Rare Disorders. https://rarediseases.org/rare-diseases/cicatricial-alopecia/.

Birch, M. P., S. C. Lalla, and A. G. Messenger. "Female pattern hair loss." *Clinical and Experimental Dermatology* (2002). https://doi.org/10.1046/j.1365-2230.2002.01085.x.

"Changes in Hormone Levels." The North American Menopause Society. https://www.menopause.org/for-women/sexual-health-menopause-online/changes-at-midlife/changes-in-hormone-levels#.

Quinn, M., K. Shinkai, L. Pasch, L. Kuzmich, M. Cedars, and H. Huddleston. "Prevalence of Androgenic Alopecia in Patients with Polycystic Ovary Syndrome and Characterization of Associated Clinical and Biochemical Features." *Fertil Steril* (2014). https://pubmed.ncbi.nlm.nih.gov/24534277/.

Lea, Laura. "Hair Loss: What Is Female Pattern Baldness?" BBC News, June 1, 2017. https://www.bbc.co.uk/news/uk-40118058.

Kumar, P., N. Magon. "Hormones in Pregnancy." *Nigerian Medical Journal* (2012). https://doi.org/10.4103/0300-1652.107549.

Oswaks, Molly. "Birth Control Made My Hair Fall Out, and I'm Not the Only One." *Daily Beast*, October 7, 2019. https://www.thedailybeast.com/birth-control-made-my-hair-fall-out-and-im-not-the-only-one.

"Polycystic Ovary Syndrome (PCOS)." UCLA Health. http://obgyn.ucla.edu/pcos.

"Stress management." Mayo Clinic. https://www.mayoclinic.org/healthy-lifestyle/stress-management/in-depth /stress-symptoms/art-20050987.

Hall-Flavin, Daniel K., MD. "Can Stress Cause Hair Loss?" Mayo Clinic, April 5, 2019. https://www.mayoclinic.org/healthy -lifestyle/stress-management/expert-answers/stress-and-hair-loss/faq-20057820.

"Telogen effluvium hair loss." American Osteopathic College of Dermatology. https://www.aocd.org/page/telogeneffluviumha.

Rajput, R. "Understanding Hair Loss due to Air Pollution and the Approach to Management." *Hair Therapy & Transplantation* (2015). https://www.omicsonline.org/open-access/understanding-hair-loss-due-to-air-pollution-and-the-approach-to -management-2167-0951-1000133.php?aid=47705.

Pinola, Melanie. "This Graphic Shows the Best Air-Cleaning Plants, According to NASA." Lifehacker, May 20, 2015. https://lifehacker.com/this-graphic-shows-the-best-air-cleaning-plants-accord-1705307836.

Ebrahim, I. O., C. M. Shapiro, A. J. Williams, and P. B. Fenwick. "Alcohol and Sleep I: Effects on Normal Sleep." *Alcoholism: Clinical & Experimental Research* (2013). doi:10.1111/acer.12006.

Campos, Marcelo, MD. "Leaky gut: What is it, and what does it mean for you?" Harvard Health Blog, September 22, 2017. https://www.health.harvard.edu/blog/leaky-gut-what-is-it-and-what-does-it-mean-for-you-2017092212451.

Goluch-Koniuszy, Z. S. "Nutrition of women with hair loss problem during the period of menopause." *Menopause Review* (2016). https://doi.org/10.5114/pm.2016.58776.

Levy, Jillian, CHHC. "How to Balance Omega 3 6 9 Fatty Acids." *Dr. Axe*, January 27, 2019. https://draxe.com/how-to -balance-omega-3-6-9-fatty-acids/.

"Taking Too Much Vitamin-D Can Cloud Its Benefits and Create Health Risks." Harvard Women's Health Watch. https://www.health.harvard.edu/staying-healthy/taking-too-much-vitamin-d-can-cloud-its-benefits-and-create-health-risks.

Park, S. Y., S. Y. Na, J. H. Kim, S. Cho, and J. H. Lee. "Iron Plays a Certain Role in Patterned Hair Loss." *Journal of Korean Medical Science* (2013). https://doi.org/10.3346/jkms.2013.28.6.934.

"Cooling Caps (Scalp Hypothermia) to Reduce Hair Loss." American Cancer Society. https://www.cancer.org/treatment /treatments-and-side-effects/physical-side-effects/hair-loss/cold-caps.html.

Humphries, Courtney. "Why do certain drugs cause hair loss, and it is reversible?" *Boston Globe*, October 20, 2014. https://www.bostonglobe.com/lifestyle/health-wellness/2014/10/19/why-certain-drugs-cause-hair-loss-and-reversible /t624qwGJ6cDmwEvPTGiCbK/story.html.

"Drug Induced Hair Loss." American Hair Loss Association. https://www.americanhairloss.org/drug_induced_hair_loss/.

"Science of Curly Hair." Redken. https://www.redken.ca/en-ca/education/hair-principles-and-fundamentals /hair-principles-and-fundamentals/curl-principles/science-of-curly-hair.

"Scale Deposits." Water Quality Association. https://www.wqa.org/learn-about-water/perceptible-issues/scale-deposits.

Sengupta, P. "Potential Health Impacts of Hard Water." *International Journal of Preventive Medicine* (2013). https://www.ncbi.nlm.nih.gov/pmc/articles/PMC3775162/.

"Water Properties Information by Topic." United States Geological Survey. https://water.usgs.gov/owq/hardness-alkalinity .html#hardness.

Price, Michael. "Want to Cure Your Hair's Split Ends? Try Washing Them with Wheat Gluten." *Science*, February 6, 2018. https://www.sciencemag.org/news/2018/02/want-cure-your-hair-s-split-ends-try-washing-them-wheat-gluten.

PHOTOGRAPH CREDITS

page 5: Bobby Doherty; 10–11: Walt Disney Television/© ABC/Getty Images (Charlie's Angels); Universal Pictures/Album/Alamy (Ringwald); courtesy of April Strunk (prom); courtesy of Tracey Cunningham (remaining); 12: Michael Ochs Archives/Getty Images (Blondie brunette); Brian McLaughlin/Michael Ochs Archives/Getty Images (Blondie blonde); 15: Ron Galella/Ron Galella Collection via Getty Images (Tracey/Bette); courtesy of Tracey Cunningham (remaining); 16: Matt Winkelmeyer/Getty Images for Sheri Bodell (Tracey & friends at bottom center); courtesy of Tracey Cunningham (remaining); 18: Rich Polk/Getty Images for Marie Claire (Tracey & Biel); Marion Curtis/Starpix/Shutterstock (Tracey & Lily Aldridge); 19: Brian Bowen Smith for The Hollywood Reporter via MRC Media LLC; 20–23: courtesy of Tracey Cunningham; 29: Universal History Archive/UIG/Getty Images (wig); Tom Grundy/Alamy (rock); 30–31: DeAgostini/Getty Images (washing); Alfio Scisetti/Alamy(flower); Mary Evans Picture Library (Elizabeth); SSPL/Getty Images (Sulfuric Acid); 32–33: Hulton Archive/Getty Images (Monroe); François Bibal/Gamma-Rapho/Getty Images (L'Oreal factory); Keystone/Getty Images (Harlow); The Advertising Archives (ad); 34–35: Harry Langdon/Getty Images; Mario Casilli/mptvimages.com (Shepard); Michel Delsol/Getty Images (Manic Panic); Tim Roney/Getty Images (Ginger Spice); 36–37: Carlos Lopez for Tracey Cunningham (two hair product pics); courtesy of Tracey Cunningham (remaining); 39: Francesco Scavullo/Condé Nast via Getty Images; 44 (l–r): Michael Buckner/WireImage/Getty Images; Jeffrey Mayer/Alamy; Steve Bukley/Alamy; Steve Granitz/WireImage/Getty Images; Francis Specker/Alamy, Color Chameleons (Stone); Frazer Harrison/Getty Images; Taylor Hill/FilmMagic/Getty Images; Vera Anderson/WireImage/Getty Images; Mark Sullivan/WireImage/Getty Images; Allstar Picture Library Ltd/Alamy (Bennett); 46–47 (l–r): Aaron Rapoport/Corbis via Getty Images; Michael Tran/FilmMagic/Getty Images; Allstar Picture Library Ltd/Alamy; Paul Morigi/Getty Images for Netflix; Jamie Rose/Getty Images (McPhee); Dia Dipasupil/Getty Images for Entertainment Weekly; Arthur Elgort/Conde Nast/Contour by Getty Images; Gregory Pace/BEI/Shutterstock; JB Lacroix/WireImage/Getty Images; Stephane Cardinale/Corbis via Getty Images (Keough); AA Film Archive/Alamy; Broadimage/Shutterstock; Jon Kopaloff/FilmMagic/Getty Images; J. Vespa/WireImage/Getty Images; Steve Granitz/WireImage/Getty Images (Paulson); 50–51: Emma McIntyre/BAFTA LA/Contour by Getty Images (Erivo); Nancy Barr Brandon/MediaPunch/Shutterstock (Parton); Alamy (Madonna); mptvimages.com (Shepard); Harry Langdon/Getty Images (Locklear); Silver Screen Collection/Getty Images (Kelly); Arthur Elgort/Conde Nast via Getty Images (Hansen); Daniela Federici/Corbis via Getty Images (Smith); Bradley Smith/Corbis via Getty Images (Andress); Aleksandra Jankovic/Stocksy/Adobe Stock (blue sky background); Janifest/Adobe Stock (black gate); People Images/Getty Images (dark gray background); 52–53: Douglas Kirkland/Corbis via Getty Images (Ladd); Bruce Glikas/FilmMagic/Getty Images (Cox); Edward Berthelot/Getty Images (Park); Walter Carone/Paris Match via Getty Images (Deneuve); Walt Disney Television/© ABC/Getty Images (Sommers); Michael Brennan/Getty Images (Harry); Shutterstock (Dunaway); Jeffrey Markowitz/Sygma via Getty Images (Clinton); Addictive Creatives/Stocksy/Adobe Stock (yellow shirt); Yuriyzhuravov/Adobe Stock (hair covering face); Philipp Nemenz/Cultura/Getty Images (blue shirt); 54–55: (row 1, l–r) Patrick Wittmann/Getty Images; courtesy of Julie Walker; Svetlana Shchemeleva/Stocksy/Adobe; Vadim Cepik/EyeEm/Getty Images; courtesy of Norah Weinstein; (row 2, l–r) Galina Zhigalova/Alamy; courtesy of Leah Belstra; Cavan/Getty Images; courtesy of Tania Whittier; Flashpop/Getty Images; courtesy of Tania Whittier; Volodymyr Tverdokhlib/Alamy; (row 3, l–r) Flashpop/Getty Images; courtesy of Maureen Roffini; Erin Lester/Getty Images; courtesy of Tania Whittier; courtesy of Maureen Roffini; Volodymyr Tverdokhlib/Alamy; Maskot/Getty Images; (row 4, l–r) Adobe Stock; courtesy of Maureen Roffini; courtesy of Leah Belstra; Jane Khmoi/Getty Images; Eve Livesey/Getty Images; Lisa Tichané/Adobe Stock; 56: clockwise from top left, Steve Granitz/WireImage/Getty Images, courtesy of Fergie (remaining); 57: Richard Corkery/NY Daily News Archive via Getty Images (Larter black tee); Gilbert Carrasquillo/GC Images/Getty Images (Larter polka dot top); courtesy of Ali Larter (4 remaining); Naomi Kaltman/Corbis Outline/Corbis via Getty Images (short hair); courtesy of Marley Shelton (6 remaining); 58: Vivien Killilea/Getty Images for NYFW—The Shows

(largest image); courtesy of Tori Praver (8 remaining); 59: Gregg DeGuire/Getty Images (largest image); courtesy of Kate Upton (3 remaining); courtesy of Tatum O'Neal (5); 60–61: courtesy of Khloe Kardashian; 62: Ian West/PA Images/Alamy (Mann yellow dress); courtesy of Leslie Mann (4 remaining); Shutterstock (Leigh horizontal); Matt Baron/Shutterstock (Leigh purple background); courtesy of Jennifer Jason Leigh (4 remaining); 63: Corey Nickols/Getty Images for Pizza Hut (Monroe purple jacket); courtesy of Maika Monroe (2 remaining); Tommaso Boddi/Getty Images (Richie black jacket); courtesy of Sofia Richie (2 remaining); Andreas Branch/Patrick McMullan/Getty Images (Bennett redhead); Bei/Shutterstock (Bennett black tank top); courtesy of Haley Bennett (3 remaining); 64: Matt Baron/Shutterstock (Romijn black top); courtesy of Rebecca Romijn (5 remaining); Michael Brochstein/SOPA Images/LightRocket/Getty Images (Rabe black tie top); courtesy of Lily Rabe (6 remaining); 65: courtesy of Marissa Ribisi (6); courtesy of Nicola Lawton (5); 66: Patrick McMullan/Getty Images; 67: clockwise from top left, Kristin Callahan/Everett Collection/Alamy; Michael Thompson/Trunk Archive (2); Michael O'Neill/Corbis/Getty Images; Cliff Watts/Trunk Archive; Mariano Vivanco/Trunk Archive; Dee Cercone/Everett Collection/Alamy; 68: Frederick M. Brown/Getty Images (Ronson's top left); Donato Sardella/Getty Images (left center); Djamilla Rosa Cochran/WireImage for Bragman Nyman Cafarelli/Getty Images (row 2 center); courtesy of Charlotte & Samantha Ronson (7 remaining); 69: Sharapova from top Sebastien Micke/Paris Match/Getty Images; courtesy of Maria Sharapova; courtesy of Valentina Novakovic (2); courtesy of Darnell DePalma (3); courtesy of Shana Zappa (3); 70: Gregg DeGuire/WireImage/Getty Images (Hilton family recent); John Barrett/Shutterstock (Kathy pink dress); courtesy of Hilton Family (remaining); 71: courtesy of Molly Sims (6); courtesy of Jessica Capshaw (2); courtesy of Drea DeMatteo (3); Jon Kopaloff/FilmMagic/Getty Images (recent Gay Hart); courtesy of Rebecca Gay Hart (1); 72: Mert Alas & Marcus Piggott/Art Partner; 73: Broadimage/Shutterstock (red hair); Steve Schapiro/Getty Images (on floor); Kypros/Getty Images (tie-dye top); Ron Galella, Ltd./Ron Galella Collection/Getty Images (black jacket); courtesy of Drew Barrymore (remaining 6); 74: Sturm from top, courtesy of Barbara Sturm (2); Chris Singer; Stewart from left, Patrick Fraser/Corbis via Getty Images (Stewart red beads); courtesy of Kimberly Stewart (2); Dahan from left, Frazer Harrison/Getty Images for Max Mara; courtesy of Ambre Dahan (2); Bello from left, Kwaku Alston/Corbis via Getty Images; courtesy of Maria Bello (2); 75: courtesy of Sabrina and Juliette Labelle (9); Theron from top left, Jason Merritt/Getty Images; Steve Granitz/WireImage/Getty Images (Theron bottom left); Allstar Picture Library/Alamy; Jim Smeal/Ron Galella Collection/Getty Images; Tsuni/USA/Alamy; 76: Alex Berliner/BEI/Shutterstock; 77: from top, courtesy of Penguin Cold Cap; courtesy of Jessica St. Clair (2); 78: Kristin Callahan/Everett Collection/Alamy Live News (pink background); Steve Granitz/Getty Images (red dress); courtesy of January Jones (7 remaining); 79: Bundchen from top, Jim Smeal/Ron Galella Collection via Getty Images; Vince Bucci/Getty Images; Hawn from left, Steve Schapiro/Corbis via Getty Images; Terry O'Neill/Iconic Images/Getty Images; Fonda AF archive/Alamy (2); 80: Basinger from left, MR Photo/Corbis via Getty Images; Warner Brothers/Michael Ochs Archives/Getty Images; Warner Bros/Eon Productions/Ronald Grant Archive/Alamy; Gary Lewis/mptvimages.com; Nicks from left, Charles Knight/Shutterstock; Fin Costello/Redferns/Getty Images; Gary Lewis/MPTV; SJP from left, Ron Galella, Ltd./Ron Galella Collection via Getty Images; Bette Marshall/Contour by Getty Images; HBO/Darren Star Productions/Kobal/Shutterstock; 81: Ekland from left, Silver Screen Collection/Hulton Archive/Getty Images, Rolls Press/Popperfoto via Getty Images; Terry O'Neill/Iconic Images/Getty Images (2); Brinkley from left, Globe Photos/Shutterstock; Walter Iooss Jr./Sports Illustrated via Contour by Getty Images (3); Hall from left, Giancarlo BOTTI/Gamma-Rapho via Getty Images; Norman Parkinson/Getty Images; Art Zelin/Getty Images (2); 82: Larry Busacca/Getty Images (Danner top left); Bruce Birmelin/NBCU Photo Bank/Getty Images (top Paltrow); Ron Galella, Ltd./Ron Galella Collection via Getty Images (Danner & Paltrow); Evan Agostini/Liaison/Getty Images (Paltrow hair up); Theodore Wood/Camera Press/Redux (Paltrow gray sweater); MPTV.com (Danner brown coat); Princess Di clockwise from left, Fox Photos/Getty Images; Tim Graham Photo Library/Getty Images; Anwar Hussein/WireImage/Getty Images; Georges De

WireImage/Getty Images; Pascal Le Segretain/Getty Images; Winfrey from top, Shutterstock; Jessie Craig/BAFTA/Camera Press/Redux; 123: clockwise from top right, Harry Langdon/Getty Images; Trinity Mirror/Mirrorpix/Alamy; AF archive/Alamy; Catherine Cabrol/Kipa/Sygma via Getty Images; Ron Galella, Ltd./Ron Galella Collection via Getty Images; Fox Photos/Getty Images; 126: Cher, clockwise from top left, © ABC/Getty Images; Pictorial Press Ltd/Alamy; Harry Langdon/Getty Images; Michael Ochs Archives/Getty Images; Frank Edwards/Fotos International/Getty Images; Harry Langdon/Getty Images; Markle from left, Samir Hussein/WireImage/Getty Images; Daniel Leal-Olivas/AFP via Getty Images; Grier from top, Michael Ochs Archive/Getty Images; Photofest; 127: Johnson from left, Mike Reinhardt/Conde Nast via Getty Images; John Vidol/Condé Nast via Getty Images; Fitz-Henley from top, Rodin Eckenroth/Getty Images; Rob Latour/Shutterstock; Williams sisters clockwise from top left, Timothy Greenfield-Sanders/Corbis via Getty Images; Robert Wilson/Contour by Getty Images; Professional Sport/Popperfoto via Getty Images; Patrick Fraser/Corbis via Getty Images; Patrick Fraser/Corbis via Getty Images; Ian White/Corbis via Getty Images; 130–31: Paul Bergen/Redferns/Getty Images (Adele); Interphoto/Alamy (Amos); Marv Newton/mptvimages.com (Spacek); Fotos International/Archive Photos/Getty Images (Burnett); Steve Azzara/Corbis via Getty Images (Mol); Harry Langdon/Getty Images (Lauren); Robin Holland/Corbis via Getty Images (Swinton); J. Vespa/WireImage/Getty Images (Messing); Matt Baron/Shutterstock (Adams); Benjamin Lozovsky/BFA.com (Van Rompaey); AD Photography/Stocksy/Adobe Stock (sky blue background); Guille Faingold/Stocksy/Adobe Stock (white tank top); Ivan Ozerov/Stocksy/Adobe Stock (laying on hand); 132–33: column 1, from top, Roger Wright/Getty Images; Flashpop/Getty Images; courtesy of Michelle Lehmann; column 2, from top, Svetlana Shchemeleva/Stocksy/Adobe Stock; Svetlana Shchemeleva/Stocksy/Adobe Stock; courtesy of Richard Schultz/Adobe Stock; Marc Bordons/Stocksy/Adobe Stock; Ana Francisconi/EyeEm/Getty Images; Flashpop/Getty Images; column 4 from top, KQS/Alamy; Thomas Vogel/Getty Images; Zoe Adlersberg/Trunk Archive; Scandinav/Adobe Stock; moodboard/Getty Images; Stefano Azario/Trunk Archive; Uwe Krejci/Getty Images (2); column 5 from top, Zoe Adlersberg/Trunk Archive; Elena Enea/EyeEm/Adobe Stock; Ada Summer/Getty Images; 134: MediaPunch/Shutterstock (Fisher recent); courtesy of Isla Fisher (3); courtesy of Alexandra Cherkashin (4); 135: courtesy of Jessica Chaffin (4); courtesy of Luxe Moody (6); 136: courtesy of Nikki Penne (4); courtesy of Kimberly Kreuzberger (4); 137: courtesy of Bryte Darden (4); Jack Guy/Corbis via Contour by Getty Images (Walsh top); courtesy of Kate Walsh (bottom); courtesy of Vanessa Krooss (4); 138: James White/Trunk Archive (top left); Matt Sayles/Shutterstock (top right); Sipa/Shutterstock (pink headband); P. Lehman/Barcroft Media via Getty Images (yellow dress); Indira Cesarine/The Untitled Magazine/Corbis via Contour by Getty Images (bottom left); courtesy of Zoey Deutch (3 remaining); 140: Vince Bucci/Getty Images; 141: (row 1 from left) courtesy of Emma Stone (2); Francois Durand/Getty Images. (row 2 from left) Fred Duval/FilmMagic/Getty Images; Florian G Seefried/Getty Images; courtesy of Emma Stone; (row 3, from left) Toni Anne Barson/Getty Images; Ben Hassett/August; Gary Friedman/Los Angeles Times/Contour by Getty Images; 142: Stubbington clockwise from top right, Christian Vierig/Getty Images; WENN Rights Ltd/Alamy; Ovidiu Hrubaru/Alamy; Christian Vierig/WireImage/Getty Images; Dicker from left, James Atoa/Everett Collection/Alamy; Daniela Federici/Corbis via Getty Images; Theo Wargo/Getty Images; 143: Lohan clockwise from top right, Matt Baron/BEI/Shutterstock; Stefanie Keenan/Patrick McMullan via Getty Images; Matthew Rolston/Corbis via Getty Images; Evan Agostini/Getty Images; Kidman clockwise from top right, Pool Benainous/Duclos/Gamma-Rapho via Getty Images; Eric Robert/Sygma/Sygma via Getty Images; Terry O'Neill/Iconic Images/Getty Images; Lance Staedler/Corbis via Contour by Getty Images; Mark Liddell/Contour by Getty Images; 144: Moore from left, Miller Mobley/August; Victor Demarchelier/August. Ringwald from left, Allstar Picture Library Ltd/Alamy; Globe Photos/zumapress.com/Alamy; Globe/MediaPunch/Alamy. Roberts from left, AA Film Archive/Alamy; AF archive/Alamy; Ron Galella, Ltd/Ron Galella Collection via Getty Images; 145: Wright from top, Jo Hale/Getty Images; Jessie Craig/Contour by Getty Images. Coddington from top, Sheila Metzner/Trunk Archive; Danielle Levitt/August; dpa/Alamy Live News. Lane clockwise from left, Mario De Biasi/Mondadori Portfolio/Getty Images; Everett Collection; Photo 12/Alamy; Pictorial Press Ltd/Alamy; 146: Reilly from top, Vera Anderson/WireImago/Getty Images; Fred Duval/Contributor/Getty Images; Michael Crabtree/PA Images/Getty Images. Everhart clockwise from top, Douglas Kirkland/Corbis via Getty Images; CelebrityArchaeology.com/Alamy; Allstar Picture Library Ltd/Alamy; John

Russo/Sygma via Getty Images. Cole clockwise from right, Kate Martin/Contour by Getty Images; Niki Nikolova/FilmMagic/Getty Images; Shutterstock; 147: Sarandon from top, Steve Schapiro/Corbis via Getty Images; AF archive/Alamy; Moviestore Collection Ltd/Alamy. Davis, clockwise from top left, Fotos International/Getty Images (with Sarandon); Michael Ferguson/PHOTOlink.net/MediaPunch/Alamy; Columbia Pictures/courtesy Everett Collection. Hendricks from left, Megan Mack/Contour by Getty Images; Matt Carr/Getty Images; 148: Elson clockwise from top left, Angela Weiss/AFP via Getty Images; Alexi/Alamy; Neilson Barnard/Getty Images for Tanqueray; John Lindquist/Contour by Getty Images. Louise clockwise from left, Silver Screen Collection/Getty Images; Silver Screen Collection/Getty Images (2); Kobal/Shutterstock; Art Zelin/Getty Images; 149: Ball clockwise from left, mptvimages.com; SilverScreen/Alamy; Eric Carpenter/Mgm/Kobal/Shutterstock; Mondadori via Getty Images. Ferguson from left, Kypros/Getty Images; David Levenson/Getty Images; Anwar Hussein/Getty Images; David Montgomery/Getty Images. Anderson from left, British Sky Broadcasting Ltd/Shutterstock; Vinnie Zuffante/Michael Ochs Archives/Getty Images; Moviestore Collection/Shutterstock; 150: (row 1, l–r) Terry O'Neill/Getty Images; Matt Baron/Shutterstock; Eugene Adebari/Shutterstock; (row 2, l–r) mptvimages.com; Everett Collection; Ron Galella/Getty Images (2); (row 3, l–r) Everett Collection; Touchstone/Getty Images; 151: Danes, clockwise from left, Timothy Green-field-Sanders/Corbis via Getty Images; Photo 12/Alamy; Allstar Picture Library Ltd/Alamy; ABC Productions/Album/Alamy. Raitt from top, David Gahr/Getty Images; Michael Putland/Getty Images; Drew Gurian/Invision/AP/Shutterstock; 154–55: Top row from left, Robert Wilson/Getty Images; Araya Diaz/Getty Images; David Needleman/August; courtesy of Eryn DeSomer; Christopher Wahl/Getty Images; Stuart Wilson/Getty Images. Bottom row from left: Marc Baptiste/Corbis via Getty Images; Paul Morigi/WireImage/Getty Images; Astrid Stawiarz/Getty Images; (above) Daniel Suchnik/WireImage/Getty Images; (below) Ron Galella/Getty Images; (above) Jay L. Clendenin/Getty Images; (below) Allstar Picture Library Ltd/Alamy; (above) Victor Virgile/Gamma-Rapho via Getty Images; (below) Daniel Suchnik/Getty Images; 156: courtesy of Juhasz Szep Anna; 157: Pedersen & Cunningham, courtesy of Tracey Cunningham; Aiken, courtesy of Michelle Aiken; 158: (from left) courtesy of Whitney; courtesy of Sumaira; courtesy of Fransje; 159: courtesy of Marina Garcia-Trovijano (5); courtesy of Nicole Freeman (5); 160–61: courtesy of Melissa Vinopal (4); courtesy of Sandrine Picard (4); courtesy of Hayley Wills (4); 162–63: courtesy of Pilar Aragon (6); courtesy of Tennille Murphy (4); courtesy of Ondine Rumner (2); courtesy of Jin Cruce (1); courtesy of Felicia Ruiz; courtesy of Priscilla Bavaresco (2); courtesy of Diane Keaton (2); 164: clockwise from top left, Mediapunch/Shutterstock; courtesy of Diane Keaton (2); Hulton Archive/Getty Images; Stein/Mediapunch/Shutterstock; Raffaella Midiri/LUZ/Redux; Globe Photos/Media Punch/Shutterstock; 165: Harris clockwise from bottom right, Edward Berthelot/Getty Images (2); Vanni Bassetti/Getty Images; Dave Benett/Getty Images; Queen from left, Bettman Collection/Getty Images; Erin Combs/Toronto Star/Getty Images; Tim Graham/Getty Images; Chris Jackson/WPA Pool/Getty Images; 166: (clockwise from top left) Darren Gerrish/WireImage/Getty Images; Can Nguyen/Shutterstock; David M. Benett/Dave Benett/Getty Images; WENN Rights Ltd/Alamy; Stephane Cardinale/Corbis via Getty Images; James Peltekian/Camera Press/Redux; ZUMA Press, Inc./Alamy; 167: Bush from top, Dirck Halstead/Getty Images; Everett Collection/Shutterstock. Smith from left, Lynn Goldsmith/Corbis/VCG via Getty Images; Christopher Wahl/Contour by Getty Images. MacGraw from left, MediaPunch Inc/Alamy; Edith Young; 173: Esperanza Moya/Trunk Archive; 180: Bobby Doherty; 184: James Wojcik/Trunk Archive; 187: Bobby Doherty; 191: Lauren Allen/Adobe Stock; 193: Viktoria Stut/Gallery Stock/Trunk Archive; 197: Tamara Kulikova/Shutterstock; 201: Francesco Scavullo/Condé Nast via Getty Images; 211, 213: Carlos Lopez/courtesy of Tracey Cunningham; 214–15: Chris Greene (5)

ACKNOWLEDGMENTS

So much creativity and work have gone into this book over the past two and a half years, and I have so many amazing people in my life who helped me make it happen.

There would have never been a book deal without my friend Ellen Goldsmith-Vein, who pushed me to make this happen. I would have never done it without her.

Thank you to the team at Abrams who helped bring my vision to life. To Rebecca Kaplan—thank you for cracking the whip and keeping us on deadline (we finally did it!). And to Shannon Kelly, thank you for your tireless guidance and Zoom patience to make sure we got everything just right.

To Alex Pollack, thank you for using your photo prowess to bring the visual aspect of this book to life. I will forever be grateful for all of the stones you overturned to unearth gorgeous blondes, brunettes, redheads, silvers . . . all of them.

Thank you to my writing partner, Erin Weinger. Throughout all the photo emails, dinner table work sessions, medi-spa visits, and Santa Barbara road trips, we've had a long adventure that's led to this victorious finish line.

And for a different adventure, thank you to Dean and Darcy Christal.

To my incredible team and my colleagues Chris Greene, Tyle Mahoney, Liz Jung, Matt Rez, Jacob Schwartz, Jacqui McFarlane, Jennifer Hendriks, Jeremy Cohen, Katrina Samson, Alanah Bushey, Sean Metcalfe, Kevin Starr, Kari Hill, Michelle Pugh, Minya Alyssa, Leslie Boyd, Kay Kennedy, and Kristy Lash: Thank you for contributing to this passion project. And thank you to my wonderful friend Sharon McConochie, who supported this dream from the beginning, too.

Thank you, Fran and Neil Weisberg, for your partnership.

Thank you to my parents, Tom and Susan Cunningham; my mom, Anita Pedersen; my brothers, Kevin and Tom; and especially my sister, Sandi, who always helps me with everything. And special thanks to Jim and Carla Palmer.

And to each and every client and friend (both IRL and Instagram) who so generously searched far and wide, called parents, dug through shoe boxes, looked on old digital cameras, and scoured family albums so their personal photos could be included in this book. I feel so lucky to be able to share your photos and stories.

Everyone needs a Jewish mother, and Bette Midler has been mine. I can't begin to thank her enough for the love and support she and her family have shown me over the years (everyone needs that, too).

Also, I thank God (seriously, He answers all of my prayers).

And finally, to my family—Max Robertson and Chris Palmer. Max has never once made me feel guilty for working too much (I do that on my own), and he has always been there for me, no matter what. Chris has been such an incredible partner both in life and in writing this book. From helping brainstorm to proofreading, his knowledge and opinions have been invaluable. Thank you, Chris, for always having my back.